ART AND HISTORY
PRAGUE

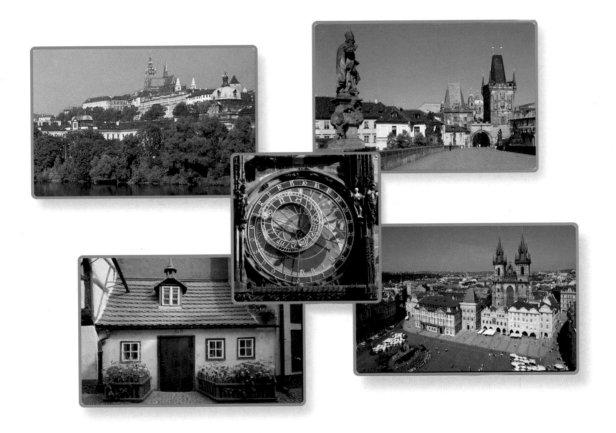

Text *by* GIULIANO VALDES

Photographs *by* ANDREA PISTOLESI

BONECHI

© Copyright by Casa Editrice Bonechi, via Cairoli 18/b Florence - Italy
e-mail:bonechi@bonechi.it - Internet:www.bonechi.it

Origination and project: Casa Editrice Bonechi
Editing Manager: Monica Bonechi
Graphic layout and iconographic research: Serena de Leonardis
Cover: Sonia Gottardo
Video-paging: Manuela Ranfagni
Editing: Giovannella Masini and Editing Studio - Pisa

Text: Giuliano Valdes
Translation: Sarah Thompson

Photographs are the property of the Archivio Bonechi and were taken by: Andrea Pistolesi,
except for those on pages: 6 below; 42 belows; 67; 70; 98; 121; 122; 123;
which are by Gianni Dagli Orti.
Drawings on pages 8-9; 56-57; 76: Stefano Benini
Map on page 126-7: Bernardo Mannucci

Printed in Italy by Centro Stampa Editoriale Bonechi.

ISBN 88-8029-556-X

* * *

INTRODUCTION

"The Magical City", "The Golden City", "The City of a Hundred Towers", the "Paris of the East"; these are just some of the most common definitions adopted by popular tourist publications when talking about Prague, a city of around 1,200,000 inhabitants and, since 1st January 1993, capital of the Czech Republic, as well as capital of central Bohemia. The city offers a wealth of architectural, artistic and cultural treasures, and possesses an individual charm: buildings everywhere are of pleasing architectural form and proportional harmony, with close attention to ornamental detail. It lies proudly along the banks of the River Vltava, amid the gentle surroundings of the hills which characterise this part of Bohemia. Prague has been a melting-pot of ethnic groups since ancient times, existing by combining Czech ele-

ments with Jewish and German ones, and allowing the development of religious movements, trade and commerce, and of industry, thanks to its favourable geographic position on the communication routes between Central and Eastern Europe, and between the North and South of the vast German and Slavonic area. A jealous keeper of its mysteries, the city is reluctant to reveal itself to the curiosity of those wanting to unearth the secrets of the alchemists of the past. The birthplace or one time residence of many famous people, such as the astronomers Tycho Brahe and Johannes Kepler, the Dientzenhofers, Albert Einstein, Wolfgang Amadeus Mozart, Antonín Dvořák, Bedřich Smetana, Jaroslav Hašek, Franz Kafka, Jan Hus, St John Nepomuk, and many other illustrious figures, the city bears witness to cultures and civilisations from all over the world.
Over the centuries it has survived wars and disasters. Only in 1968 the tanks of the Warsaw Pact were able to defeat its rebellious nature: the people's thirst for freedom was satisfied 23 years after Jan Palach had been engulfed by flames, making him the martyr of a shattered "Spring".
The first settlements on the site of the modern city date back to Neolithic times, and fortified settlements were first recorded in the 9th century. Primitive centres joined together around the fortresses of Hradčany and Vyšehrad between the 9th and 10th centuries, and from that time onwards the Přemyslids made this the most important castle in Bohemia. As a result it became the focal point for the activities of craftsmen and merchants, attracting mainly Jews and Germans. Having become a Bishop's See in 973, Prague obtained city status between 1232 and 1235. Charles IV then made it the capital of the Empire, founding the University here in 1348 and preparing the ground for large scale urban development. In 1419 the followers of Želivský freed the Hussites held prisoner in the New Town Hall, and threw out the Catholic counsellors. This marked the beginning of a long period of religious conflict. In fact, the ascension of the Habsburgs in 1526 marked the decline of

Prague, and this became even more marked after the failure of the revolt against the Viennese sovereigns in 1547.
While having suffered limitations to its autonomy and the loss of its Court, which had been transferred to Vienna, the city underwent a brief period of revival under Rudolph II who settled here between 1583-1610, and who also contributed to the Germanisation of the city. The Czech revolt of 1618, which began with the "Second Prague Defenestration", led to the Thirty Years' War. Following its defeat in the Battle of the White Mountain (8th Nov 1620) Prague entered a period of deep decline from all points of view: the wave of middle-class emigration in the first half of the 17th century was of biblical proportions. The uprisings of 1848 failed in their attempt to gain freedom for the Slavs who opposed the centralisation policy introduced by Joseph II. 1861 marked a clear turning-point with the success of the Slavs in the municipal elections.
Between the 19th and 20th centuries the economic and industrial development of Prague led to a considerable influx of the rural population, and caused a growing interest on the part of the nobility in cultural and intellectual pursuits. After the First World War Prague was proclaimed the Capital of Czechoslovakia.
The city endured the brutal domination of the Nazis from 1939 until 1945 when it was liberated by the Russians. In 1948 a Communist coup d'état transformed Czechoslovakia into a Popular Republic, and 1960 marked the birth of the Czechoslovakian Socialist Republic.
The long ordeal seemed to be coming to an end in 1968 when the new, more liberal programme adopted by Dubček (the so-called "Prague Spring"), appeared to open the way towards reform and civil liberties. However, the ever-present threat of the Soviet, Communist monolith was brutally felt on 20th August 1968 when tanks were sent into Prague, causing the indignant reaction of its inhabitants, and culminating in the suicides of the students Palach and Zajíc. Twenty years later a protest march was held against the Soviet occupiers to demand liberty and civil rights. Despite police repression, which was repeated a year later to oppose the demands of the "Charta 77" movement, this event later led, through the "Velvet Revolution", to the fall of the Communist Regime in Czechoslovakia and to the resignation of Gustáv Husák. Václav Havel took his place and became President of the Republic at the end of 1989. The free elections of 1990 marked the victory of the list led by Havel and Dubček, the latter having returned to his country from Slovakia. On 1st January 1993 the division of the Federal Republic of Czechoslovakia was ratified, giving rise to the Czech and the Slovak Republics, with Prague and Bratislava as their respective capitals.

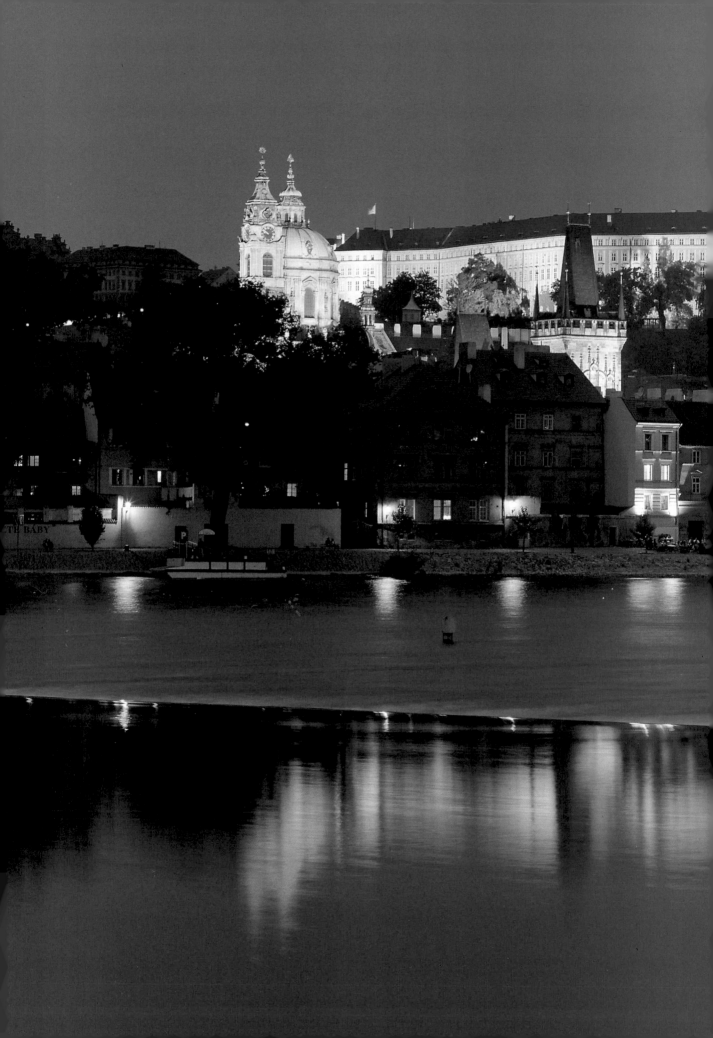

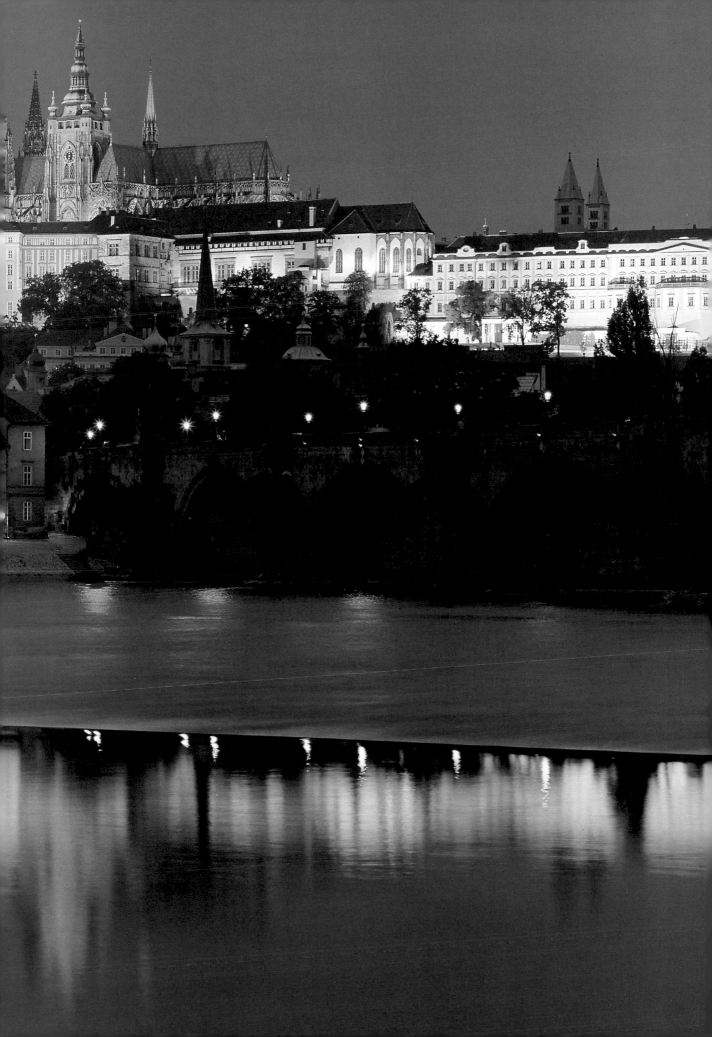

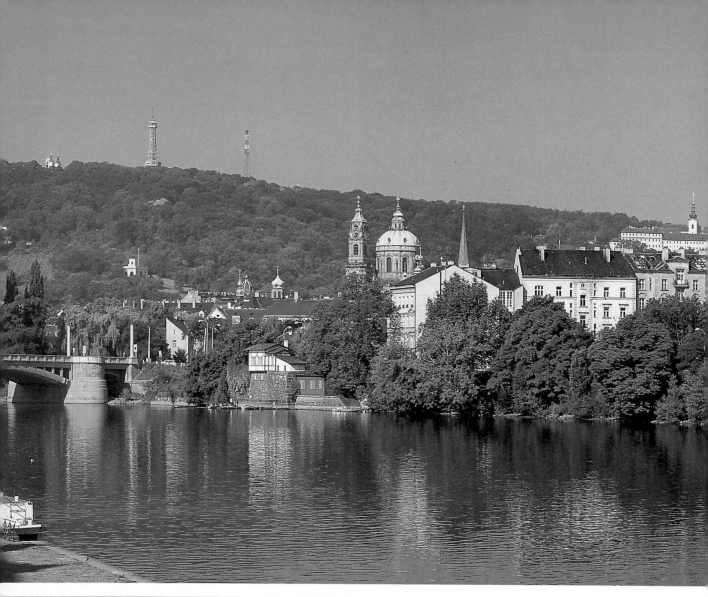

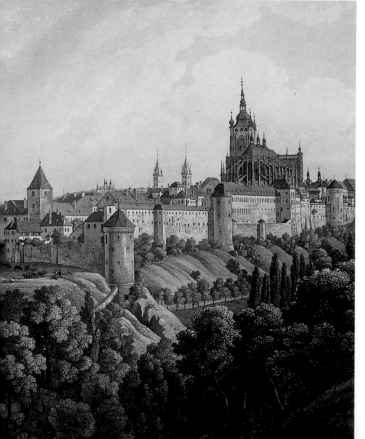

On the previous pages: evocative nocturnal view towards
Charles Bridge, Malá Strana and the monumental
Castle of Prague.

A lovely panorama of Prague, from Petřín Hill to the quarter
of Malá Strana, dominated by the Castle.

Prague in the 19th century
(detail from a water-colour by Morstadt).

Main entrance to the Castle from Hradčanské náměstí.

THE CASTLE
Pražský hrad

One of the largest fortresses in the world, the Castle
of Prague represents the essence of the Bohemian city
and the historical memory of the infant Czech
Republic. It was founded by the Přemyslids in the
second half of the 9th century, and the additions
made over the centuries, following episodes of fire
and devastation, give us the grand complex as we see
it today. It is a combination of Romanesque, Gothic,
Renaissance and Baroque elements which bear wit-
ness to the stratification of various cultures, historical
eras, architectural and artistic trends.

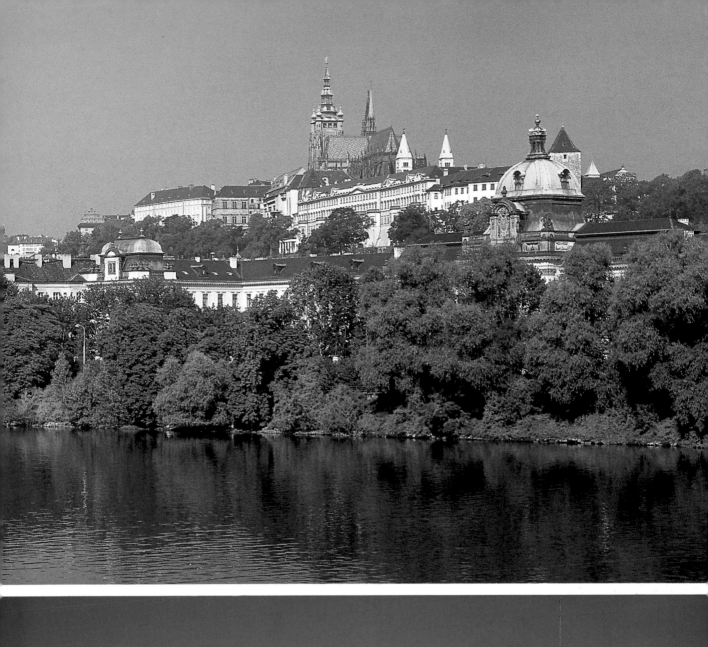

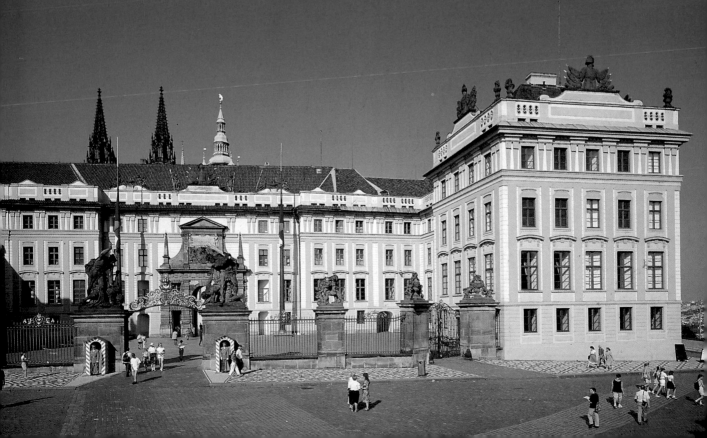

THE CASTLE

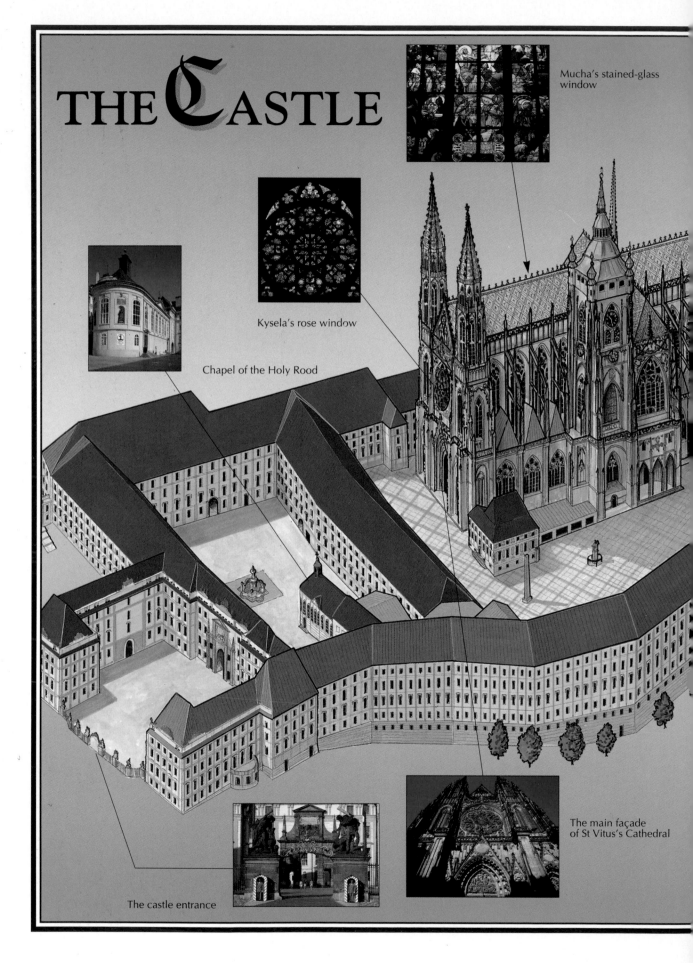

Mucha's stained-glass window

Kysela's rose window

Chapel of the Holy Rood

The main façade of St Vitus's Cathedral

The castle entrance

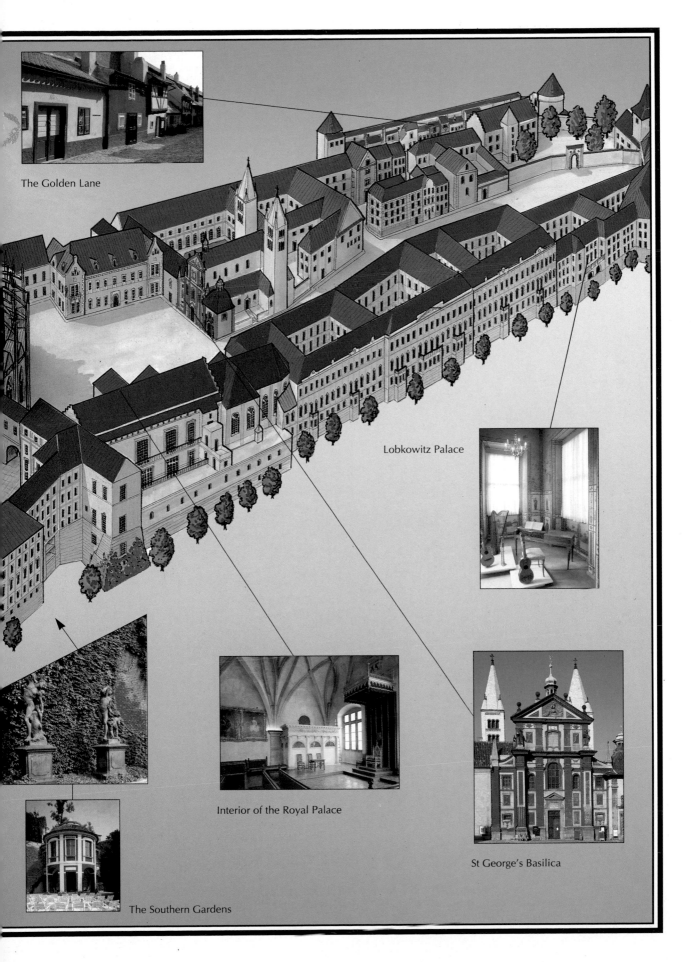

The Golden Lane

Lobkowitz Palace

Interior of the Royal Palace

St George's Basilica

The Southern Gardens

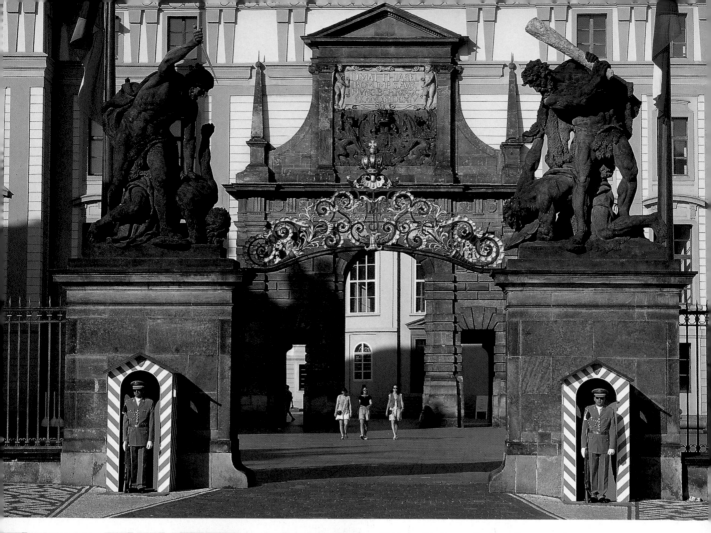

The gate leading to the Grand Courtyard.

Detail of the 'Fighting Giants' (copy by I. Platzer the Elder) which stand above the entrance gate to the Grand Courtyard.

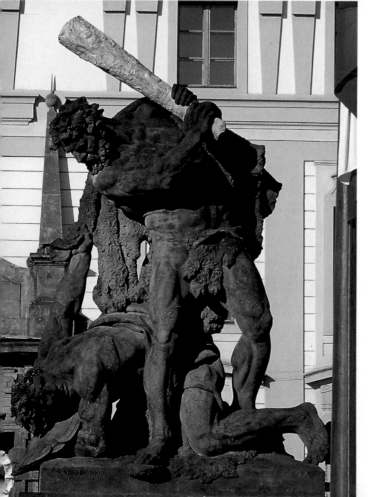

The **Grand Courtyard** (also called the **First Courtyard**) was completed in the Habsburg period (18th century); Maria Theresa of Austria entrusted the project to the Court architect, N. Picassi, and the work was carried out under the direction of A. Lurago.

On the piers of the entrance gate are copies of I. Platzer the Elder's **_Fighting Giants_** (18th century). The **Second Courtyard** is reached through the 17th century **Matthias Gate** and is decorated with a 17th century Baroque fountain with sculptures by H. Kohl.

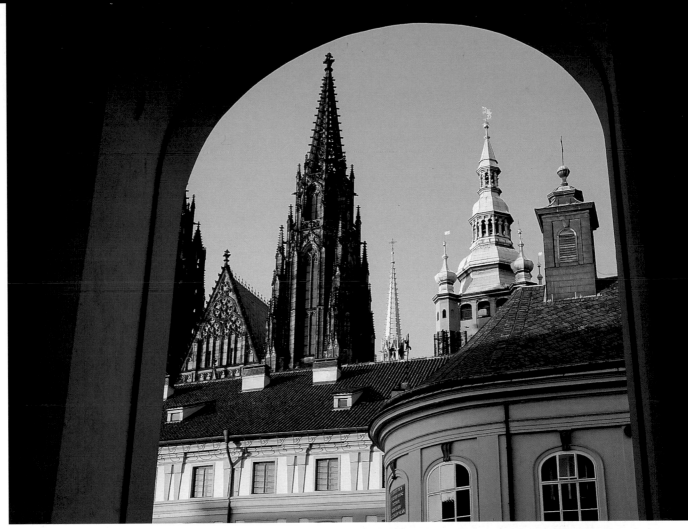

The Cathedral towers seen from Matthias Gate.

Detail of the sculptures which adorn the fountain in the second courtyard.

CASTLE GALLERY
Obrazárna Pražského hradu

The building in the north-western corner of the court-yard has housed the Castle Gallery since 1965, and this includes paintings previously displayed in the Rudolph and Ferdinand II galleries. This interesting gallery contains works by excellent European artists. Among the most important are Jacopo Robusti, known as 'Tintoretto' (*Shepherds in adoration of*

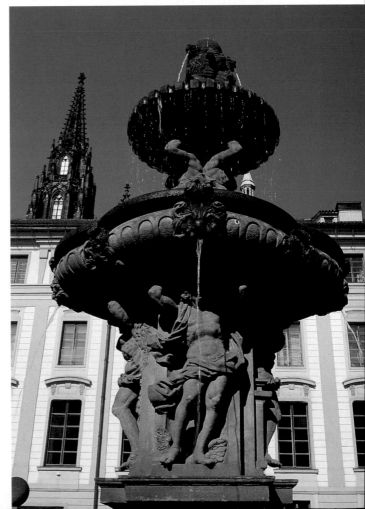

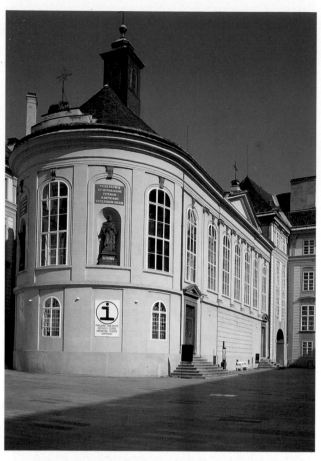

Jesus, Jesus and the Adulterer); Titian (*Young Woman*, better known as *The Toilet of a Young Lady*); P. Brandl (*Paul the Apostle*); Veronese (*Saint Catherine with the Angel*); G. Reni (*Nessus and Deianeira*); P.P. Rubens (*The Assembly of the Olympic Gods*); Hans von Aachen (*Portrait of the Emperor Matthias*); Jan Kupecký; J. P. Brandl.

On the opposite side of the courtyard is the **Chapel of the Holy Rood**, built by A. Lurago in the 18th century. The walls bear paintings by V. Kandler and J. Navrátil, while the 19th century sculptures are by E. Max (*St Peter and St Paul, St John Nepomuk*).

The **Third Courtyard**, once the hub of fortress activity, contains the central nucleus of the Castle - the Cathedral, the Old Provostship and the Royal Palace.

An external view of the elegant Chapel of the Holy Rood.

Chapel of the Holy Rood: the elegant ornamentation adorning its interior.

Chapel of the Holy Rood: magnificent frescoes decorate the unique barrel-vaulting.

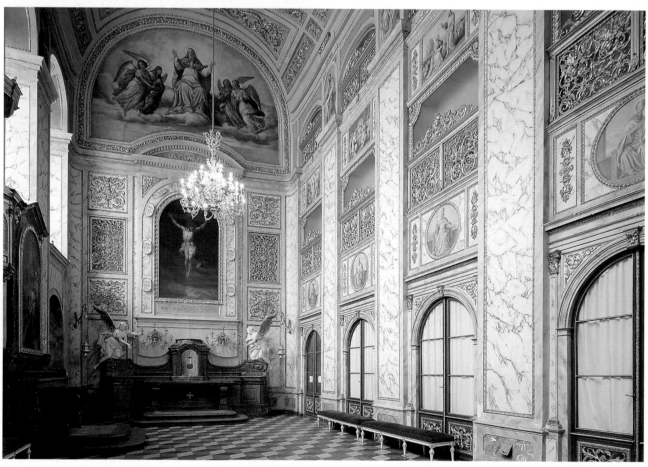

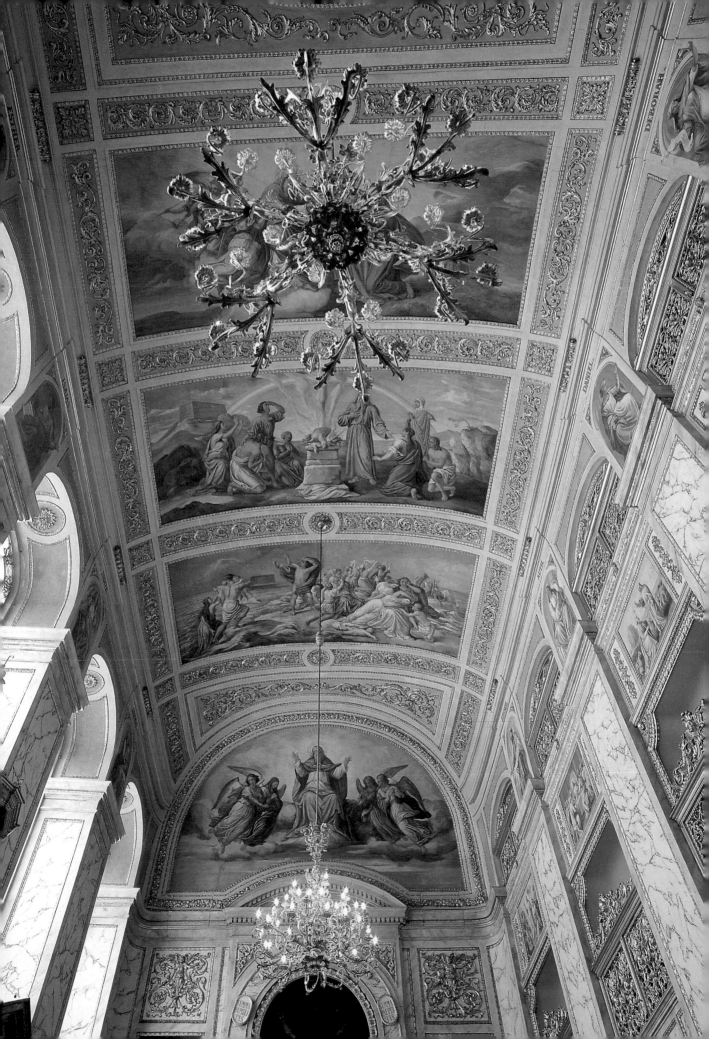

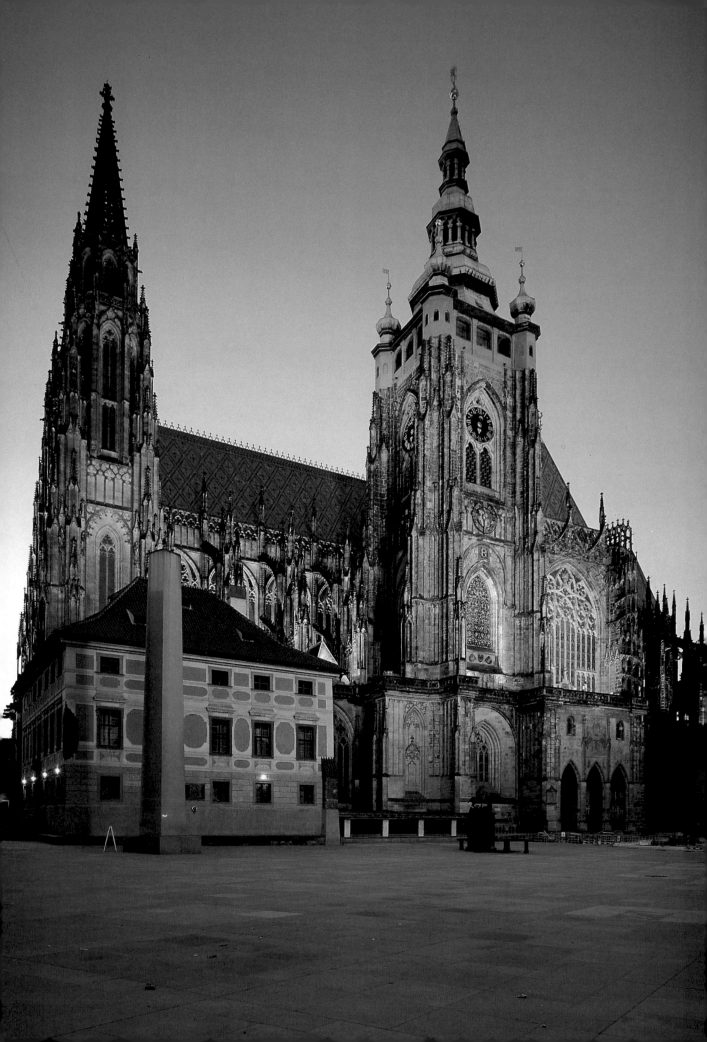

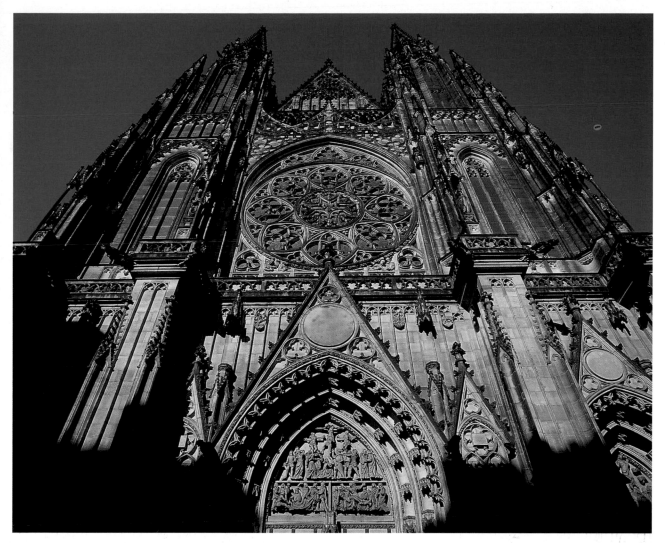

St Vitus's Cathedral at dusk, with its highest tower, the Old Provost's Lodging and the Obelisk commemorating the victims of the Great War.

St Vitus's Cathedral: detail of the superb neo-Gothic façade highlighting the elaborate portal and splendid rose window.

CATHEDRAL OF ST VITUS
Chrám svatého Víta

The history of this majestic edifice, only completed in 1929, begins around 926 when St Wenceslas had the rotunda of St Vitus built on the same site. More than a century later a Romanesque basilica rose here, and on these foundations a Gothic cathedral was later erected, starting in the first half of the 14th century. The plans were drawn up by M. d'Arras, a French architect invited to Prague by Charles IV. He started the eastern side, taking inspiration from early French Gothic and using the cathedrals of Toulouse and Narbonne as models. The work he began included the Cathedral chancel which is particularly impressive in size, being 47m long and 39m high. On the death of d'Arras the work was taken over by Peter Parler (1356) who enriched the Cathedral, modelling it on German Gothic style. The impressive bell tower stands 99m tall, dominating the Cathedral; in the latter half of the 16th century Hans of Tyrol and B. Wohlmut added its Renaissance steeple and balustrade, while the uppermost pinnacle in Baroque style was added by Pacassi (1770). The bell tower houses the 16th century *St Sigismund bell* which is the largest in Bohemia. In 1872 J. Mocker started work to complete the grandiose building. He adhered faithfully to the plans drawn up by Peter Parler, working on the western part of the cathedral which is notable for its fine neo-Gothic features. The main portal was also begun at that time, and completed in 1929

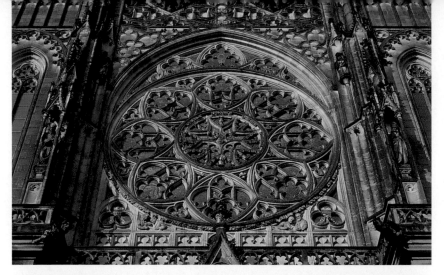

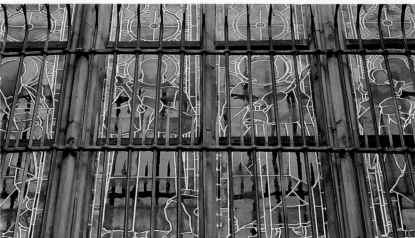

by K. Hilbert. The cathedral, now finally completed, was consecrated in the same year, 1000 years after the death of St Wenceslas. The beautiful **façade**, wedged in between twin steeples, is a masterpiece of neo-Gothic architecture, and is remarkable for its ornate decoration, particularly in the central rose window and the portals. This decorative work was carried out during the completion stage, between the second half of the 19th century and the first half of the 20th century. The fine rose window, showing *Scenes from the Creation*, was created by F. Kysela between 1925 and 1927. The monumental **interior**, a triumph of Gothic, is incredibly vast: it is

St Vitus's Cathedral: details showing the exquisite rose window which ennobles the western façade, and an example of the artistic stained-glass windows.

Elaborate scenes from the 'Passion of Christ' enrich the lunette of the entrance portal.

View of the mighty buttresses on the exterior of the chancel, and the rich Gothic ornamentation.

Detail showing one of the external gargoyles, inspired by monstrous figures.

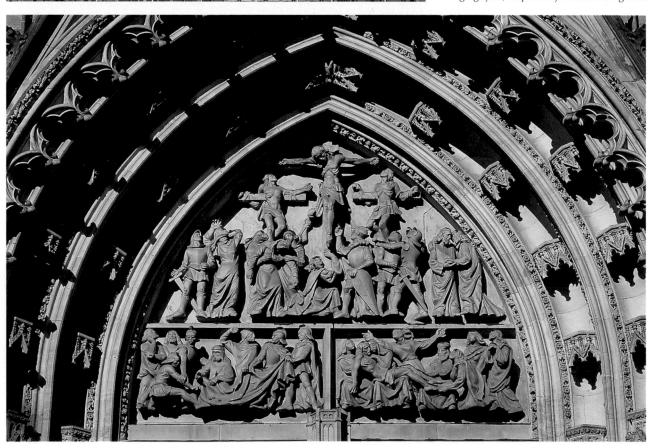

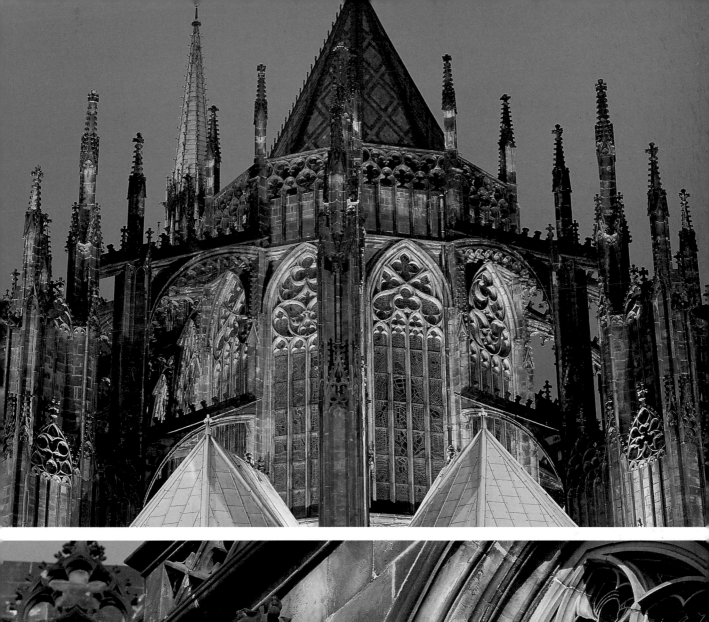
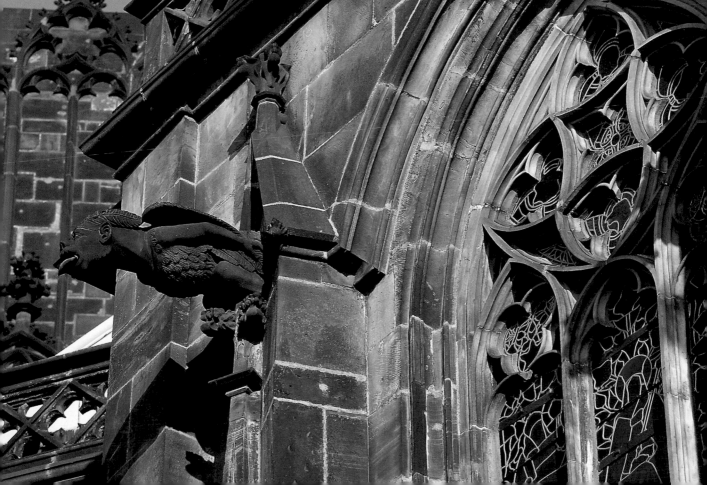

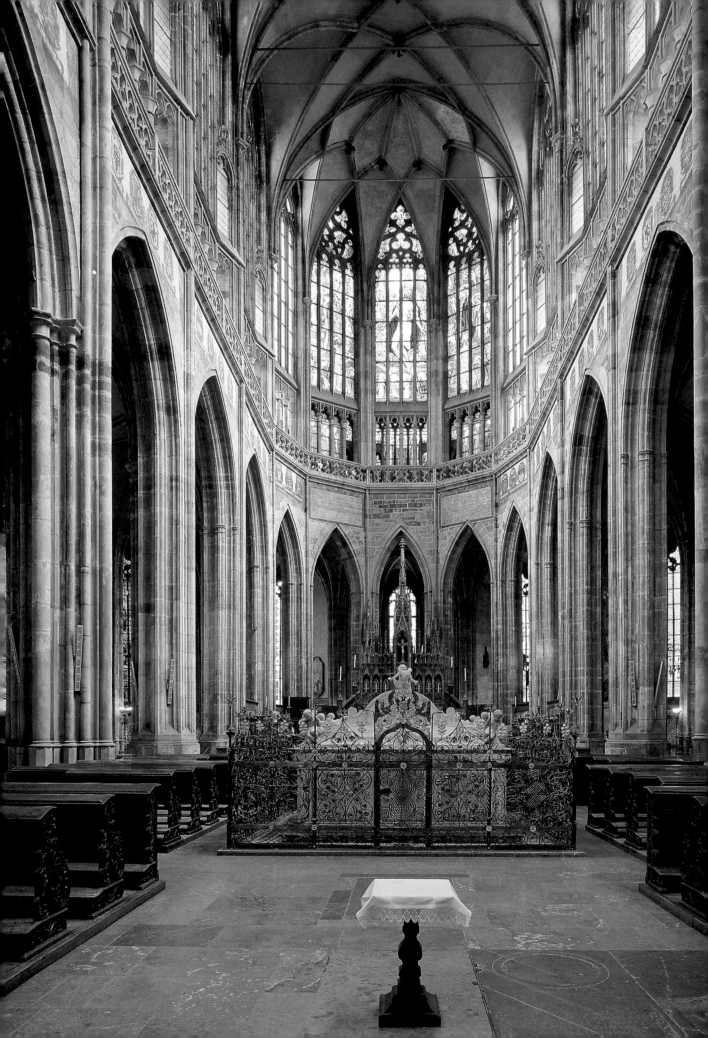

124m long and 33m high in the main nave, and 60m wide across the transept. This is the largest church in Prague and one of the most majestic buildings in the entire Castle complex. The interior is divided into three naves by massive pillars supporting ogival arches. Note the beautiful ribbed cross-vaults, and the magnificent finely illustrated mosaic windows. Some of these windows are the remarkable work of 20th century Czech artists; note for example the window crafted by A. Mucha (third chapel of the left-hand nave). The triforium holds the busts of the Cathedral's designers, illustrious figures, and members of Charles IV's family.

The southern portal (or *Golden Portal*) is crowned on the outside by a 14th century **mosaic** (*Last Judgement*), and decorated with the portraits of *Charles IV* and *Elizabeth of Pomerania*. Higher still is the mullioned window showing the *Last Judgement*. This was designed in 1934 by M. Švabinský who used no fewer than 40,000 pieces of glass. In the

St Vitus's Cathedral: scene of the interior, highlighted by the geometric forms and embroidery-like designs of the Gothic architecture.

View of the pulpit.

Detail of the fine stained-glass window by Max Švabinský in the apse.

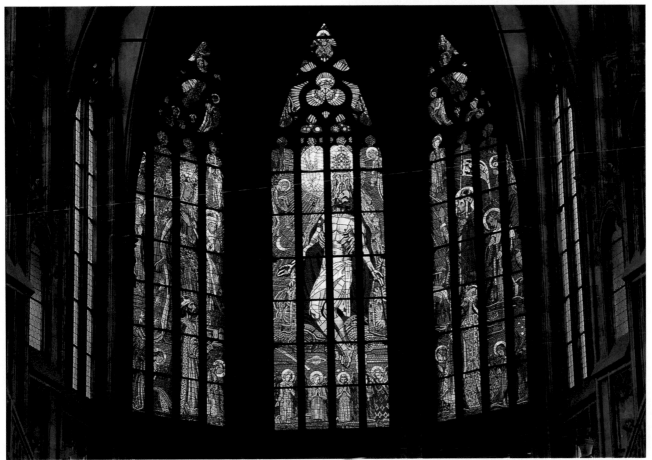

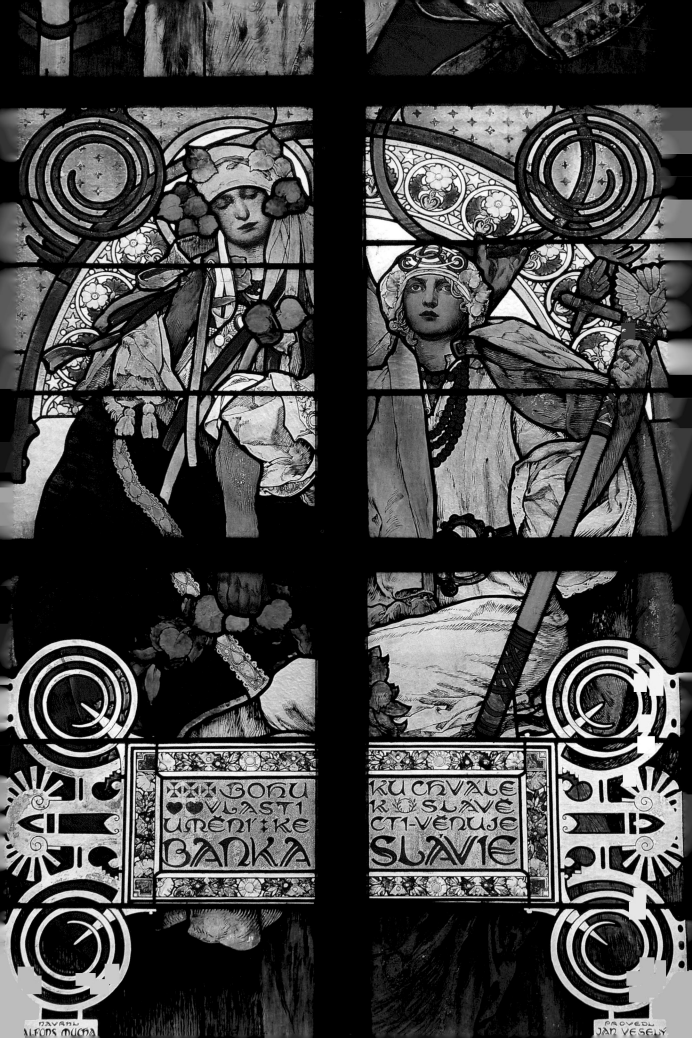

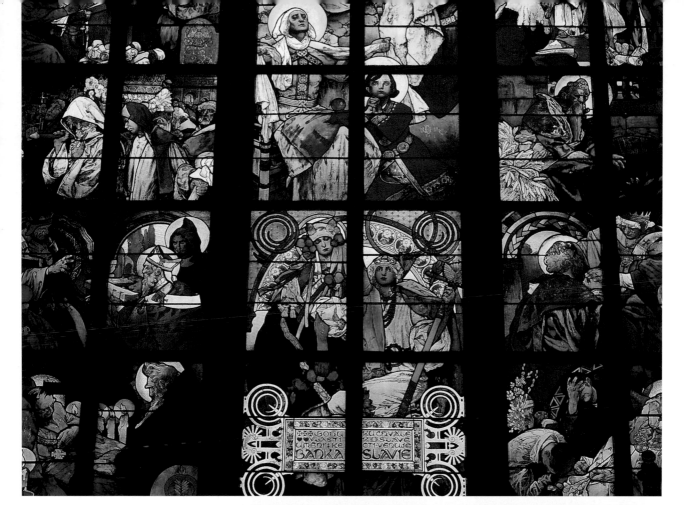

St Vitus's Cathedral: detail of the modern stained-glass window ('St Cyril and St Methodius') by Alfons Mucha.

Complete view of Alfons Mucha's stained-glass window (third chapel of the left-hand nave).

The rose window seen from the inside of the cathedral.

chancel situated opposite there is a majestic 18th century organ. The *Imperial Tomb*, in front of the high altar, is a kind of Habsburg mausoleum; it was completed in the second half of the 16th century by A. Colijn and is decorated with the statues of *Ferdinand I, Anne,* and *Maximilian II.* Members of the royal family are portrayed in the medallions. The **Chapel of St Wenceslas** is one of the most interesting of the many chapels: it was built in the 14th century by P. Parler on the site of

21

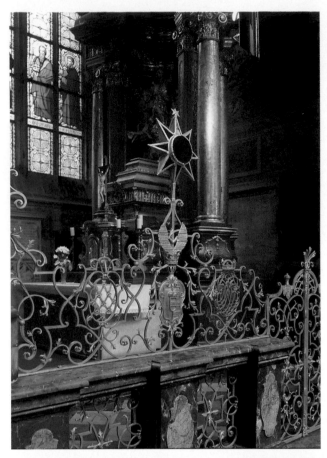

the earlier rotunda which contained the remains of St Wenceslas. Observe the beautiful decoration in semi-precious Bohemian stones. The frescoes of the *Passion* were painted by Master Oswald of Prague in the 14th century; those depicting the *Legend of St Wenceslas* date from the 16th century and are by the Master of the Litoměřice Altar.

The chapel leads to the *Royal Treasury* (containing the Bohemian crown jewels, and open on special occasions only).

The nearby *Chapel of the Holy Rood*, leads down to the *Royal Crypt*. This was renovated in the first half of the 20th century and contains the remains of the Bohemian sovereigns (including Charles IV, Wenceslas IV, Ladislav Postumus, Jiří of Poděbrad and Rudolph II). The *Old Sacristy*, otherwise known as *St Michael's Chapel*, is noted for its fine stellar vaulting, the work of P. Parler. Close to *St Anne's Chapel* is a delicately carved wooden panel depicting *The Flight of Frederick V of the Palatinate;* this refers

St Vitus's Cathedral: Chapel of St Sigismund.

View towards the chapels of the left-hand nave.

Images of the tomb of St John Nepomuk and a detail of the same; the sepulchre of the patron of Bohemia is a valuable 18th-century work in silver.

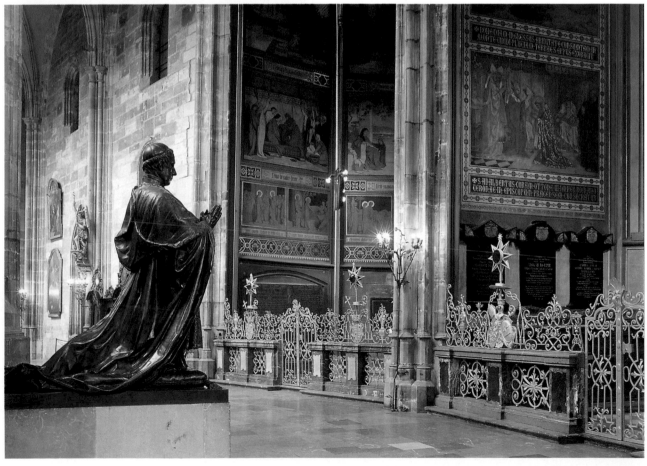

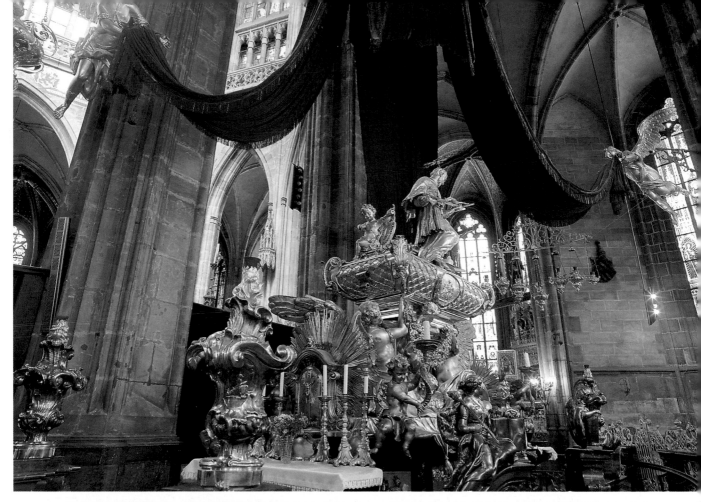

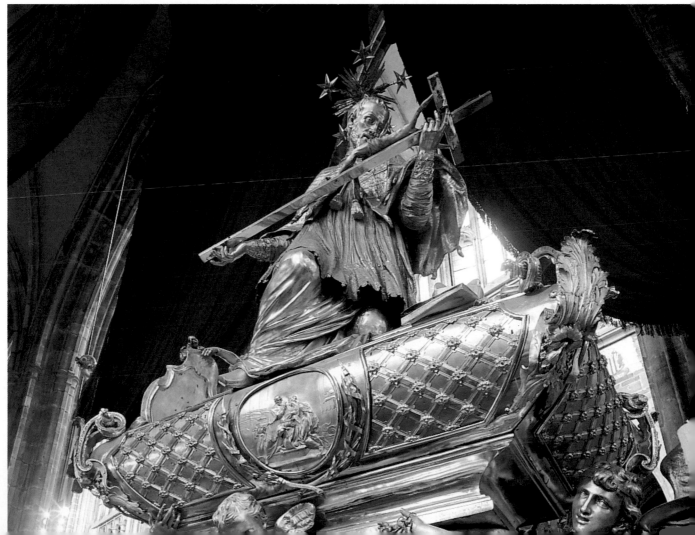

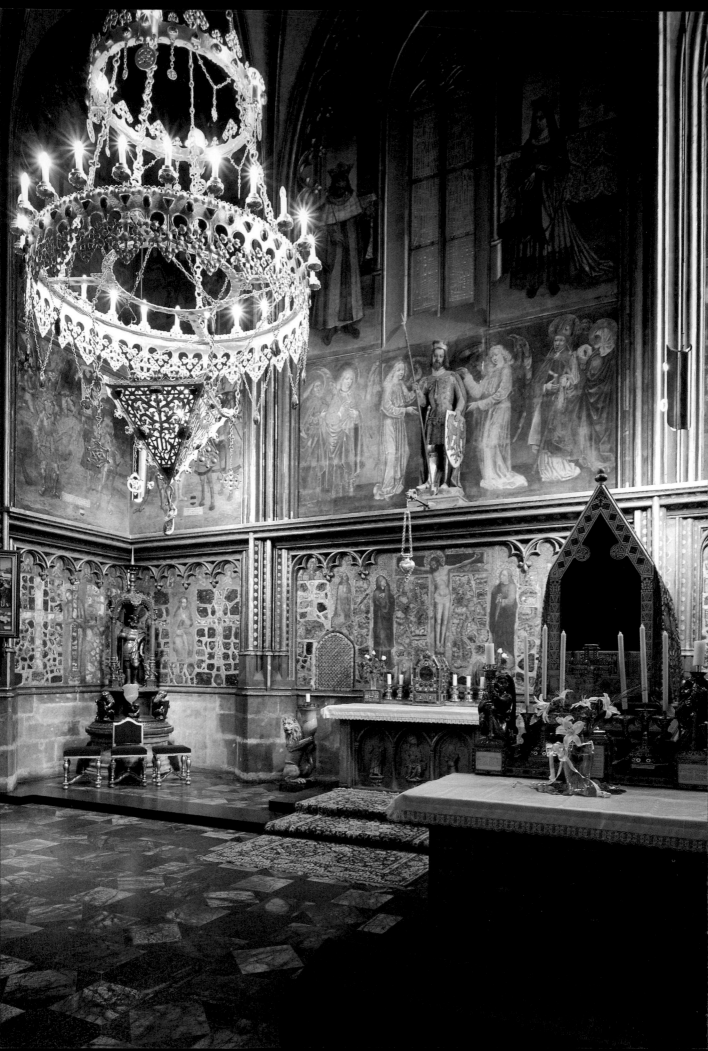

St Vitus's Cathedral: the Chapel of St Wenceslas,
a fine example of Parler architecture (14th century).

St Vitus's Cathedral: two pictures showing details
of the Chapel of St Wenceslas.

On the following pages: further details (tabernacle and altar)
of the Chapel of St Wenceslas, splendidly painted
and undoubtedly the most important chapel
in the Cathedral of Prague.

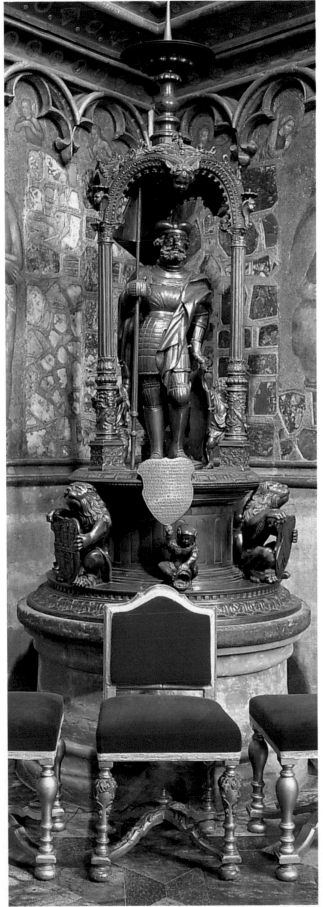

to a famous episode in the city's history, The Battle of the White Mountain in 1620. The most interesting feature of this carving is, however, a minute and richly detailed image of Prague as it was in 1630. The choir chapel dedicated to *St John Nepomuk* is of particular interest for its silver busts of *St Adalbert, St Cyril, St Wenceslas* and *St Vitus* (late 17th century). In front of this is the elaborate *Tomb of St John Nepomuk*, crafted in silver by A. Corradini and J. J. Würth in the first half of the 18th century, following a design by J. E. Fischer von Erlach. In the centre of the apse, behind the high altar, is the *Lady Chapel.* This contains several tombs by artists from the Parler workshop. In front of the chapel is the *Tomb of St Vitus*, and the statue representing the Cathedral's saint is by J. Max. The adjacent *Chapel of the Holy Relics,* also known as the *Saxon Chapel,* contains some of the tombs of the Přemyslids, from the Parlers' workshop.

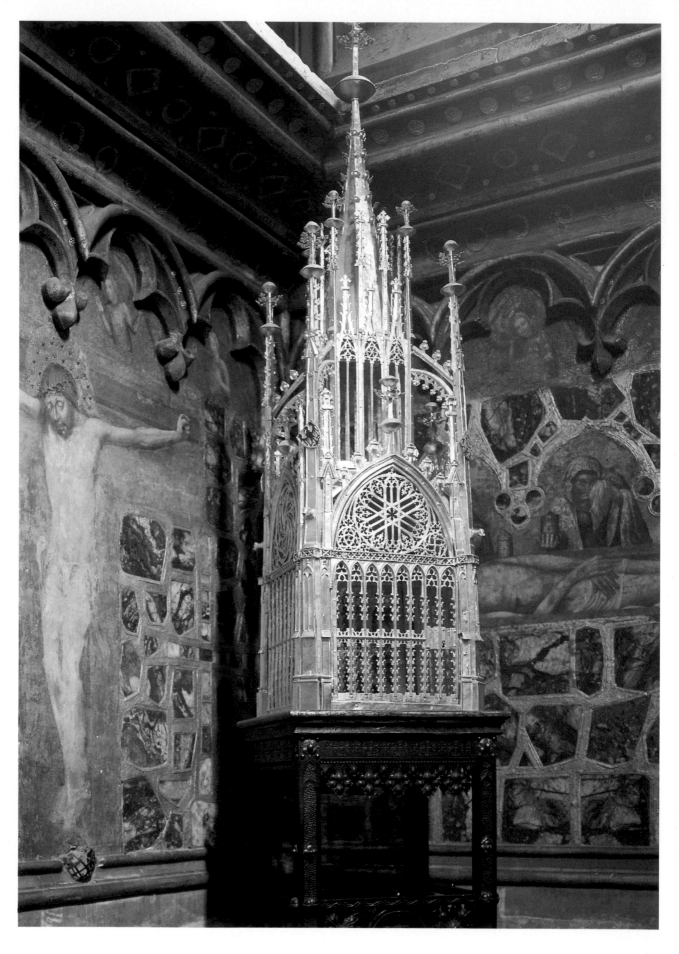

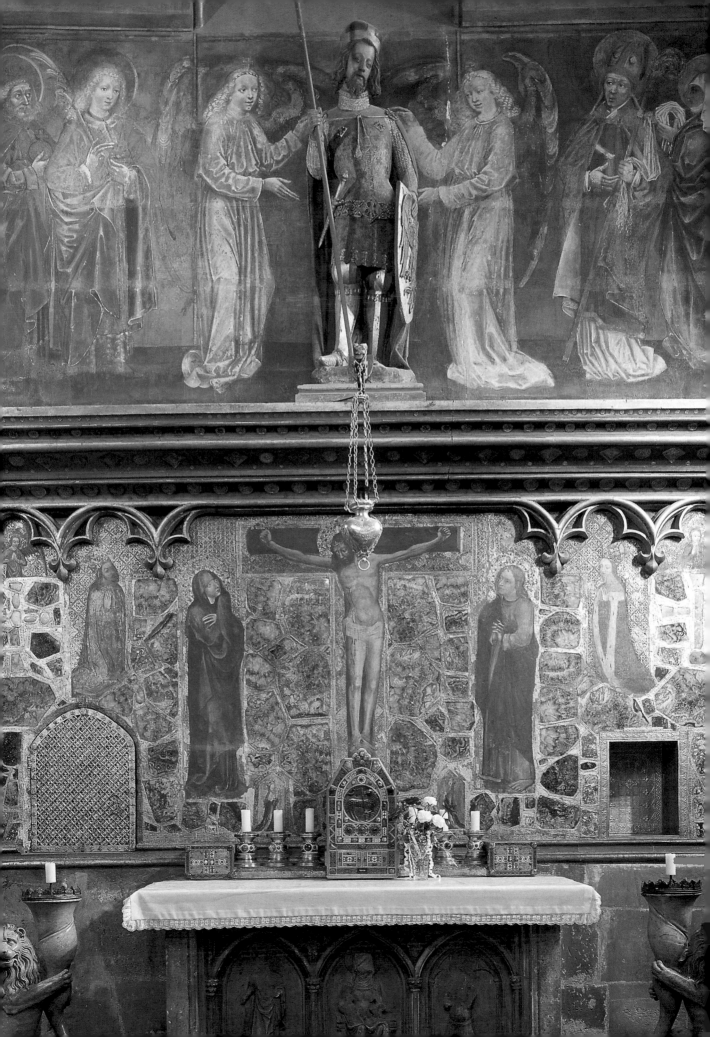

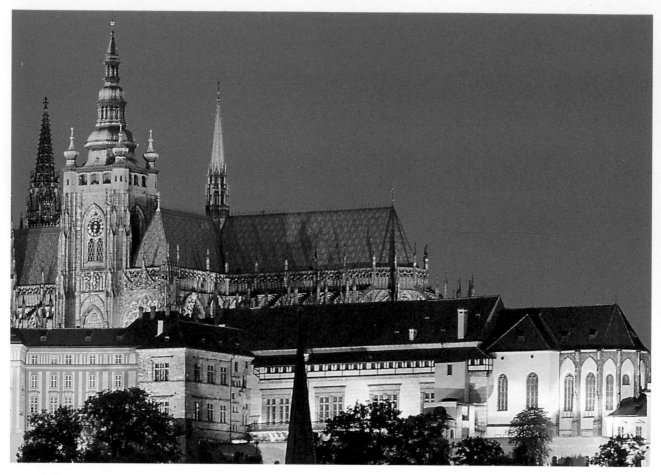

View of the Royal Palace from the Vltava river.

Old Provost's Lodging (*Staré proboštství*).
Once the Bishop's Palace, this building flanks the façade and south-west side of the Cathedral. It was restored in Baroque style in the 1600s. Note the 17th century *Statue of St Wenceslas* by J. J. Bendl. Near the building stands the granite *Obelisk* (1928), erected to commemorate those who died in the First World War, and the *Equestrian Statue of St George* (a copy of the 14th century original by Georg and Martin von Klausenburg).

ROYAL PALACE
Starý královský palác

The palace was built in the 12th century on the site of a 9th century prince's court. It was originally Romanesque in style, but subsequently rebuilt and extended (in the 12th, 13th, 14th, 15th and 16th centuries). It was the seat of the Bohemian sovereigns up until the Habsburg period. One of the most important of the palace's many rooms is the *Vladislav Hall*, designed by B. Ried of Piesting and built by the end of the 15th century. Observe in particular the magnificent late Gothic ribbed vaults. Once used for solemn lunches or formal dinners, the hall is now the setting for the election of the President of the Republic. The adjoining *All Saints' Chapel* was built in the 14th century by P. Parler and was later remodelled and enlarged after a fire in the latter half of the 16th century. On the right hand side altar there is a late Renaissance *Deposition*.
A painting of the *All Saints* decorates the high altar which dates from the mid 18th century.
The *Diet Hall*, built in the 14th century, was reconstructed following a fire in the second half of 16th century. Lastly, it is worth visiting the *Louis Palace* with its *Bohemian Chancellery* (which was the scene of the "defenestration" of the imperial governors which marked the prelude to the Thirty Years' War), and the *Green Chamber*, decorated with numerous coats of arms and once the setting for royal audiences and administration of justice.

Royal Palace: detail of the splendid late Gothic vaulting over the Riders' Staircase.

Royal Palace: view of the interesting Riders' Staircase.

Royal Palace: the historical atmosphere of the Vladislav Hall, with its magnificent late Gothic vaulting.

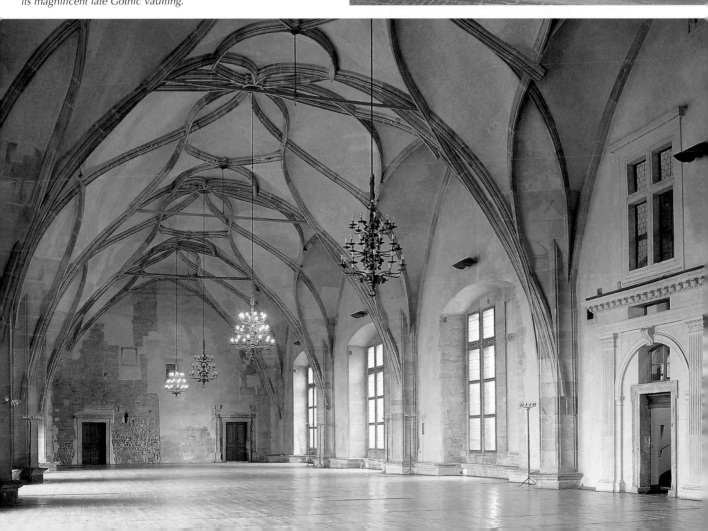

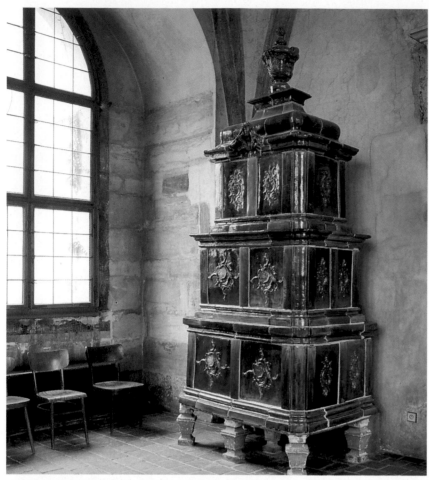

Royal Palace: valuable 17th-century heater from the Bohemian Chancellery.

The Diet Hall and its throne.

The ceiling and walls of the Land Rolls Hall decorated with numerous coats of arms.

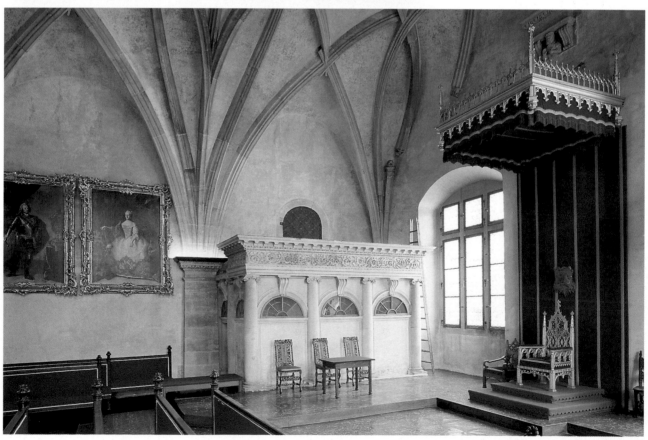

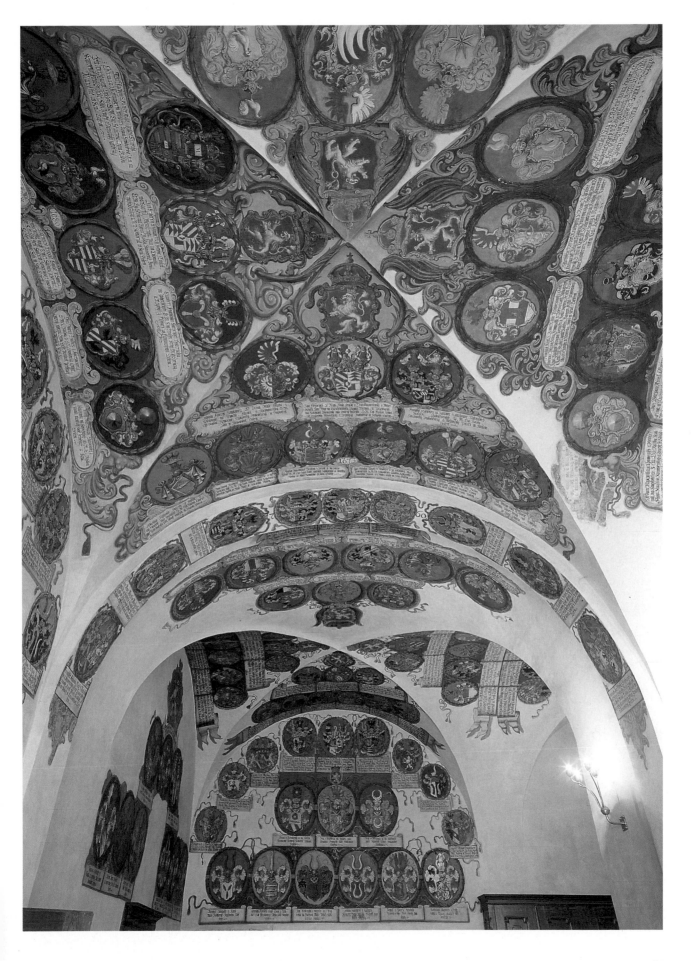

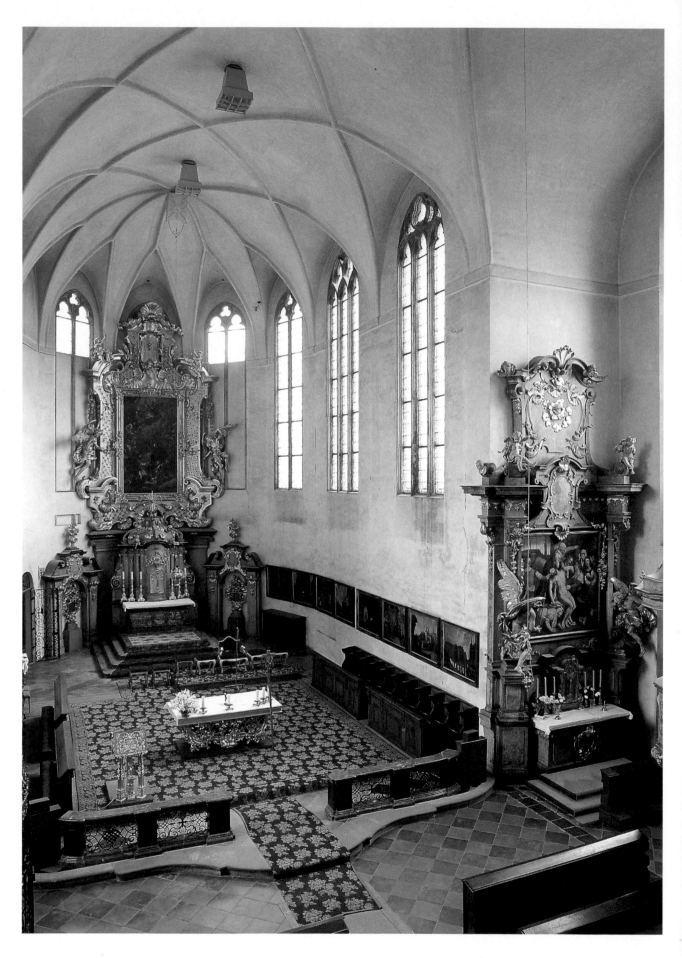

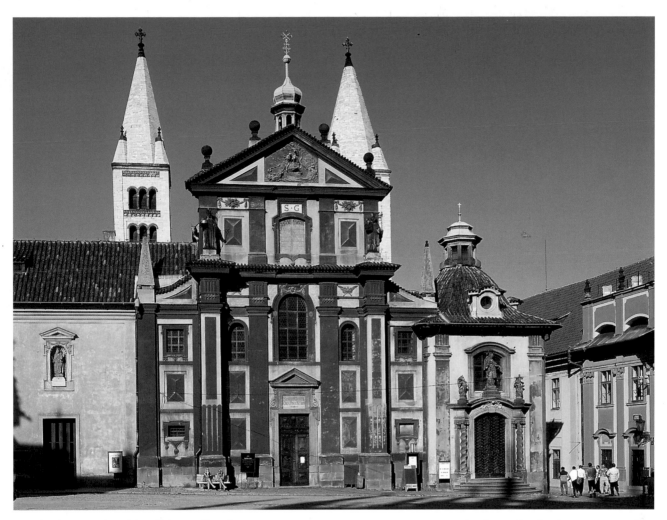

Royal Palace: interior of the All Saints' Chapel, originally designed by Peter Parler (14th century).

The elegant façade of St George's Basilica.

ST GEORGE'S BASILICA
Bazilika svatého Jiří

This Romanesque building with its 17th century Baroque **façade** opens onto the *Jiřské náměstí*, opposite the Cathedral apse. The basilica is one of the best examples of Romanesque architecture in Bohemia. Dominated by twin towers, it was founded by Prince Vratislav between 915 and 921 and has been rebuilt several times following various episodes of destruction. The *Chapel* of *St John Nepomuk* was added in the 18th century. Note the *Statue* of the saint on the façade, and the ceiling frescoes (*Apotheosis of St John Nepomuk*). The central nave is distinguished by its architectural features dating back to between the 10th and 12th centuries. Traces of some 13th century frescoes (*Heavenly Jerusalem*) can be seen on the ceiling of the chancel, while the ceiling of the apse is decorated with frescoes showing *The Coronation of Our Lady* of the 16th century. The *Crypt* (mid 12th century) houses a *Statue of Bridget* by B. Spinetti. The 13th century *Chapel of St Ludmila* contains the *Sepulchre* of the saint, patron of Bohemia. Parts of the tomb are probably from Parler's workshop (14th century). Some 19th century frescoes by J. V. Hellich depict *Events from the Life of St Ludmila*, and other late 16th century religious paintings can also be seen.

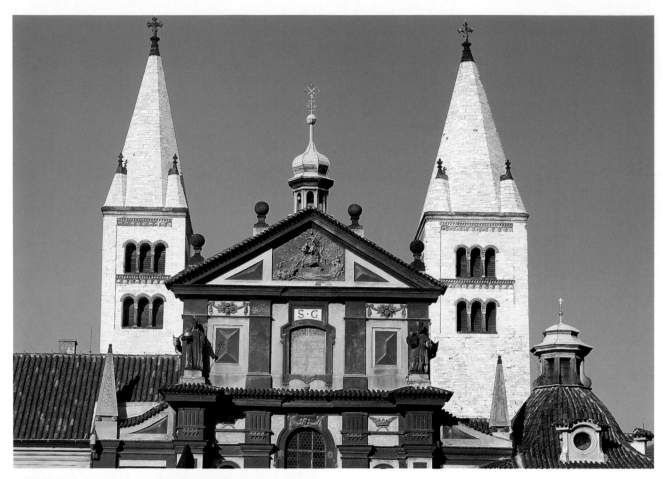

Detail of the façade of St George's Basilica, perspectively wedged between the twin towers, and a detail of the tympanum.

An enchanting interior view of St George's Basilica.

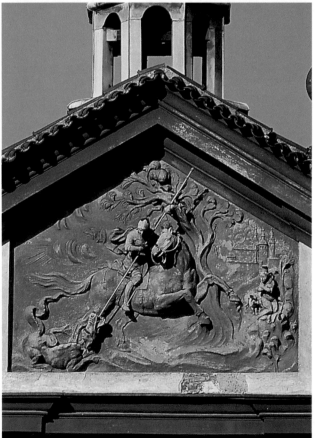

ST GEORGE'S CONVENT

The National Gallery Collection of Early Bohemian Art (*Sbírka starého českého umění Národní galerie*). These important collections are exhibited in the adjacent **St George's Convent,** a Benedictine building constructed in 973, and destroyed, rebuilt and transformed several times. It was the first building to be founded by this monastic order in Bohemia. The Baroque reconstruction work was carried out in the latter half of the 17th century. The monastery ceased to function as such in the latter half of the 18th century, and between 1962 and 1974 it was renovated in order to house the art collections. These begin, in chronological order, with the Gothic works whose subject is mainly the Virgin Mary, and which were brought here from churches around Bohemia. As well as some early Gothic sculptures of *Madonnas,* the northern corridor (on the lower floor) contains the magnificent tympanum from the Church of Our Lady of the Snows. The 13th century *Cycle of the Master of the Vyšší Brod Altar* is inspired by episodes from the life of Christ. The *Statue of St George on Horseback,* at one time situated in the third courtyard of the

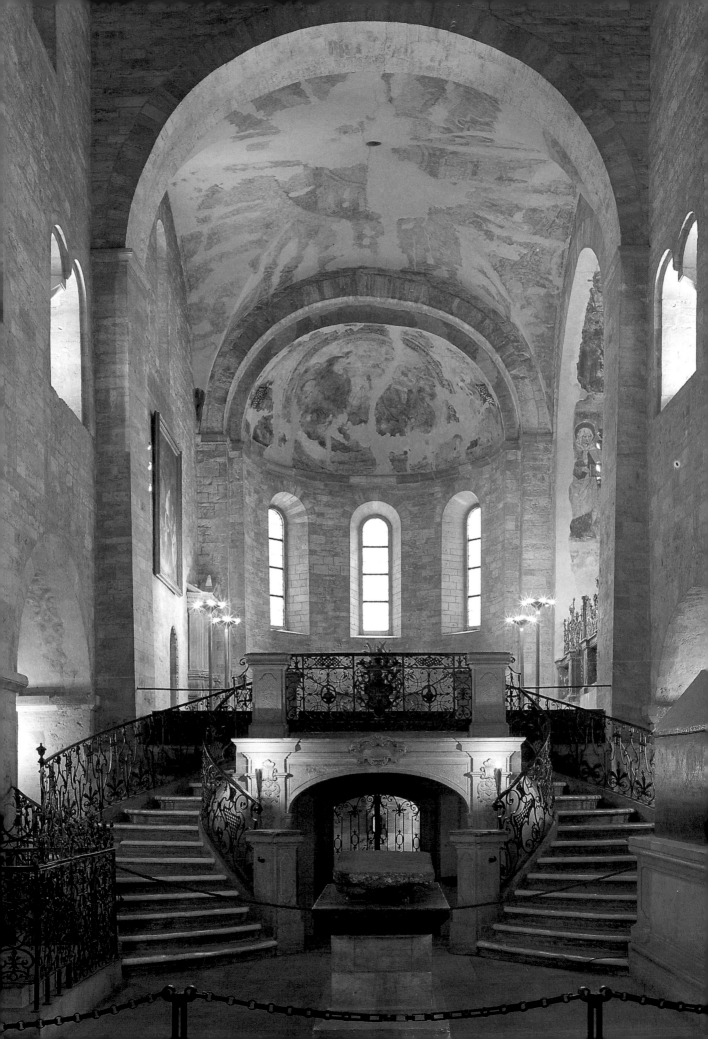

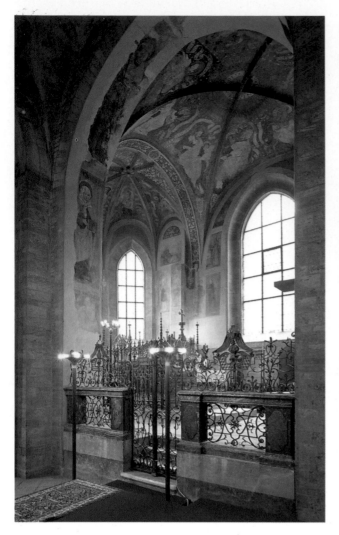

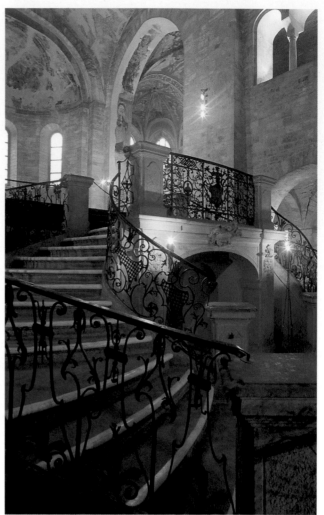

Images of the interesting interior of St George's Basilica: one of the chapels, the finely painted dome, and a detail of the charming staircase.

The finely painted dome of St George's Basilica.

Castle, was sculpted in the 14th century by Martin and Georg von Klausenburg. The *Master Theoderick Hall* contains some of the panel paintings by this outstanding artist of the "beautiful style" of Gothic painting in Bohemia (14th century), commissioned by Charles IV. On the ground floor, one of the halls contains the *Cycle of the Master of Třeboň*, with fragments of altar pieces showing themes from the life of Christ, images of saints and apostles. Another hall contains the tympanum of the northern portal of the Church of Our Lady of Týn, the work of artists from the Parlers' workshop (15th century). The northern corridor contains numerous paintings and sculptures

inspired by the Madonna (14th - 15th centuries), and a 15th century *Crucifixion* by the Master of Raigern. The Renaissance is represented by the *Lamentation of Christ* by Žebrák, *The Visitation of the Virgin Mary* by the Master of the Litoměřice Altar, and the wooden reliquary by the Master IP, a follower of A. Dürer. On the first floor are exhibits of works by the Mannerists active at the Bohemian court (H. von Aachen, B. Spranger, J. H. Roelandt Savery, A. de Vries); works by Baroque painters and sculptors (J. P. Brandl, V. V. Reiner, J. Kupecký, M. L. Willmann, I. F. Platzer, F. M. Brokoff, M. B. Braun); and works by Rococo painters (A. Kern, N. Grund).

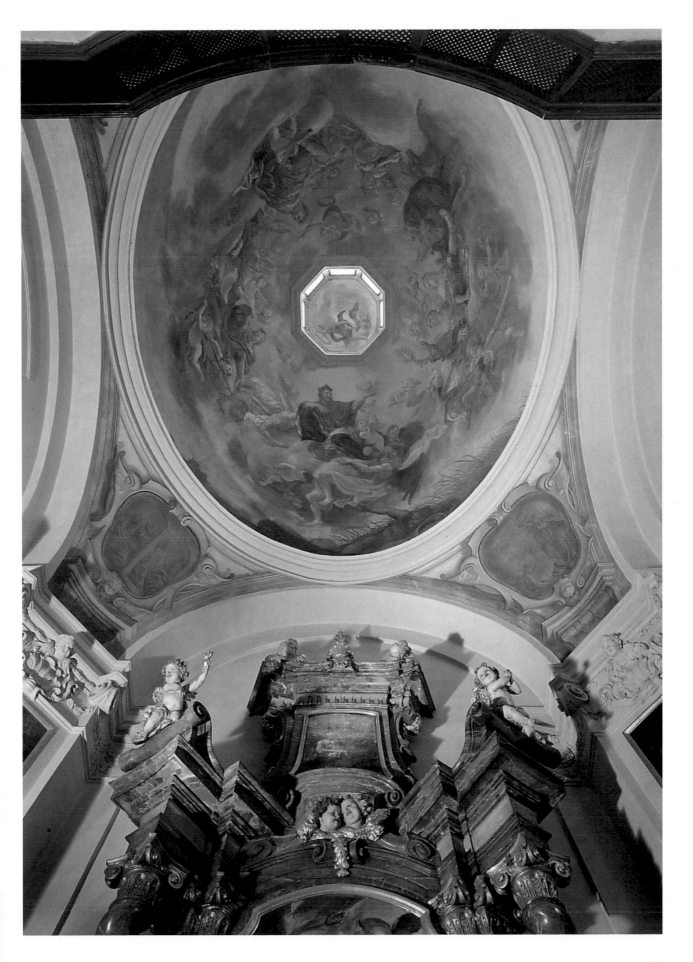

GOLDEN LANE
Zlatá ulička

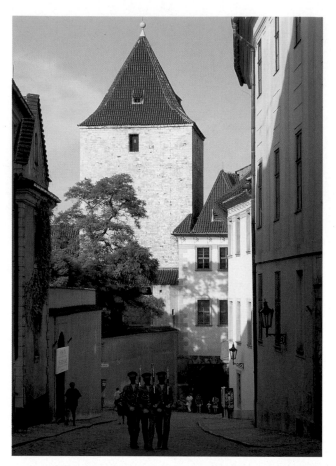

This picturesque little street is an essential stop for visitors to the Castle. Also known as the *Alchemists' Lane,* it is evidence of "The Magical City". In the laboratories of the **Mihulka Tower** Rudolph II's alchemists are supposed to have pursued the myths of the philosophers' stone and the production of gold. At least, this is how the legend goes, and it is certainly one of the most charming to have flourished around "The Golden City". However, it would appear that in reality these little cottages were built towards the end of the 16th century to house Rudolph II's guards. Only later did the goldsmiths establish themselves here. Today, various shops attract the tourists: the cottages which were once home to craftsmen and the city's poor are now picturesque little stores selling souvenirs and local arts and crafts. At n° 22 between 1916 and 1917 Kafka wrote some of his stories, and the poet Jaroslav Seifert, who won the Nobel prize in 1984, also lived in this charming corner of the Czech capital for a while.

The Black Tower from the Jiřská.

Various views of the Golden Lane and its picturesque cottages.

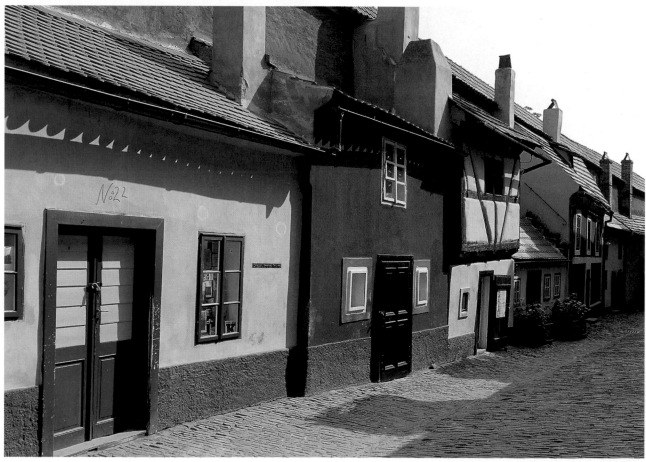

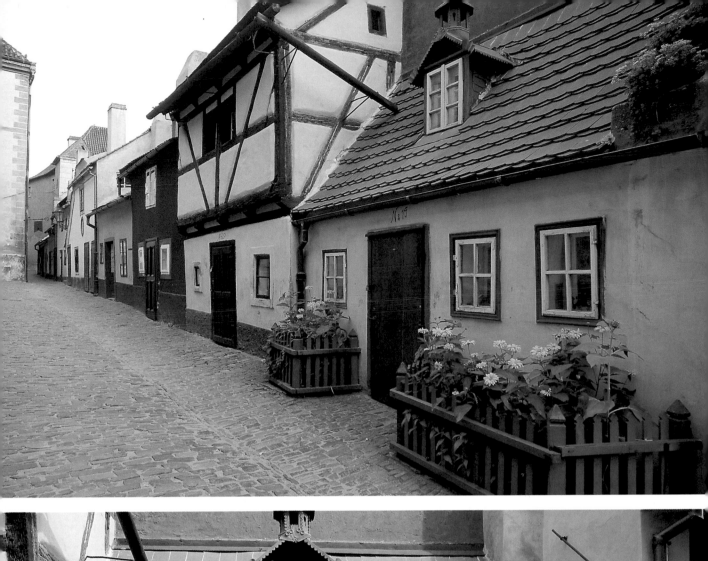
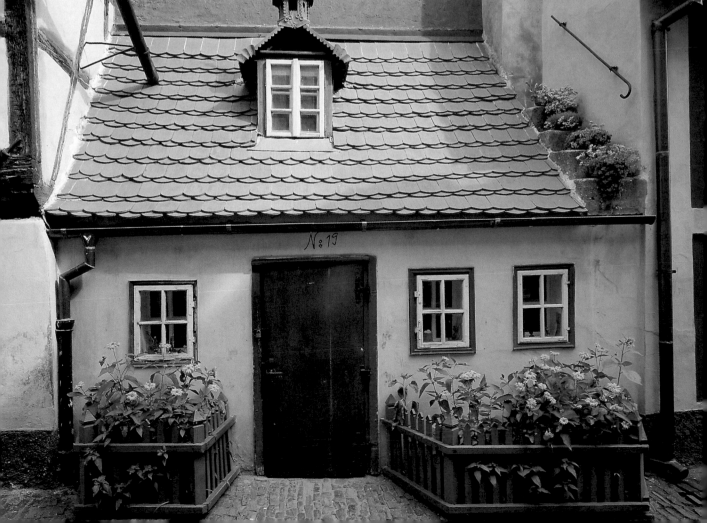

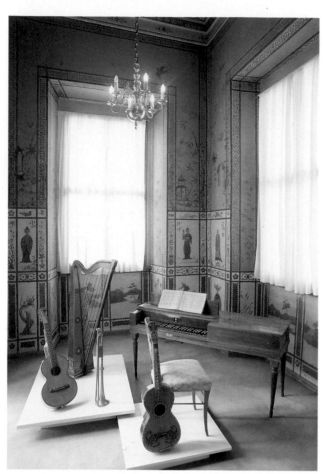

LOBKOWITZ PALACE

Not far from here, in the southern wing of the Castle, is the Lobkovitz Palace. Within the palace there is an **Exhibition of the history of Bohemia**, which extends from the Roman period to the mid 19th century.

One of the rooms in Lobkowitz Palace showing the elaborate elegance of its interior. The rooms are often used for theatrical and concert programmes.

Detail of one of the painted ceilings of Lobkowitz Palace.

Southern Gardens: beside the Music Pavilion stand four statues of 'Classical Gods'.

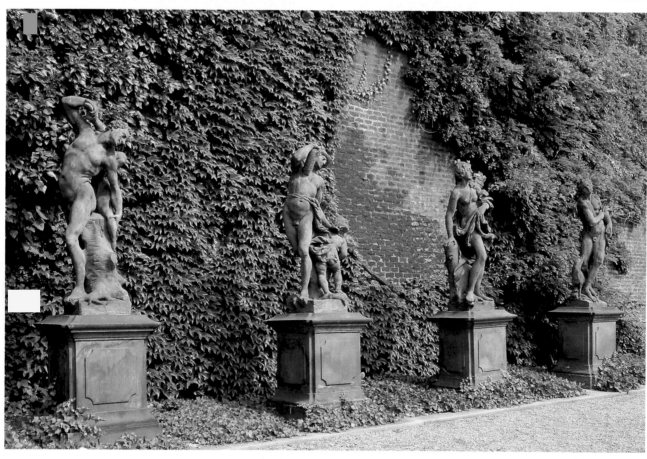

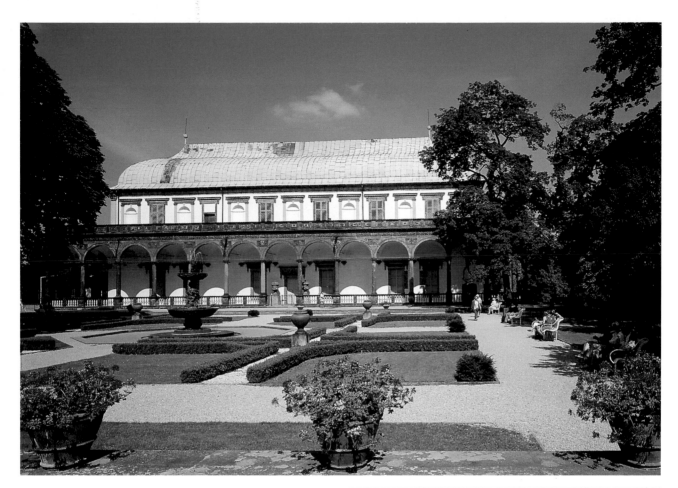

A charming external view of the "Royal Belvedere in the Royal Garden", with its portico-lined palace and the Singing Fountain.

Detail of the Singing Fountain in the "Royal Belvedere in the Royal Garden". In order to appreciate the unusual acoustic effect that has given it its name, you need to get quite close to this fine bronze fountain.

SOUTHERN GARDENS
Jižní zahrady

These large gardens extend to the south of the southern curtain wall of Prague Castle. They are the result of the joining together, at different times, of various separate gardens. In this area of greenery, which dominates the incomparable panorama over the Malá Strana quarter, lies the oldest part of the gardens known as **Paradise Garden** (*Rajská zahrada*). This was laid out in the second half of the 16th century and contains the **Matthias Pavilion** from the first half of the 17th century; its wooden ceiling is carved with the emblems of the countries belonging to the Habsburg Empire.

Next to the Paradise Garden is the **Garden on the Ramparts** where two obelisks, erected in memory of the Imperial governors who were the victims of the second 'Prague defenestration' (1618), mark the spot where they fell to the ground. In the lower area of the Southern Gardens is the **Music Pavilion**, a Baroque work by G. B. Aliprandi, and nearby stand four statues of *Classical Gods*.

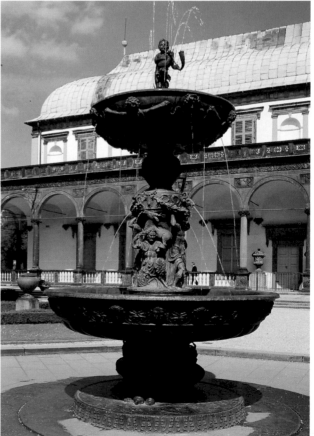

ROYAL GARDEN
Královská zahrada

In the 16th century, along the northern perimetre of the Castle, Ferdinand I built the Royal Garden, and entrusted P. della Stella with the construction of the **Belvedere**, a summer residence for his wife Anne, with prominent Renaissance features. The frieze above the portals on the ground floor bears an ornamental motive showing themes inspired by Greek mythology. The ornamentation is completed with a *Portrait of Ferdinand I.* Inside, the hall was painted with frescoes in the 19th century by C. Ruben. Nearby is the *Singing Fountain*, a work in bronze by T. Jaroš. Its curious name derives from the melody produced by the water as it hits the basin. Worthy of note is the **Míčovna**, a richly decorated Renaissance building erected by B. Wohlmut in 1567-1569.

Sculptural group in the Ball Game Hall.

Prague from the Belvedere, 19th century engraving.

View towards the Mihulka Tower and the Cathedral.

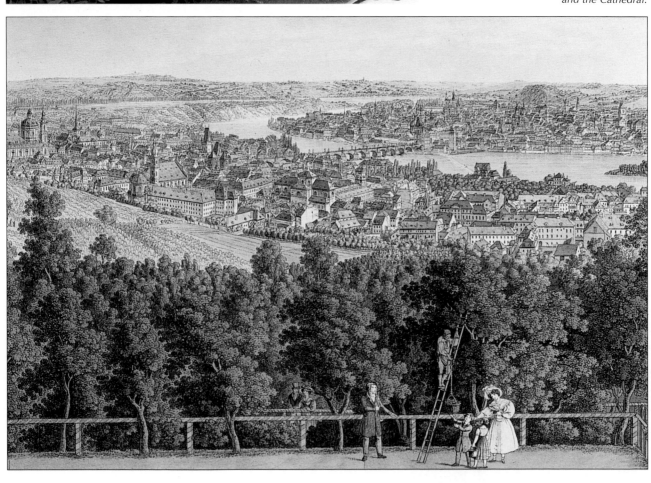

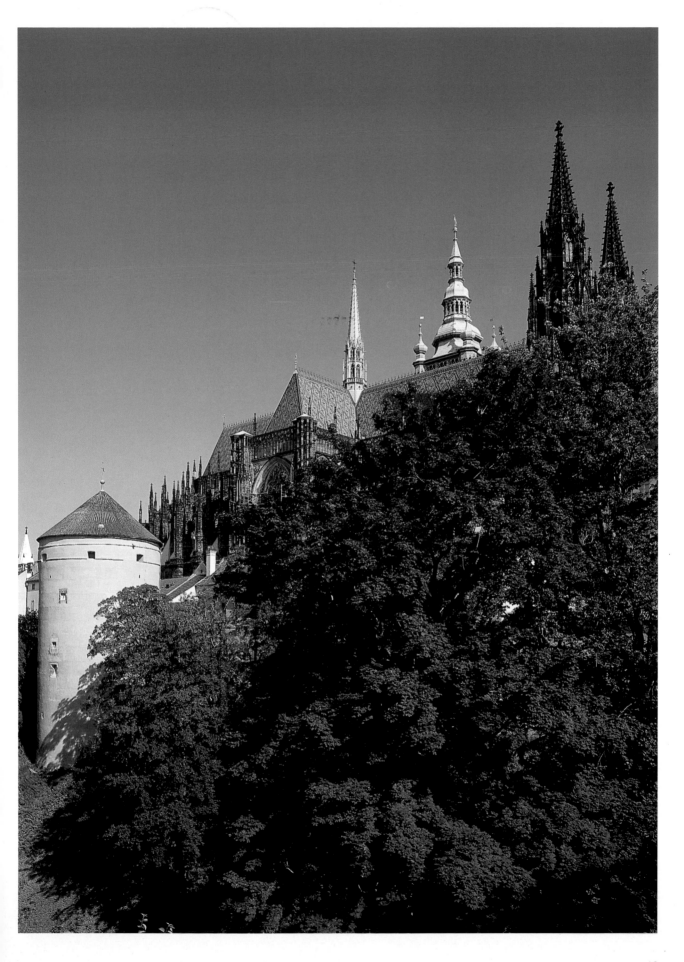

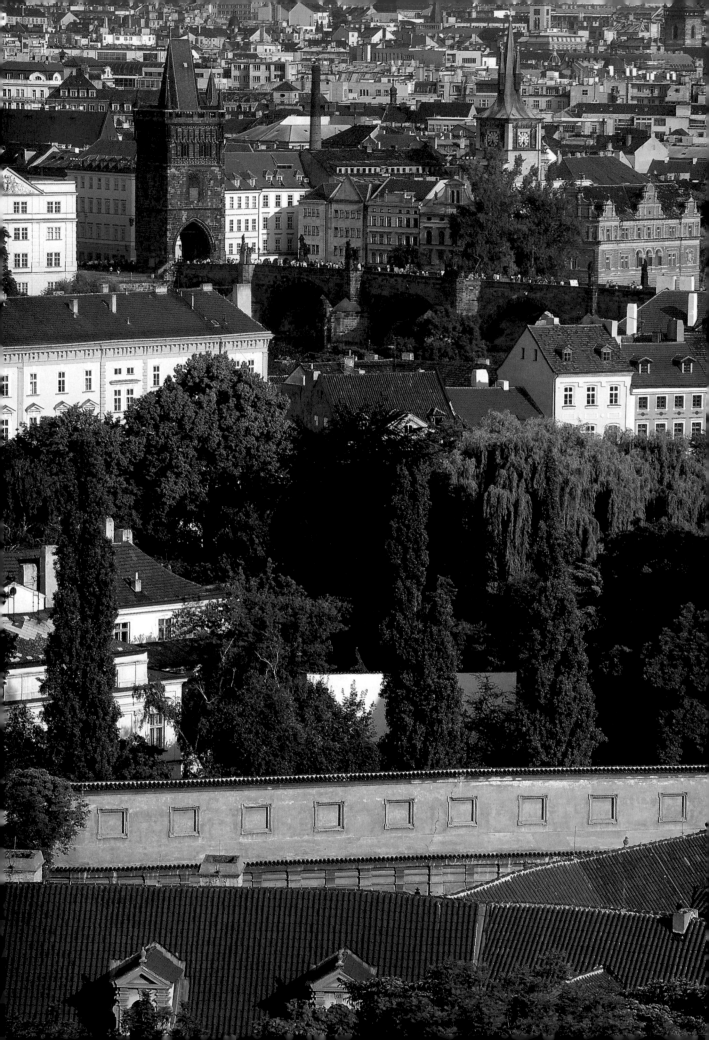

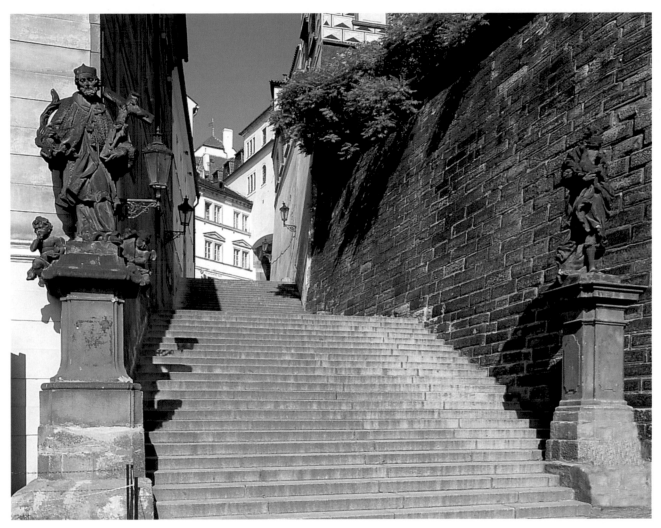

A charming perspective of the rooftops of Malá Strana and the Charles Bridge.

The picturesque steps leading from Hradčany to the quarter of Malá Strana.

MALÁ STRANA

The quarter of Malá Strana grew up, starting in 1257, on the left bank of the Vltava, between the hills of Hradčany and Petřín. It was founded by Přemysl Otakar II whose intention it was to create a home for the German colonists.

At the time of Charles IV the urban network underwent considerable expansion: old churches were restored or completed, and fortifications and defensive works appeared everywhere. During the 15th and 16th centuries the quarter was tormented by fires, as a result of which the building and extension work intensified, transforming Malá Strana into a coveted residential quarter.

The area was chosen by the nobility and the wealthy as their permanent residence, and they enriched it with sumptuous palaces and magnificent churches. Malá Strana's charm was enhanced by the fact that the coronation processions of the Bohemian sovereigns passed through its very streets.

MALOSTRANSKÉ NÁMĚSTÍ

The ancient heart of the Malá Strana quarter centres around two small squares, both surrounded by buildings of considerable architectural importance. The upper square contains the 18th century Plague Column, with sculptures reproducing the *Holy Trinity* and the *Patron Saints of Bohemia* by F. Geiger and J. O. Mayer. Both squares were previously decorated with fountains: the upper one was replaced by the Plague Column, and the lower one by a *Monument to Radetzky* (today kept in the Lapidarium of the National Museum). The most noteworthy buildings are **Kaiserštejn Palace**, created in the first half of the 17th century by joining together pre-existing Gothic houses; the **House at the Sign of the Stone Table** with its prominent Rococo features; **Liechtenstein Palace**, dating from the late 16th century; and the 17th century, late Renaissance **Town Hall of Malá Strana** (the stone plaque on its façade commemorates the promulgation of the *Confessio Bohema* in 1575).

45

Along the Nerudova.

VRTBA PALACE (*Vrtbovský palác*)

This building was restructured according to the canons of late Renaissance architecture in the first half of the 17th century. The Garden of the same name represents a fine example of Baroque garden and is one of the most important in central Europe. It was designed by F. M. Kaňka, and built in the first half of the 18th century.

Observe the statues of *Ceres* and *Bacchus,* of the same period, by M. Braun, the double staircase with Baroque decorations and sculptures inspired by Greek mythology. A beautiful view can be enjoyed from the upper terrace.

NOSTITZ PALACE (*Nostický palác*)

Now the seat of the Dutch Embassy, this building looks onto *Maltézské náměstí.* It was built in Baroque style in the second half of the 17th century, designed by F. Caratti who was commissioned by J. H. von Nostitz. The palace was completed in the 18th century with the addition of dormer windows with a balustrade, *Statues of the Emperors* from the Brokoff workshop (those on show today are copies), and the

Rococo portal mounted between coupled columns, the work of A. Haffenecker. Inside the palace, observe the rooms used to house the **Dobrovsky Library** (painted with frescoes showing mythological themes), and the fine courtyard.

GRAND PRIORY
OF THE KNIGHTS OF MALTA
(*Palác maltézského velkopřevora*)

Originally a Renaissance building, this construction was transformed in the first half of the 18th century by Bartolomeo Scotti who added ornamental cornices, oriel windows and the doorway. The palace now holds an interesting collection of musical instruments, part of the **Music Department of the National Museum**. Note the rich furnishings of the Baroque interiors, the inlaid flooring, the Baroque ceramic heaters and the wooden panelling.

BUQUOY PALACE (*Buquoyský palác*)

Currently the French Embassy, this building was designed by G. Santini and F. M. Kaňka in the first half of the 18th century on behalf of Marie Josefa von

Thun. It was subsequently extended and decorated with sculptures by M. B. Braun. When the Buquoys took over as the new owners of the palace, it was furnished in Baroque style. In the latter half of the 19th century, J. Schulz added the staircase and the rear wing, in keeping with the characteristics of neo-Renaissance style. Some splendid 16th and 18th century wall-hangings can be seen in one of the rooms. The whole palace was renovated at the beginning of the 20th century. The adjoining park slopes right down to Kampa Island.

NERUDOVA ULICE

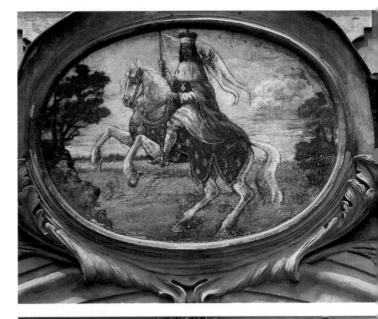

This street, which branches off from *Malostranské náměstí* and climbs steeply up to the Castle, is one of the most characteristic and charming corners of the Malá Strana quarter. One of its main features is its wealth of elegant houses, some of the finest examples of late Baroque building in Prague. Characteristic coats of arms and shop signs, and picturesque front doors capture the visitor's attention: N° 12 was the home of the lute-makers, the Edlingers, and the sign with three crossed violins is still here today; **Valkoun House**, at n° 14 was remodelled in late Baroque style by G. Santini; typical signs can also be seen on the houses named **The Golden Cup** (N° 16, Renaissance style), and **St John Nepomuk** (n° 18, Baroque); the **Theatine Monastery** (n° 24) was the setting for performances of the *Kajetan Dramas* in Czech, while the adjacent building, **The Rocking Donkey**, supplied the setting for a story by Neruda; n° 32 is the quarter's old pharmacy, restored in 1980 and now housing the **Museum of Pharmacy in Countries of the Bohemian Crown;** n° 33 is the **Bretfeld Palace**, also known as *Summer and Winter*; it was here that famous people such as Casanova and Mozart stayed; on the front door of the **House at the Golden Horseshoe** (n° 34) there is an image of *St Wenceslas*; at n° 49 a white swan forms the sign of an elegant Baroque residence. A nearby flight of steps leads to the Castle.

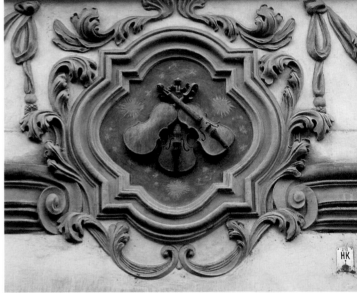

Details and signs along the Nerudova.

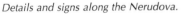

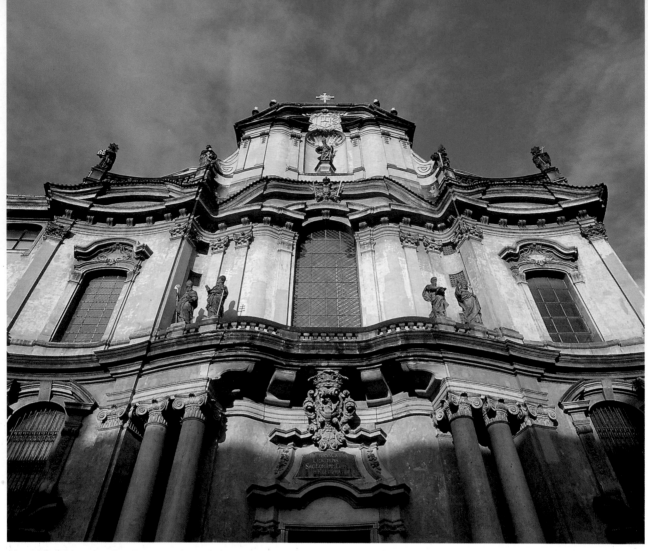

The splendid Baroque façade of the Church of St Nicholas in Malá Strana, animated by its flowing architectural style.

The dome of the Church of St Nicholas in Malá Strana, and its elegant bell tower, two of the most characteristic features on the Czech metropolis's urban landscape .

CHURCH OF ST NICHOLAS IN MALÁ STRANA
Chrám svatého Mikuláše

This splendid example of Bohemian Baroque architecture - previously belonging to the Jesuits who made it the focal point of the Counter-Reformation in Bohemia - was built on the site of a Gothic church. Work on the building started at the beginning of the 18th century and lasted until 1756 when A. Lurago completed the Bell Tower (79m). The magnificent two-tier Baroque **façade** is decorated with the coats of arms of the Count of Kolovrat and *Statues of the Fathers of the Church* carried out by followers of J. B. Kohl. The chancel and the high Dome (75m) are the work of K. I. Dientzenhofer.

The **interior** contains some magnificent Baroque ornaments, and the ceiling of the central nave was beautifully painted with frescoes by J. L. Kracker (18th century). These show *Episodes from the life of St Nicholas* and are some of the largest of their kind in Europe. The dome bears the splendid contemporary fresco (*Apotheosis of St Nicholas* and *Last Judgement*) by F. X. Palko who is also responsible for the frescoes in the chancel, painted in collaboration with J. Hager. I. Platzer the Elder is the author of the sculptures situated in the central nave, the chancel and at the high altar (*St Nicholas*). Also note the 18th century pulpit by Richard and Peter Prachner, the grandiose, modern organ by T. Schwarz, as well as the altar-pieces and the paintings in the side chapels (works by J. L. Kracker, I. Raab, F. X. Palko, and F. Solimena). Adjoining the church is the **Cloister** of a 13th-14th century Minorite convent.

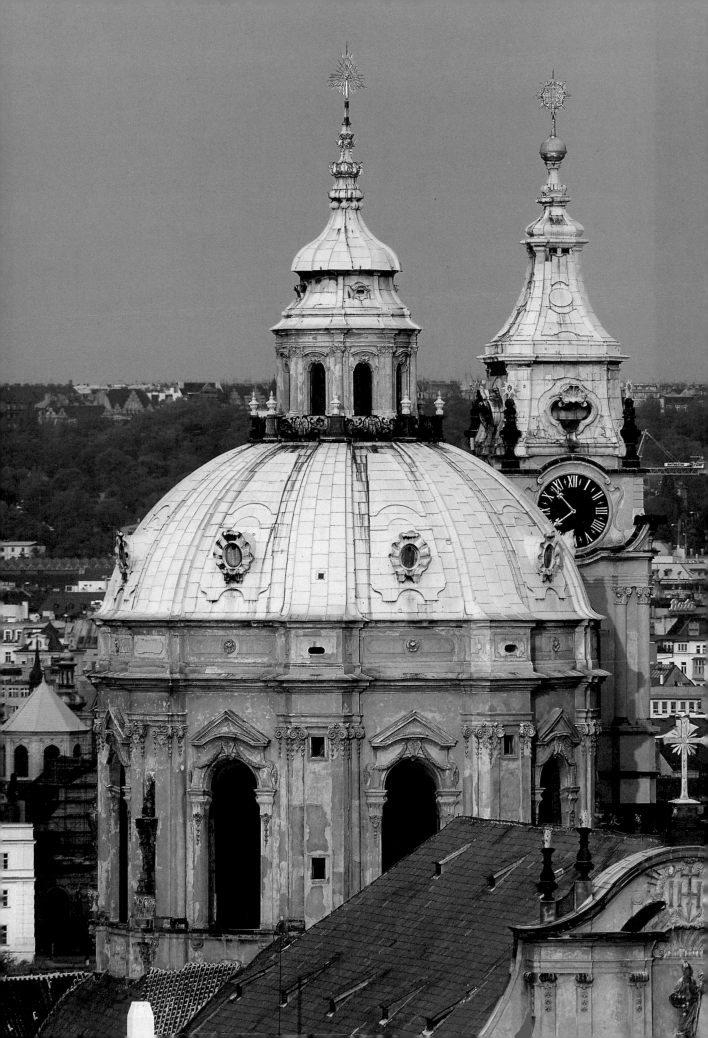

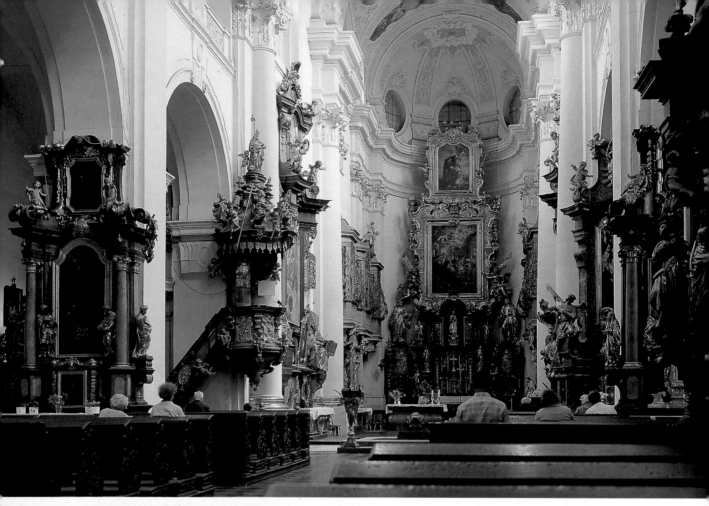

The interior of the Church of St Thomas, distinguished by its elaborate Baroque ornamentation.

Church of St Thomas: ceiling frescoes representing 'Episodes from the life of St Augustine'.

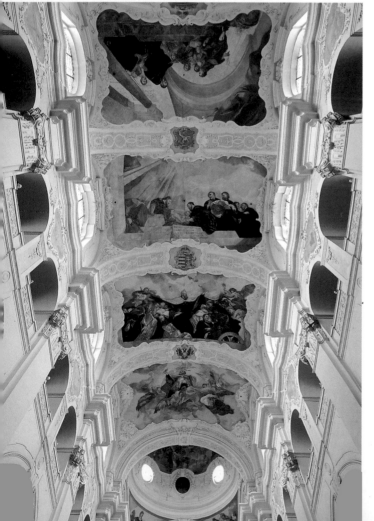

CHURCH OF ST THOMAS
(*Kostel svatého Tomáše*)

This Augustinian building preserves clear traces of its early Gothic origins, despite the Baroque restoration work carried out by K. I Dientzenhofer in the first half of the 18th century. The church was founded by Wenceslas II in 1285 as a place of worship for the Augustinians, and was completed a century later. The **façade** is adorned with a Renaissance portal by Campione dei Bossi (17th century), and statues of *St Augustine* and *St Thomas*, the late 17th century work of H. Kohl. The **interior** is remarkable for its magnificent decoration by Bohemian artists who produced a wealth of paintings and sculptures here. The ceiling frescoes (*Episodes from the Life of St Augustine*) were painted by V. V. Reiner in the 18th century, and the paintings in the dome and chancel (*The Legend of St Thomas*) are also attributed to him. The 18th century high altar is by K. Kovář and it is embellished with sculptures of *Saints* by I. Müller, J. A. Quittainer, and F. M. Brokoff. 17th century works by Škréta adorn the transept altar (*St Thomas*) and the chancel (*Assumption of the Virgin*). Rudolph's court architect, O. Aostalli, and the sculptor A. de Vries are buried in the church.

CHURCH OF OUR LADY VICTORIOUS
(Kostel Panny Marie Vítězné)

The name of the church recalls the victorious Battle of the White Mountain when the Catholic League triumphed over Protestant troops on 8th November 1620. The church, which was completed by the Italian architect G. M. Filippi in the first half of the 17th century, is considered to be the first Baroque church in Prague. It stands in *Karmelitská* street and its **interior**, modelled on the Gesù Church in Rome, is famous for the much revered *Statue of the Holy Infant of Prague* ("Jezulátko"). This small wax figure (50cm), situated on the right-hand wall of the church, was brought from Spain as a gift from Princess Polyxena of Lobkowitz in 1628. The 18th century altar bears statues by P. Prachner, and a silver casket of the Holy Infant from the same era. The 18th century high altar is the work of followers of J. F. Schor. Underneath the church lie the **Catacombs** (closed to the public), with mummified remains of Carmelite friars and their benefactors.

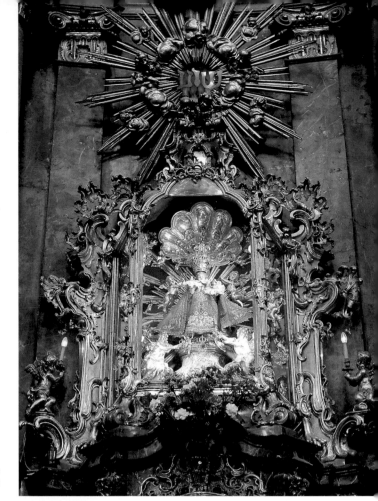

Church of Our Lady Victorious: detail of the authentic image of the 'Jezulátko', the much revered 'Holy Infant of Prague', object of the devotion of thousands of pilgrims.

An idyllic view along the Čertovka, a branch of the Vltava, towards Kampa Island; on the right is the wheel of an old mill.

KAMPA ISLAND

This island, mostly given over to parkland, stretches between the two bridges, Most Legií and Mánesův most. The Čertovka, a branch of the Vltava which leads off to the left of the main course of the river, separates Kampa Island from the picturesque quarter of Malá Strana. During Medieval times the waters of this branch of the Vltava fed several water mills. To the west the Karlův most rests on the island, and looking south from the bridge along the Čertovka the wheel of an old mill can be seen; to the north the stream runs through the charming area known as the 'Venice of Prague', with its characteristic canals and picturesque houses.

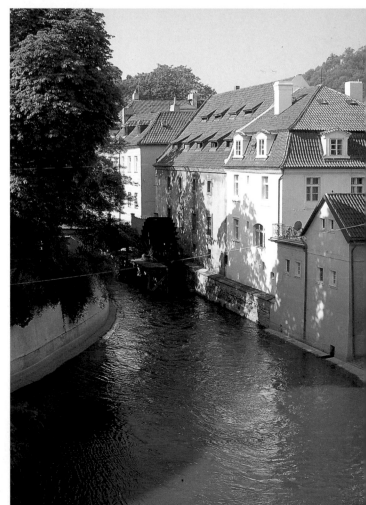

WALLENSTEIN PALACE
(Valdštejnský palác)

This magnificent residence, some-where between a palace and a fortress, was built in the first half of the 17th century for the Bohemian commander Albrecht Wenzel Eusebius von Wallenstein. The plans were drawn up by A. Spezza and G. Pironi and the work carried out by G. B. Marini. The building is a clear example of a residence commissioned by a layman, in direct antagonism with the regal power. Wallenstein wanted his actions and grandeur to be reflected in the majestic palace, and this self-congratulato-ry intention is clear from the paintings which portray him. The ceiling of the *Hall of Cavaliers* bears a 17th century fresco (*Wallenstein in the Guise of Mars in his Triumphal Chariot*). The other rooms are decorated with paintings, including a *Portrait of Wallenstein on Horseback*. The palace chapel's altar is said to be the oldest in the city. The building is also the seat of the Ministry of Culture and houses the **J. Á. Komenský** (Comenius) **Museum** with exhibits on this 16th-17th century humanist.

The fairy-tale Wallenstein Palace reflected in a pond which forms part of its splendid gardens, watched over by the mighty construction of the Castle.

52

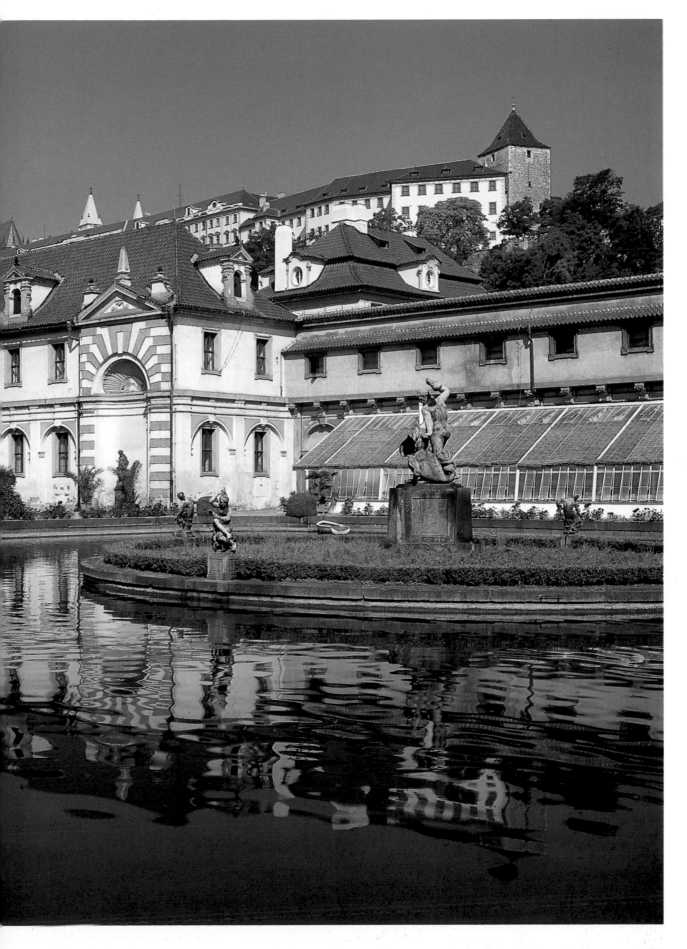

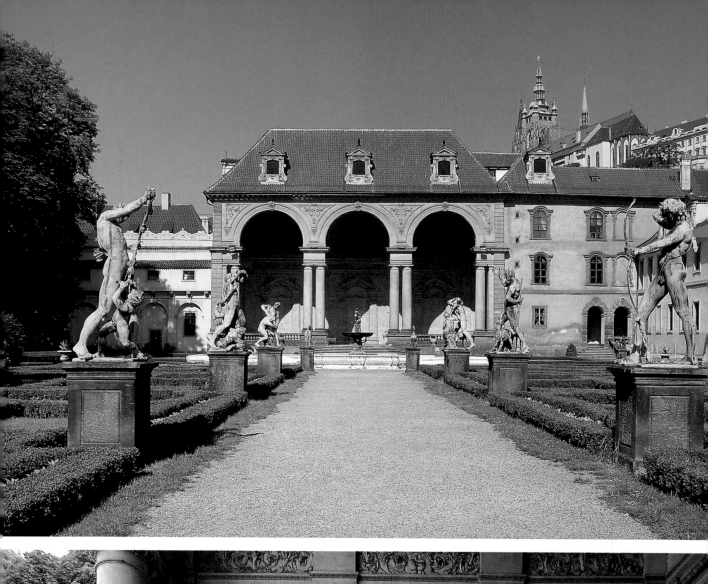

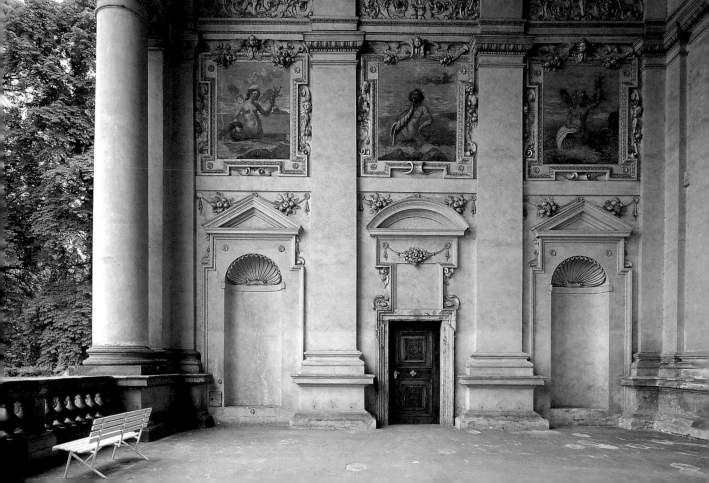

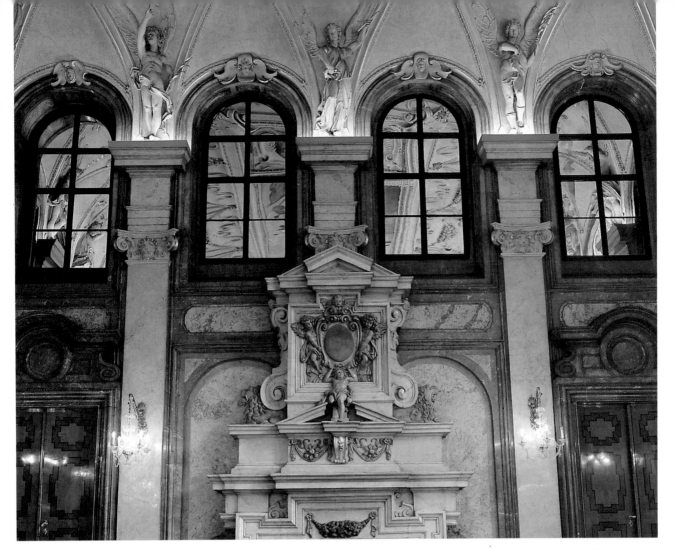

Another splendid vista of the Wallenstein Gardens overlooking the Sala Terrena.

Wallenstein Palace: detail of the Sala Terrena, with its refined decorative motives.

Wallenstein Palace: detail of the Hall of Cavaliers.

Wallenstein Palace: ceiling painting from the Hall of Cavaliers showing 'Wallenstein in the guise of Mars in his Triumphal Chariot'.

The Wallenstein Garden (*Valdštejnská zahrada*) is also a part of the palace complex. It was modelled on the prototype of the Italian Baroque garden, and contains copies of sculptures by A. de Vries. The *Sala Terrena*, with frescoes by B. del Bianco, is used for theatrical and concert performances.

On the following pages: spectacular panorama over the Vltava, with the Charles Bridge, the Smetana Museum and the Aqueduct Tower of Staré Město.

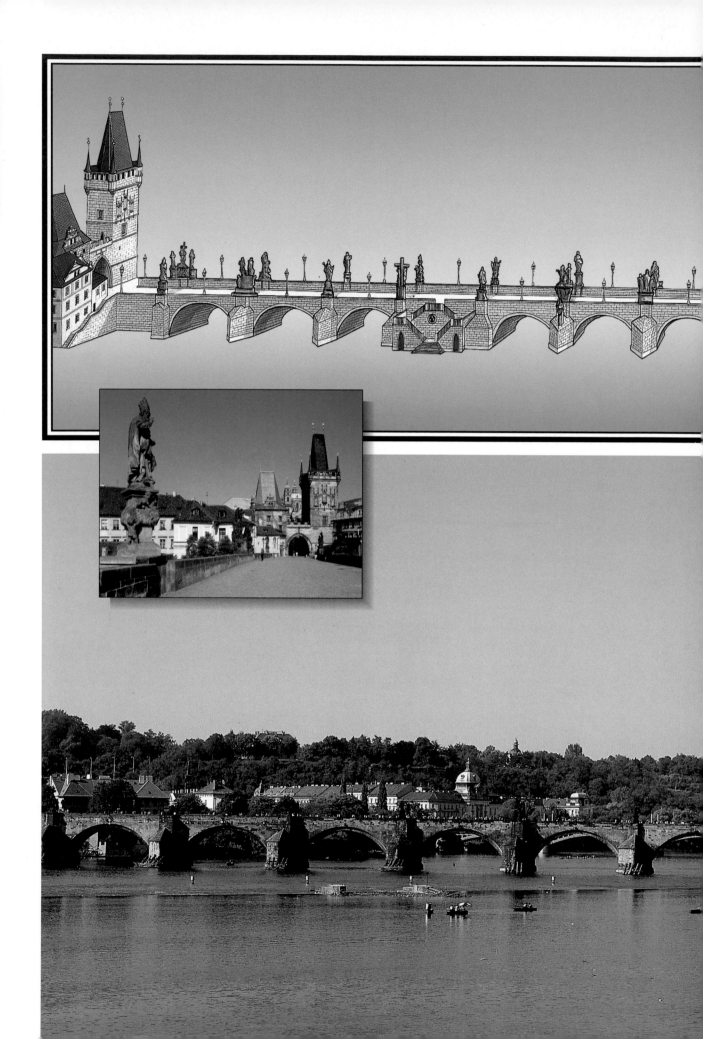

CHARLES BRIDGE

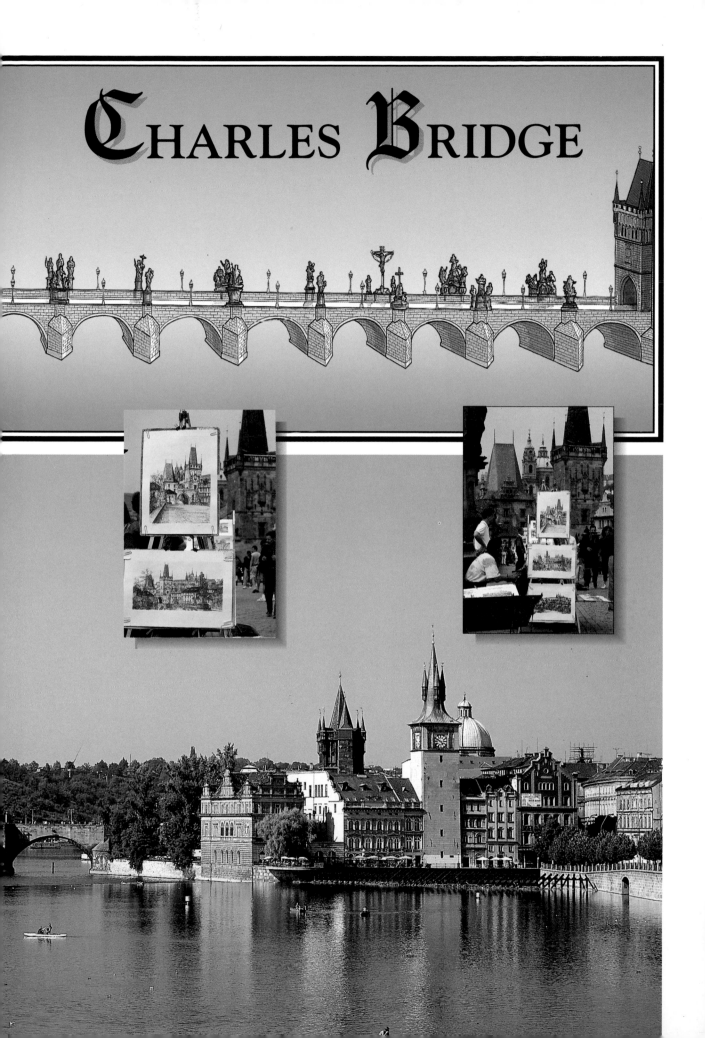

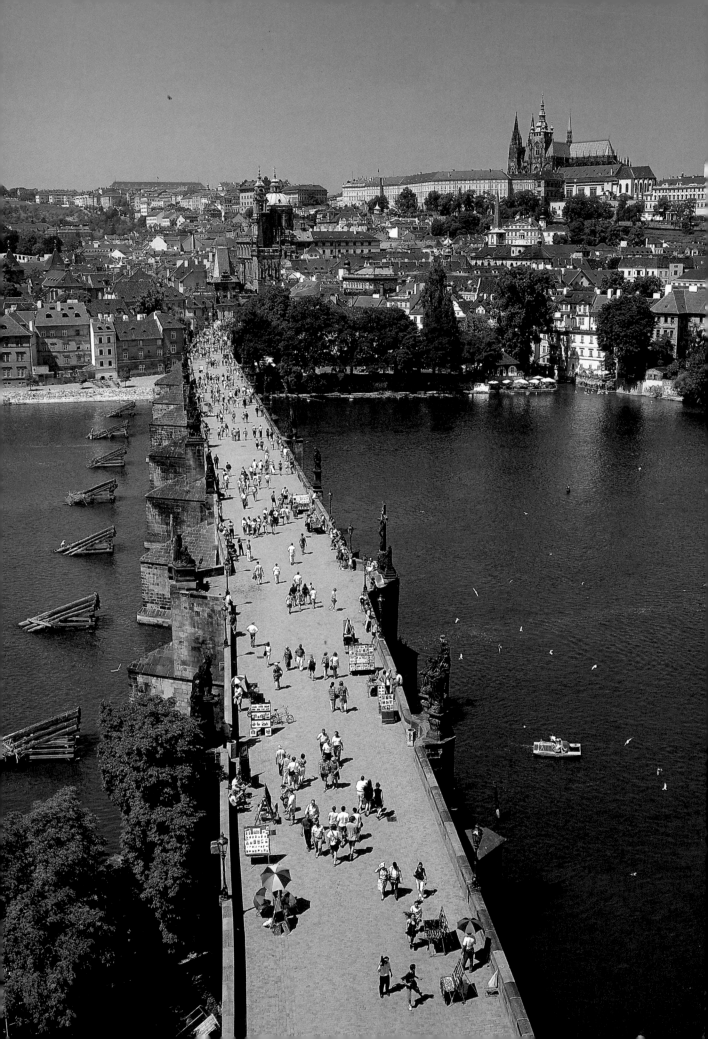

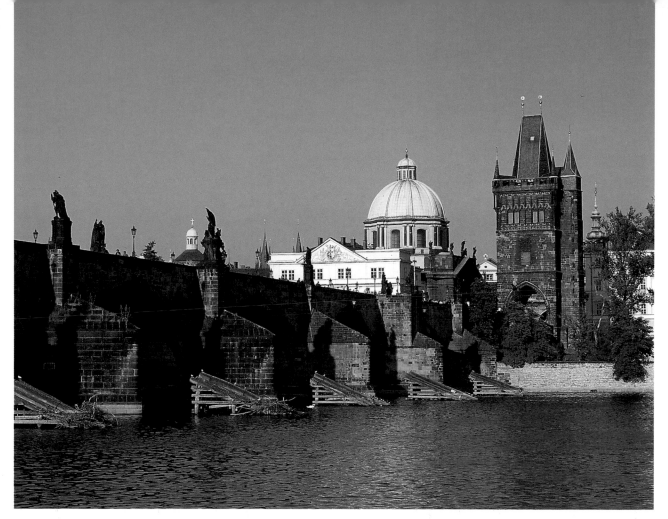

Spectacular view of Charles Bridge from the Tower of Staré Město; in the background lies the quarter of Malá Strana and the Castle.

Charles Bridge from Kampa Island, towards the Tower of Staré Město and the dome of the Church of St Francis Seraphicus at the Knights of the Cross.

CHARLES BRIDGE - KARLŮV MOST

The "Charles Bridge" is one of Prague's symbols *par excellence*. It joins the historic quarters of Staré Město and Malá Strana. Work was begun on its construction at the time of Charles IV (latter half of the 14th century) by P. Parler and J. Ottl, and it was completed in the early 15th century, under the reign of Wenceslas IV. The strain of the centuries and the destructive floods of the Vltava have certainly put the Charles Bridge to the test, and in fact two of its arches had to be rebuilt in 1890. The pedestrian bridge, which affords fantastic views of the city, is 516m long, 10m wide and is supported by 16 pillars. It is watched over by mighty towers at both ends, and the whole bridge was once part of the defensive works of Prague. Its monumental Gothic feel is softened and enlivened by what we might call a genuine open-air sculpture gallery: there are as many as 30 statues and groups of sculptures on show, contributing to the magical atmosphere of Prague and the splendid views. In 1657, following the restoration of a bronze

Crucifix which had stood here since the 14th century, statues and sculptural groups began to be placed along the parapet of the bridge: 26 of them between 1706 and 1714. Among the artists who have displayed their talents here are J. Brokoff and sons, M. B. Braun, and Josef and Emanuel Max. The group of *St Cyril and St Methodius* was sculpted in 1928 by K. Dvořák. Most of the statues have been replaced with copies since the originals are made of sandstone which is easily damaged by pollution. These are therefore kept in the Lapidarium of the National Museum. The *Statue of St Luitgard* is the most valuable one, while the figure of *St Philip Benizzi* is the only work in marble. The only bronze statue is that of *St John Nepomuk*, situated at the centre of the bridge. It is a 17th century work based on models by M. Rauchmüller and J. Brokoff. A relief carving between the sixth and seventh pillar shows where the saint was hurled into the river. A Hebrew epigraph, close to the *Crucifixion Group*, commemorates the sacrile-

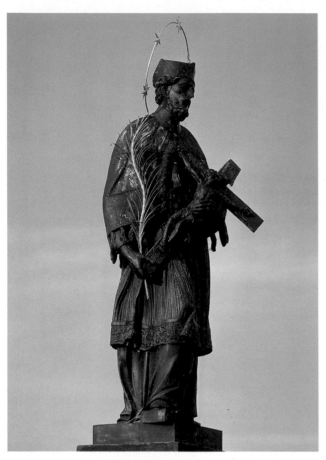

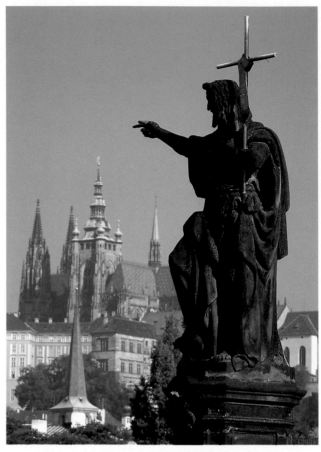

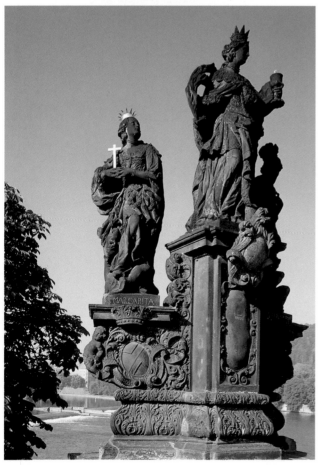

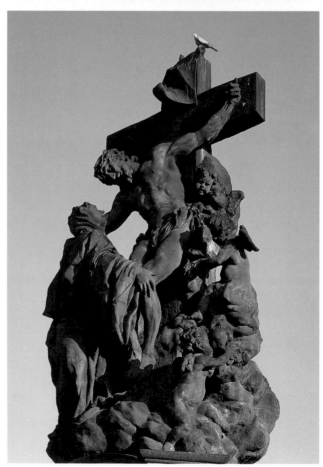

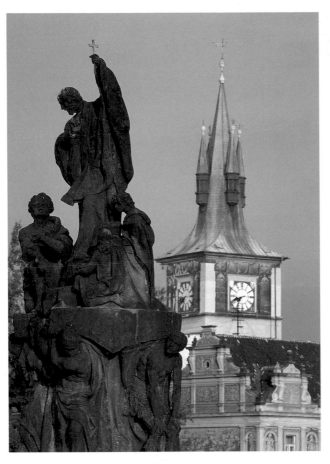

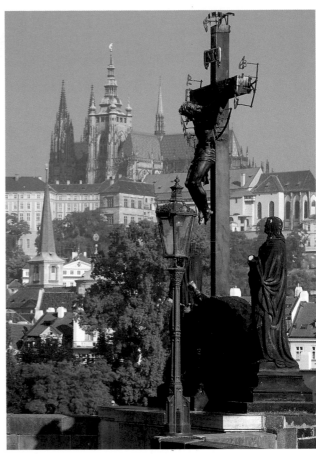

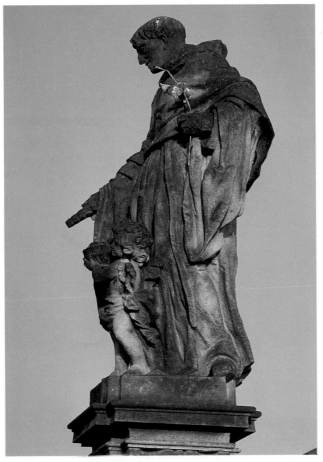

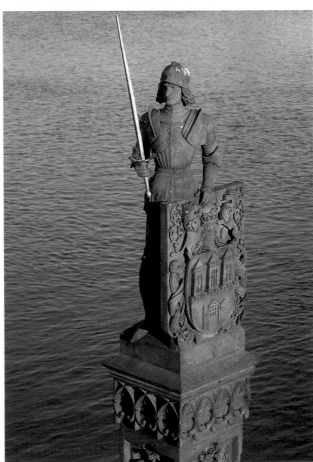

gious act of a Jewish blasphemer (1696). A scroll situated below the 19th century *Statue of St Francis Seraphicus* bears the verses of Psalm 90/11: "God will put his angels in charge of you to protect you wherever you go". Near to the bridge (on Kampa Island) is the *Roland Column,* a 19th century copy of the 16th century original. The bridge is one of the focal points of tourist Prague: it is forever crowded with a babel of visitors, while artists, vendors and craftsmen offer their work for sale in an atmosphere reminiscent of the Parisian *Rive Gauche*. The **Towers of Malá Strana** mark the end of the bridge where it meets the quarter of the same name. The lower of the two towers, from the late 12th century, formed part of the old Judith Bridge. Some architectural and ornamental reconstruction work was carried out on it towards the end of the 16th century. The higher tower, built in the second half of the 15th century, was ordered by Jiří of Poděbrad and took the place of an old Romanesque tower.

On the previous pages: some of the individual statues and sculptural groups which adorn the parapets of the Charles Bridge, making it an authentic open-air museum. Most notable are: St John Nepomuk; St John the Baptist; the group representing St Barbara, St Margaret and St Elizabeth; St Luitgard touching Christ's wounds; St Francis Saverio; the 'Calvary' group (17th century); the 'Roland Column'.

Charles Bridge in the direction of the towers of Malá Strana.

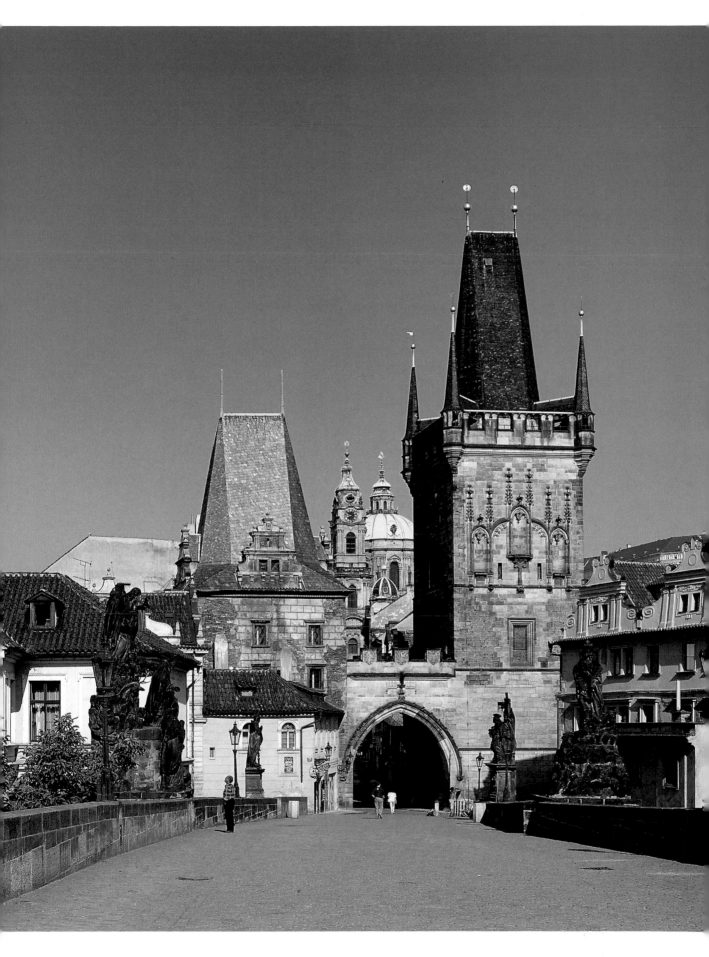

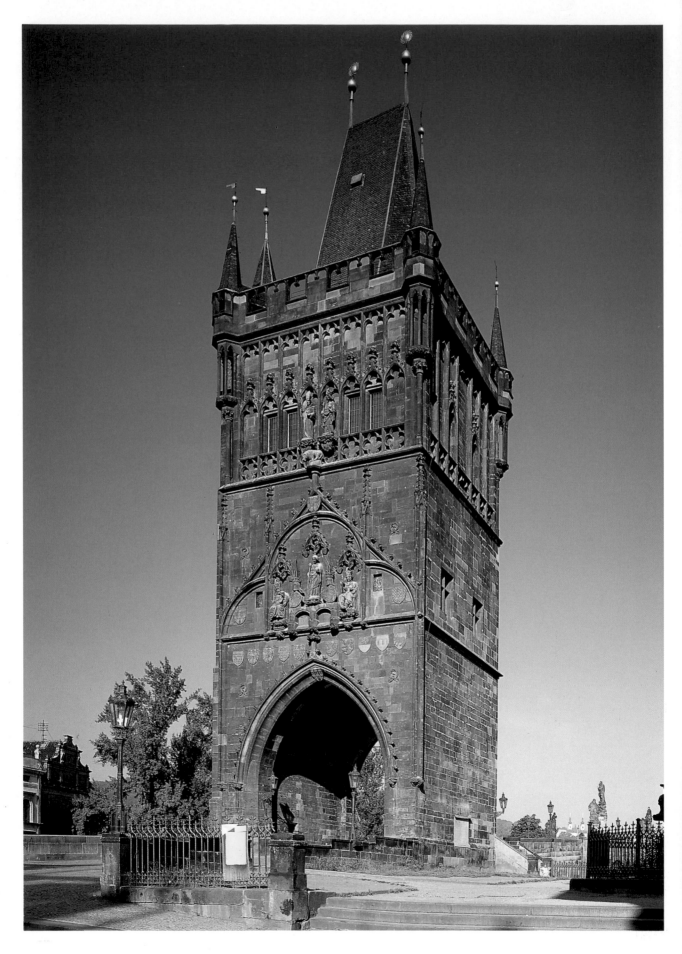

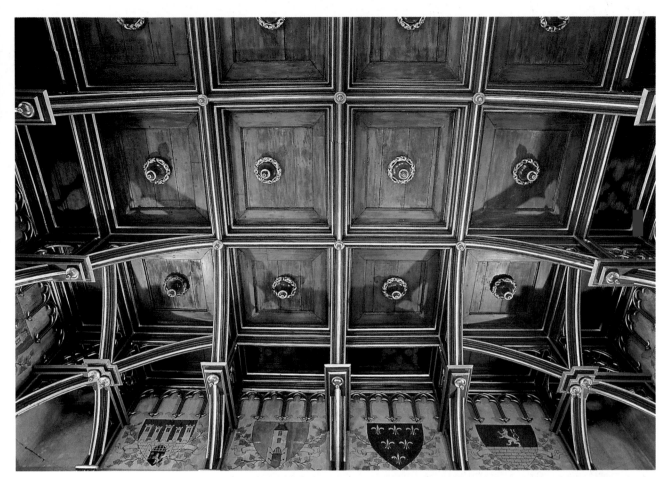

Detail of the wooden ceiling of the Tower of Staré Město.

The imposing Tower of Staré Město which forms the entrance to the Charles Bridge from the right bank of the Vltava.

Detail of the sculptures adorning the exterior of the Tower of Staré Město.

TOWER OF STARÉ MĚSTO

The Tower of Staré Město stands watch over the entrance to the bridge on the right bank of the Vltava, where the quarter of the same name lies. Its construction was begun in the late 14th century and completed at the time of Wenceslas IV, under the direction of P. Parler. The elegant beauty of this Gothic tower is magnified by the wealth of sculptures and statues which decorate it. These are considered to represent some of the finest examples of 14th century Gothic sculpture in Bohemia (they include coats of arms, heraldic emblems, figures of saints, sovereigns and patrons of Bohemia). The Gothic paintings were restored in the 19th century, as was the whole tower which was given the roof we see today.

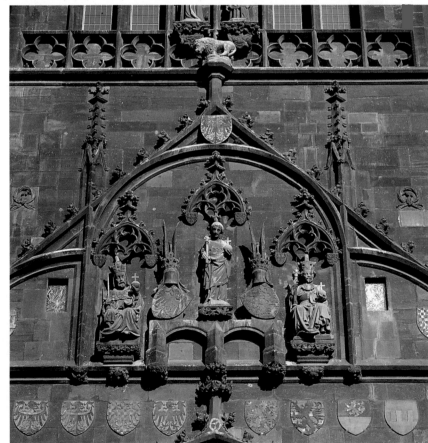

Splendid shops with magnificent signs line Karlova, one of the main shopping streets.

Clam-Gallas Palace: detail of the 'Giants'; the portal and façade of Rott House.

One of Prague's buildings of architectural merit.

Interior of the Church of St Giles (Kostel svatého Jiljí), noted for its Baroque furnishings.

OLD TOWN - STARÉ MĚSTO

KŘIŽOVNICKÉ NÁMĚSTÍ

This square begins at the eastern end of Charles Bridge. It was created in the 16th century and was part of the route followed by the coronation processions of the Bohemian sovereigns. It is distinguished by the *Statue of Charles IV*, cast in iron in the first half of the 19th century. The **Church of the Holy Saviour**, once part of the *Clementinum* (situated next to the church), is a Jesuit temple, built between the 16th and 17th centuries in Renaissance style. The porch in front of the main portal was added in the 17th century by C. Lurago and F. Carati; the sculptures and vases which decorate it are the work of J. J. Bendl. The addition of the towers in the 18th century marked the completion of the church's construction. The **interior** boasts a 17th century ceiling fresco (*The four quarters of the World*, by K. Kovář). The *Charles IV Monument* (1848) is situated between the Tower of Staré Město and the **Church of St Francis Seraphicus at the Knights of the Cross**. The plans for this Baroque church were drawn up by J. B. Mathey, and building was completed in the second half of the 17th century.

The temple, which was built on the site of an earlier Gothic church, is distinguished by its elegant dome and its **façade**, inspired by French Pre-Classicism. The statues near the entrance (*Madonna* and *St John Nepomuk*) are by M. W. Jäckel. Other sculptures on the façade represent *Angels* and *Patron Saints of Bohemia*. The **interior** is richly decorated, and the dome bears a fresco of the *Last Judgement* by V. V. Reiner (18th century). The nearby *Vintners' Column* bears a *Statue of St Wenceslas* (17th century).

In the southern part of *Mariánské náměstí* stands **Clam-Gallas Palace,** a splendid example of Baroque art, designed by the Viennese J. B. Fischer von Erlach. The building now houses the Prague city archives. M. Braun and C. Carlone were among those who contributed to the decoration of the palace with sculptures and paintings. Note the 19th century *Vtlava Fountain* by V. Prachner, situated close to the wall of the courtyard.

The Civic Library occupies the northern side of Mariánské náměstí. It was inaugurated in 1928 and stocked with over 750,000 volumes. Observe the allegorical statues by L. Kofránek, situated on the balcony.

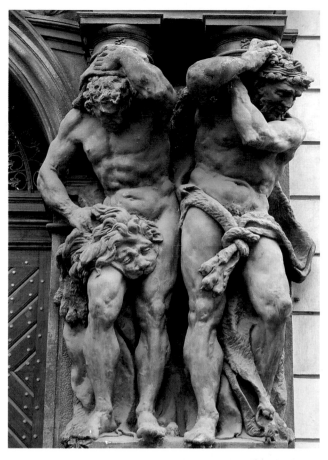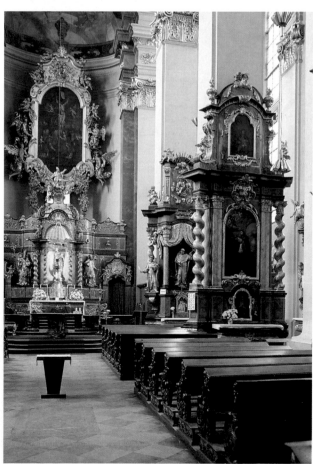

SMETANA MUSEUM

The embankment *Smetanovo nábřeží* is named after the 19th century composer B. Smetana; it leads from the National Theatre to a peninsular facing Charles Bridge. Of particular interest, besides the *Monument to Francis I* and the 15th century **Aqueduct Tower of Staré Město**, is the old 19th century Waterworks for its architectural design and the *sgraffiti* used to decorate it. The Smetana Museum is housed here, with exhibits regarding the musician. On the quay facing the museum is the *Smetana Monument*, erected in 1984 by J. Malejovský.

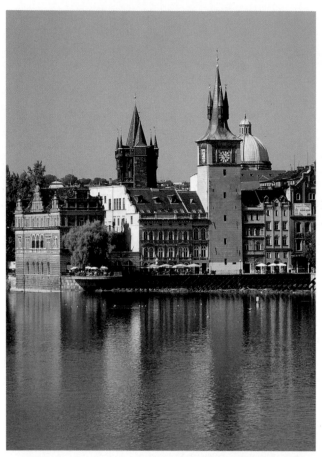

Old Waterworks and Aqueduct Tower in Staré Město; the Waterworks houses the Smetana Museum.

Smetanovo nábřeží: Smetana Monument, with Charles Bridge and the Castle in the background.

Smetana Museum: the musician at the piano (from an historical painting).

Smetana Museum: portrait of the musician by Geskel.

Smetana Museum: opera costume from 'The Devil's Wall'.

Smetana Museum: opera costume of Přemysl from 'Libuše', (1915).

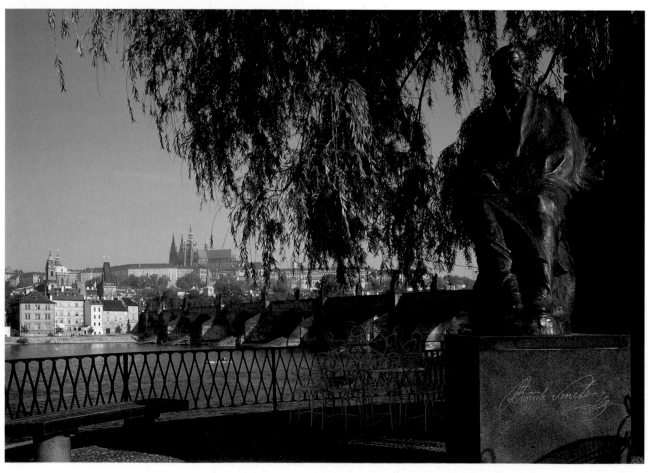

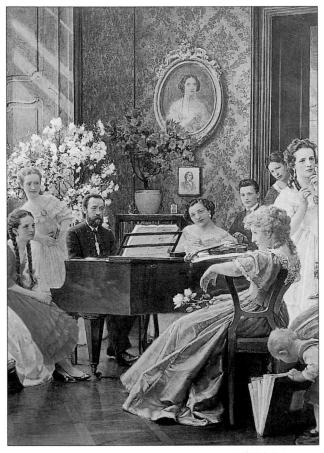

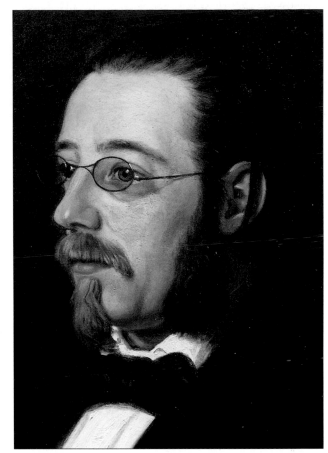

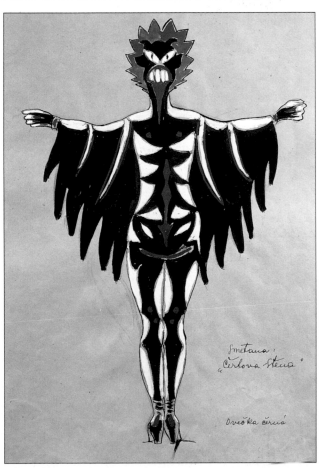

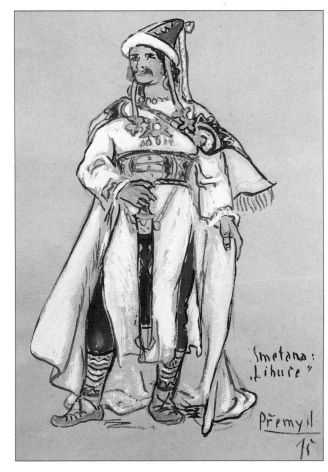

CLEMENTINUM (Klementinum)

Formerly the Jesuit College, this building is considered to be the most impressive architectural complex in the capital, after the Castle. An entire quarter, including elegant homes, and churches and gardens, was demolished in the second half of the 16th century in order to make way for the complex. The reason for this was to support the Jesuit apostolate in their efforts to expand and consolidate Catholicism in Prague. This grandiose scheme of urban reconstruction was planned by F. Caratti and F. M. Kaňka. The 17th century main **façade** is decorated with stucco ornaments and busts of *Roman Emperors*. The **interior** houses the **National Library** (numbering more than five million volumes, 6000 manuscripts, including the valuable *Vyšehrad Codex*, and 4000 incunabula). The *Hall of the Jesuit Library* is decorated with ceiling frescoes (*Biblical themes, Muses*); *The Mozart Hall* and the former *Chapel of Mirrors* are noted for their pictorial decoration; the *Hall of Mathematics* contains a collection of globes and antique table clocks. Also of interest, in the south-western courtyard (not always open), is the *Statue of the Prague Student*, in memory of those who defended the Charles Bridge at the end of the Thirty Years' War.

National Library: Pietro da Crescentino offering his treatise on agriculture to the Emperor Charles IV.

National Library: the baker (from a chronicle by Ulrich of Richental).

National Library: page from a medical treatise by M. Albik.

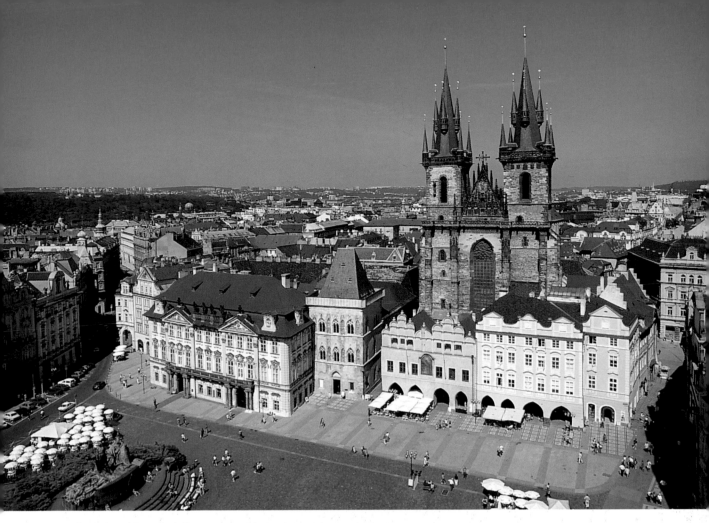

Fine view from the Old Town Hall Tower towards Staroměstské náměstí and the city, dominated by the spires of the Church of Our Lady of Týn's bell towers.

OLD TOWN SQUARE
Staroměstské náměstí

This huge square is the living heart of old Prague. Its historical importance, on the right bank of the Vtlava, can be compared to that of the Castle on the opposite side of the river. *Staroměstské náměstí* is not merely an impressive blend of architectural styles and monuments; it represents the very essence of the city itself. It has been the setting for the many events, both happy and tragic, which have marked Prague's long history: in 1422 the preacher J. Želivský was executed here (a plaque commemorates the event); in 1621 the leaders of the Protestant revolt were executed (see commemorative plaque); in 1915 the bronze *Jan Hus Monument* was inaugurated, on the occasion of the 5th centenary of his death (the work is by L. Saloun, and an epigraph reads *The truth will win*); in 1945 the people of Prague joyfully welcomed the Soviet army at the end of the Second World War; in 1968 the crowd bombarded Soviet tanks with Molotov cocktails for shattering the dream of the "Prague Spring", and the Hus Monument was veiled as a sign of mourning; in 1988 the people of Prague demanded freedom, civil rights and the removal of the "brothers" of the Warsaw Pact; and in 1990 the square was one of the settings for the "Velvet Revolution" which marked a return to democracy. The square at night, with its carefully studied illumination, is especially charming: the lights create surreal, fantastic, almost fairy-tale dimensions on the façades of the noble buildings and up towards the incredible spires of the Church of Our Lady of Týn. All around, in the square and along *Karlova*, jugglers and musicians brighten the city's evenings, again offering a typically "Parisian" image.

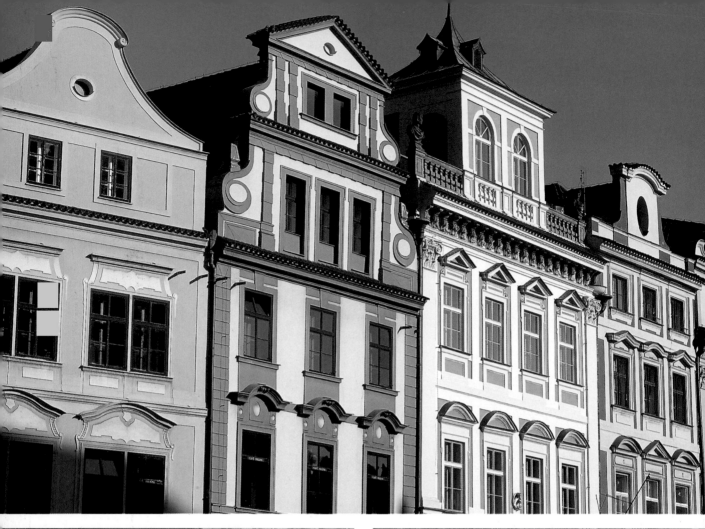

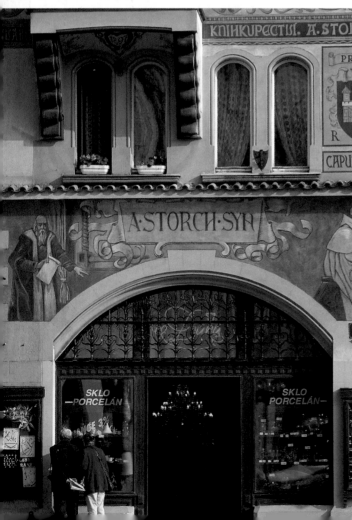

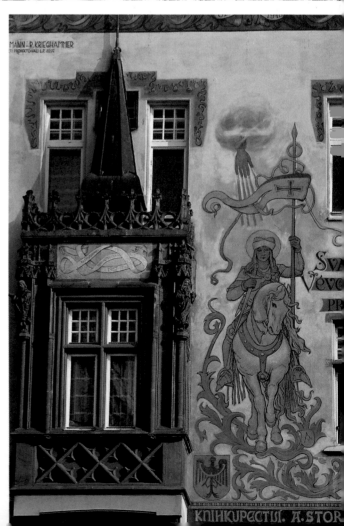

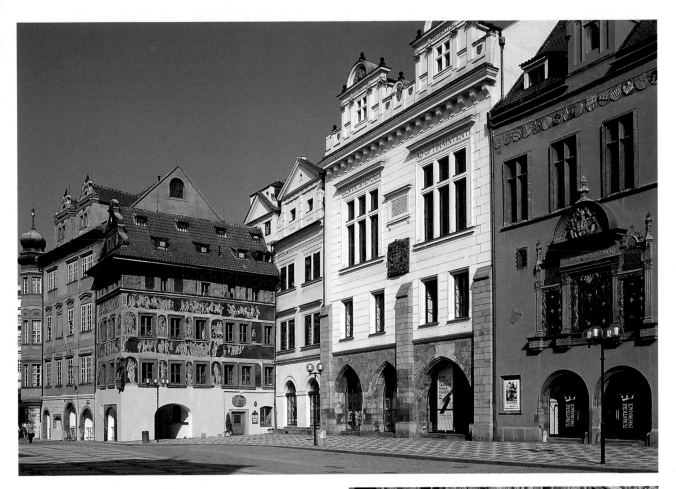

Other buildings in the square of Staré Město.

Two details of the lovely Storch House: the painted entrance and the bay window flanked by the fresco of 'St Wenceslas on horseback'.

Detail of the House at the Minute, richly decorated with sgrafitti work.

The epigraph reading 'Praga caput regni' stands out on this elegant window of Křiž House (Old Town Hall).

HOUSE AT THE GOLDEN UNICORN

This building, at n° 20, was extended as early as the 14th century, and towards the end of the following century it was rebuilt in late-Gothic style. The **façade** bears the hallmark of late Baroque and dates from the 18th century. A plaque here commemorates the famous composer, B. Smetana, who opened his first music school in this house.

STORCH HOUSE

This lovely building, situated at the lower end of the square at n° 16, close to *Celetná ulice*, is distinguished by its beautiful decorations and the architectural details which ennoble the fine **façade**. The painting which adorns the façade, and which recalls the type of fresco-decorated houses common among the aristocratic residences of central Europe, depicts *St Wenceslas on horseback*. Originally a 14th-15th century Gothic residence, Storch House was restored in Neo-Renaissance style towards the end of the 19th century and remains as such today. The building next door, known as the **House at the Stone Ram** (n° 17), is also called *At the Unicorn* because of the subject of the bas-relief which decorates the façade.

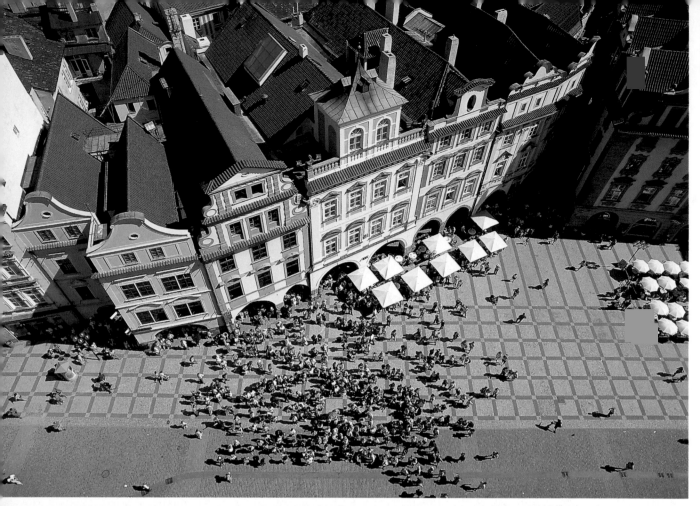
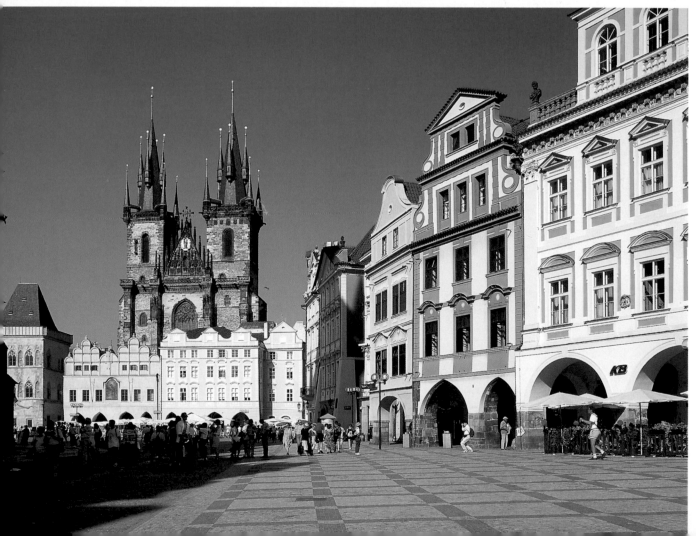

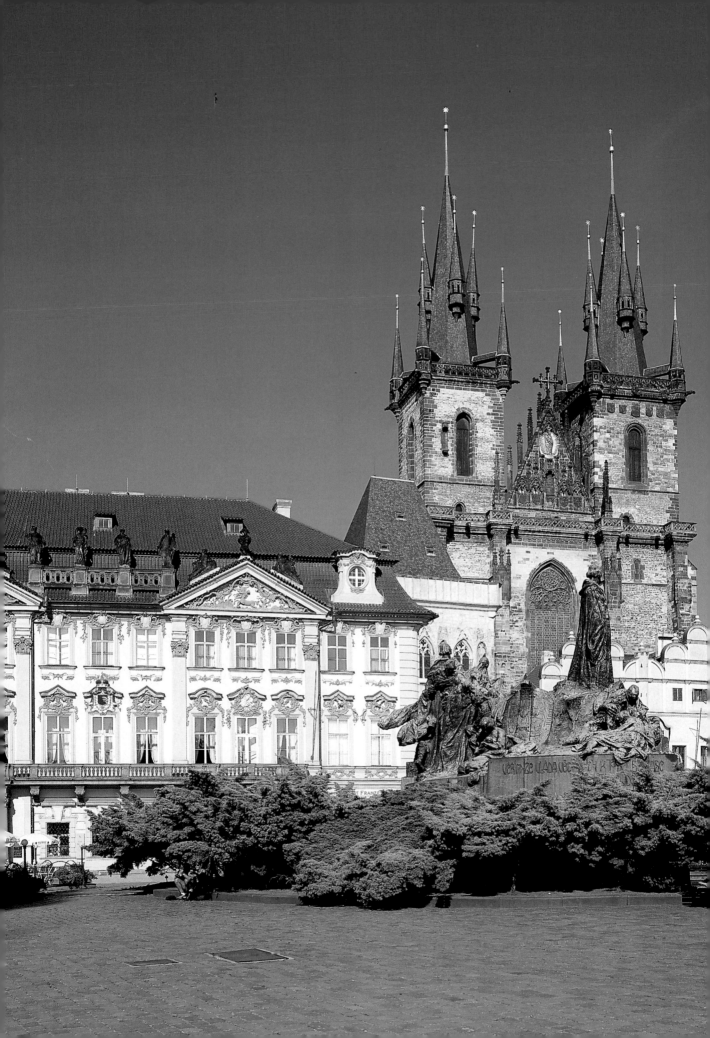

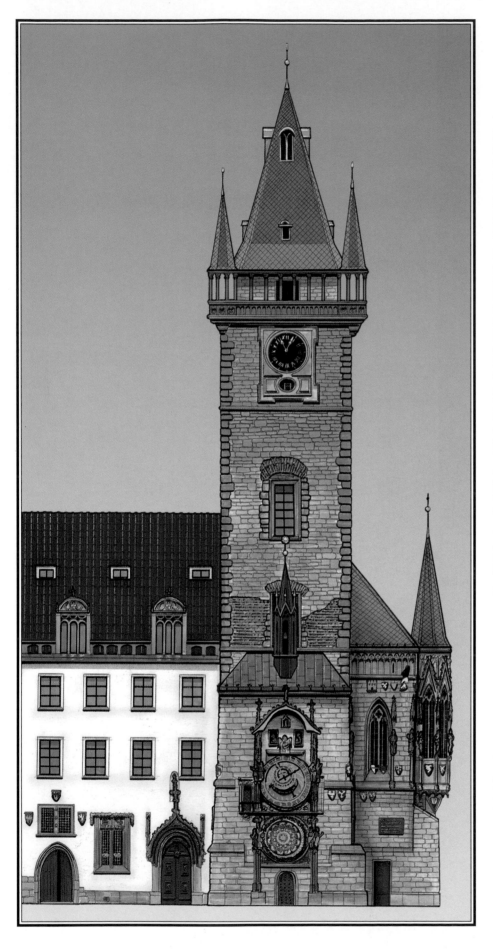

OLD TOWN HALL
Staroměstská radnice

The history of this building begins in the 12th century and continues uninterruptedly, through various periods of extension, damage, destruction and reconstruction, right up until the last restoration work carried out between 1978 and 1981. The original central part of the building was constructed in 1338; a tower was then added in 1364. Křiž House was built before this, in 1360, and stands out today because of its lively paintwork and the epigraph *Praga caput regni*. Serious damage was inflicted on the complex at the end of the Second World War. The *Council Chamber* has maintained its Gothic character which originates from the second half of the 15th century. The huge *Meeting Hall* contains paintings by V. Brožík (*Jiří of Poděbrad elected King of Bohemia, J. Hus before the Council of Constance*). There is a charming view from the top of the 69m high **Old Town Hall Tower**, which can be reached by lift.

On the previous pages: view over the rooftops of Staré Město from the Old Town Hall Tower; Staroměstské náměstí, towards the Church of Our Lady of Týn; the Jan Hus Monument dominates the spacious square, watched over by some of the most beautiful examples of Prague architecture.

The Old Town Hall with its Astronomical Clock, and in the background the Church of St Nicholas in Staré Město.

Detail of the Gothic portal of the Town Hall and two details of the interior.

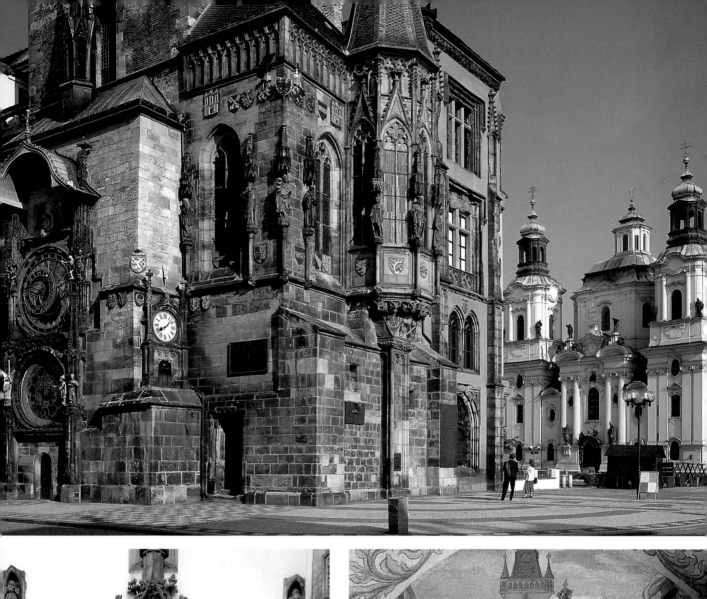

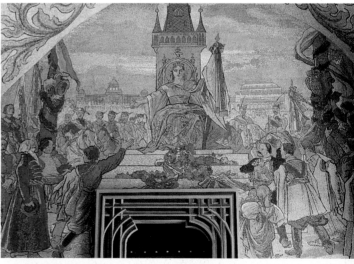

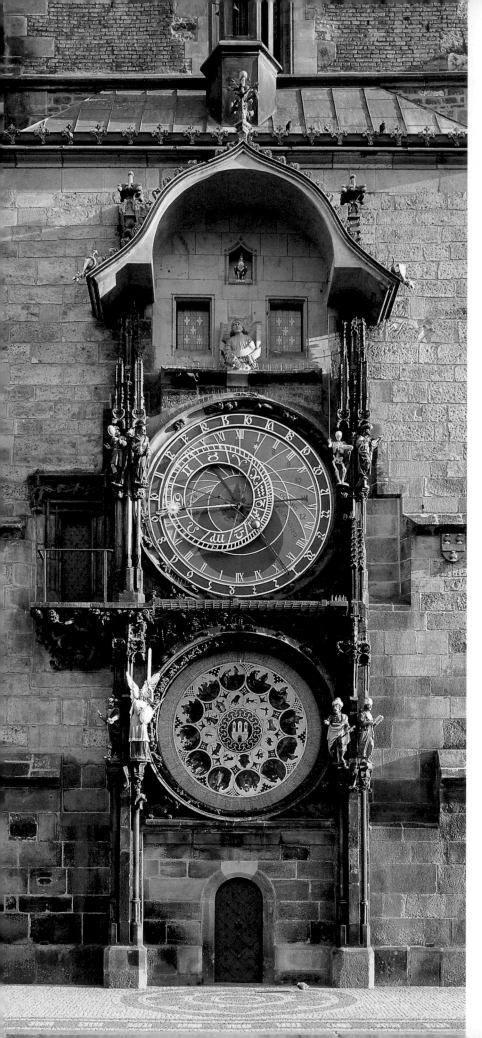

ASTRONOMICAL CLOCK
Orloj

The clock was built by Master Mikuláš of Kadan and was mounted in the lower part of the Old Town Hall Tower at the beginning of the 15th century. At the end of the century Master Hanuš took charge of its rebuilding, and in the second half of the 16th century it was perfected and enlarged by J. Táborský. Every hour the charming *Procession of Apostles* appears with its eloquent allegories, attracting the surprised attention of tourists and visitors who crowd round in the attractive little square below.

The Astronomical Clock in its entirety.

The Old Town Hall and its tower, seen from the Old Town Square.

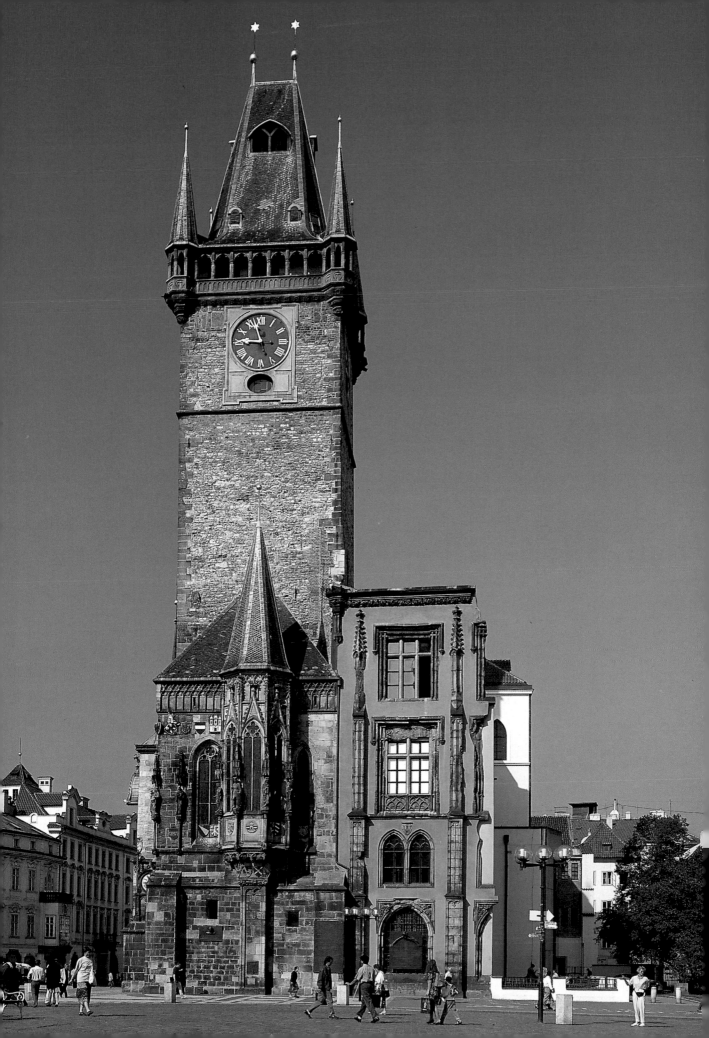

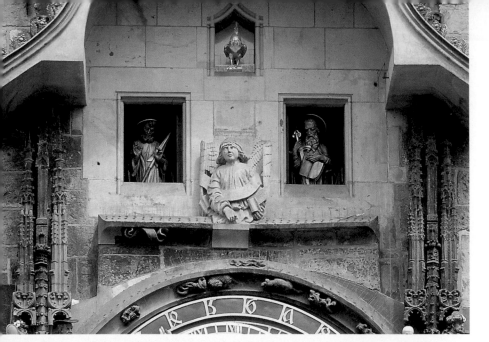

Astronomical Clock: a detail of the Procession of Apostles.

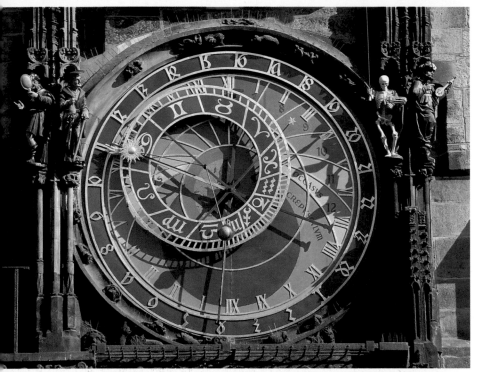

Astronomical Clock: upper face (signs of the zodiac).

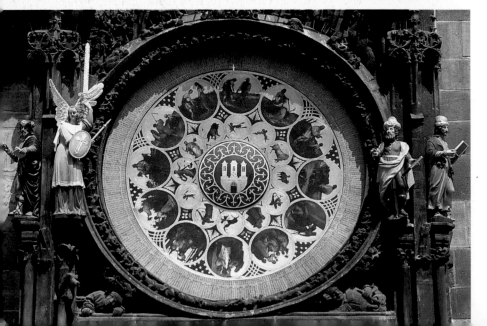

Astronomical Clock: lower face (calendar).

Astronomical Clock: four images showing the figures which stand on each side of the clock faces; those beside the upper face are allegorical and represent 'Vanity', 'Greed', 'Death' and 'Lust'.

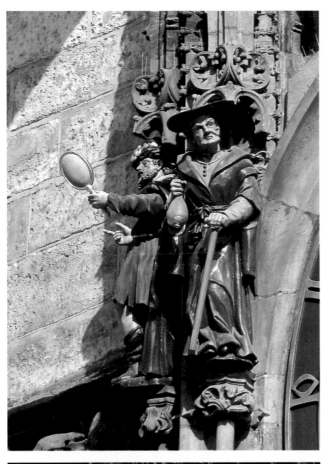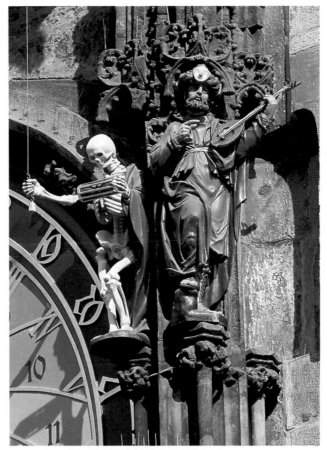

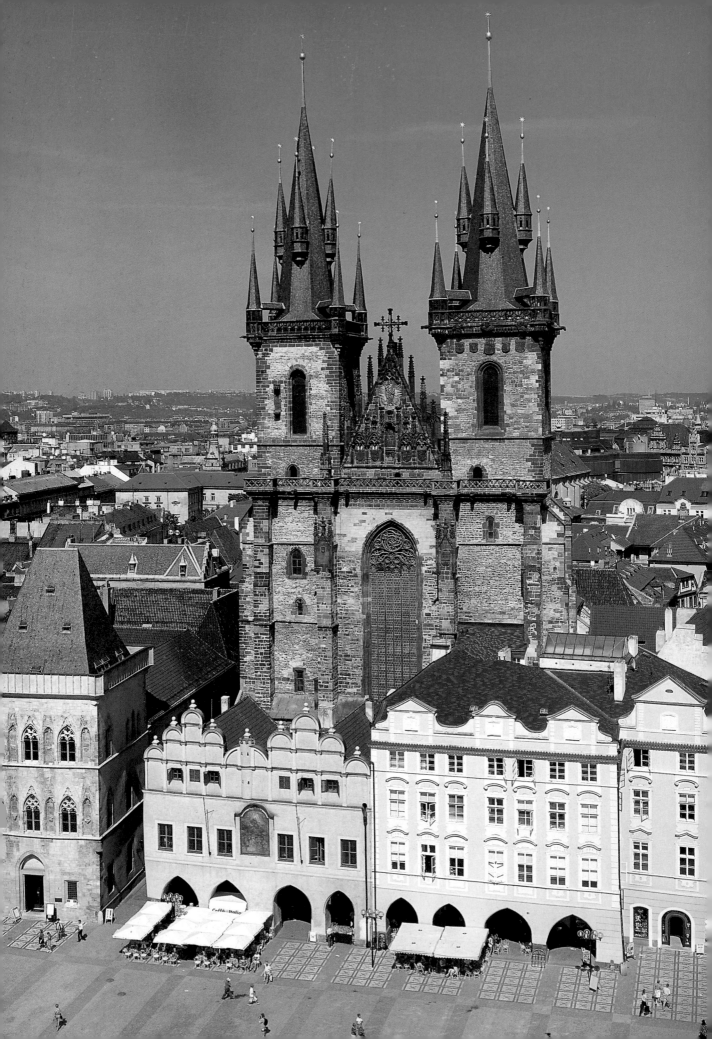

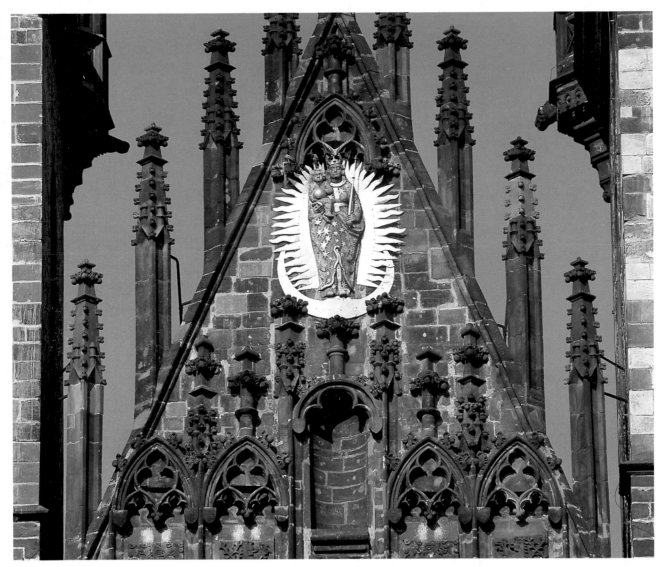

View of the imposing Church of Our Lady of Týn which, with its pointed bell towers, dominates the historic centre and the spectacular square of Staré Město.

Detail of the tympanum of the Church of Our Lady of Týn which contains a 'Madonna' on a gold mounting.

CHURCH OF OUR LADY OF TÝN
Kostel Panny Marie před Týnem

This mighty construction, one of the capital's most famous symbols, rises high above the rooftops of old Prague. The present day building was erected on the site of an earlier Romanesque church in the second half of the 14th century, and the choir was completed towards the end of that century. The **façade**, in all its austere, Gothic magnificence, was completed in the second half of the 15th century at the request of Jiří of Poděbrad. The tympanum contains a *Statue of the Madonna*, and the façade is dominated by twin bell towers, although these were built at different times (the northern one in the 15th century and the southern one in the 16th century). They are both 80m high and crowned with soaring pinnacles and angular turrets which contribute to the fairy-tale setting. The high, majestic **interior** is distinguished by the mighty pillars which separate the three naves and support the imposing ogival arches. The ceiling above the naves is formed of cross-vaults. Fine wooden altars with gold-leaf work stand against the pillars. The Church also contains the *Tomb of Tycho Brahe*, Court Astronomer to Rudolph II; a Gothic *Madonna and Child* (15th century); and the Late-Gothic baldachin by M. Rejsek (late 15th century). The paintings on the high altar (*Holy Trinity* and *Assumption of the Virgin*) are by Karel Škréta (17th century).

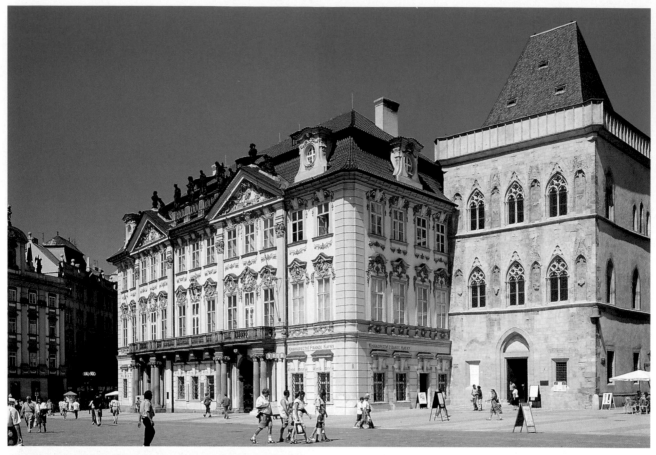

Staroměstské náměstí: Goltz-Kinský Palace and the House at the Stone Bell.

The tympanum of Goltz-Kinský Palace with the bell towers of the Church of Our Lady of Týn in the background.

Goltz-Kinský Palace: detail of a stucco figure on the façade.

GOLTZ-KINSKÝ PALACE
(Palác Goltz-Kinských)

This impressive late Baroque palace, which animates the eastern side of the square with its Rococo and neo-classical designs, is the result of the joining together of a Romanesque building and an early Gothic house. Count J. E. Goltz entrusted the project to K. I. Dientzenhofer, while the actual building work was carried out by A. Lurago in the latter half of the 18th century. It was subsequently acquired by Prince R. Kinský. Note the **façade** and its interesting features: the pilaster strips, the triangular tympanums, the long balcony resting on the columns situated on either side of the portals, the windows decorated with stuccowork and Rococo patterns, and the statues situated on the attic. The palace houses the **National Gallery Collection of Graphic Art**.

HOUSE AT THE STONE BELL
('U kamenného zvonu')

The building's elegant Gothic **façade** was only restored to the public eye in the 1960s when some reconstruction work brought it to light underneath a dubious late 19th century addition. The house's origins date back to the 13th century, and its name is already mentioned in records of the 15th century. Its appearance was then gradually altered until no trace remained of the beautiful building which, however, visitors can now admire again.

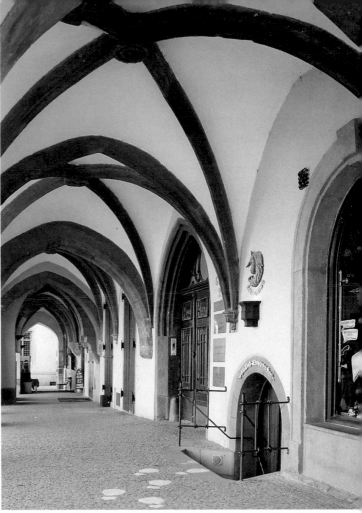

Staroměstské náměstí: Gothic portal of the ancient School of Týn which now gives access to the church of the same name.

House at the Stone Bell, which takes its name from the bell visible at the corner of the building, on a level with the first string course.

Detail of this fine floral-style building, now the seat of the Ministry of Commerce.

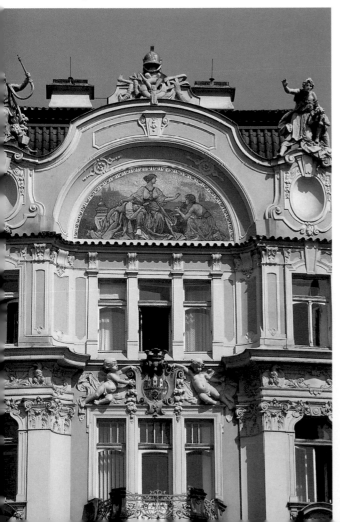

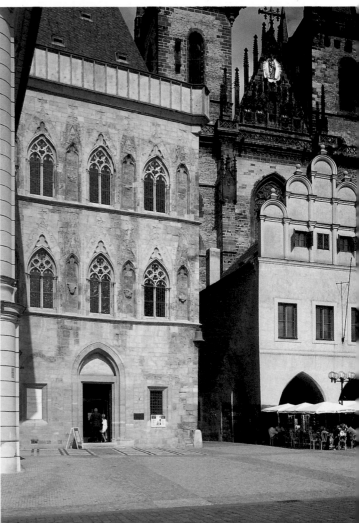

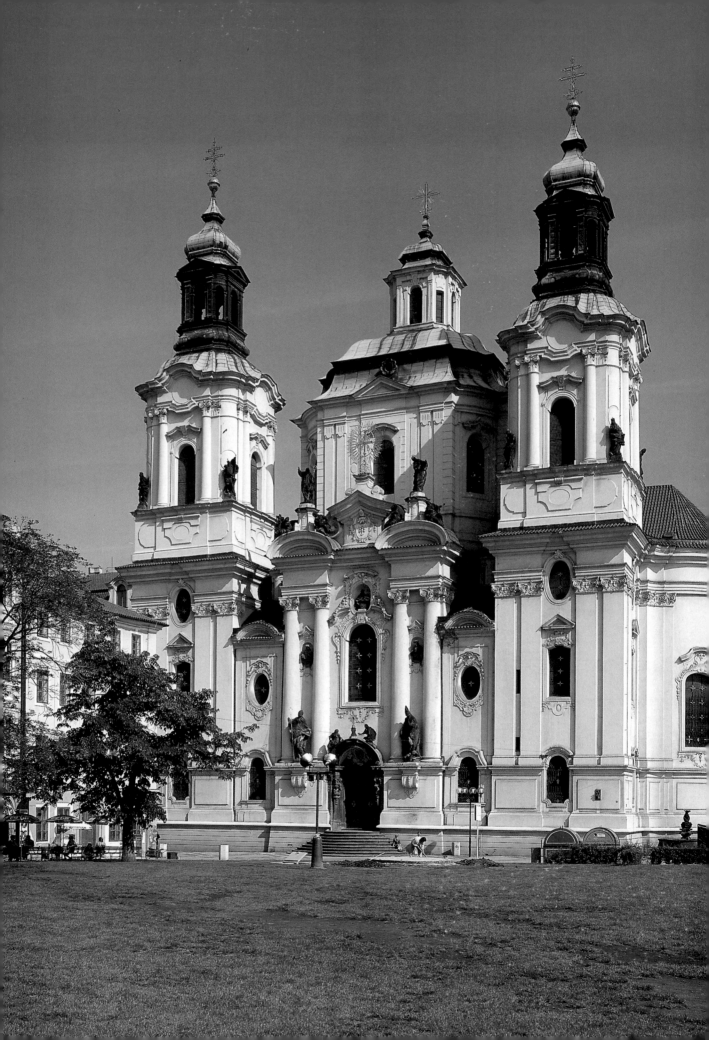

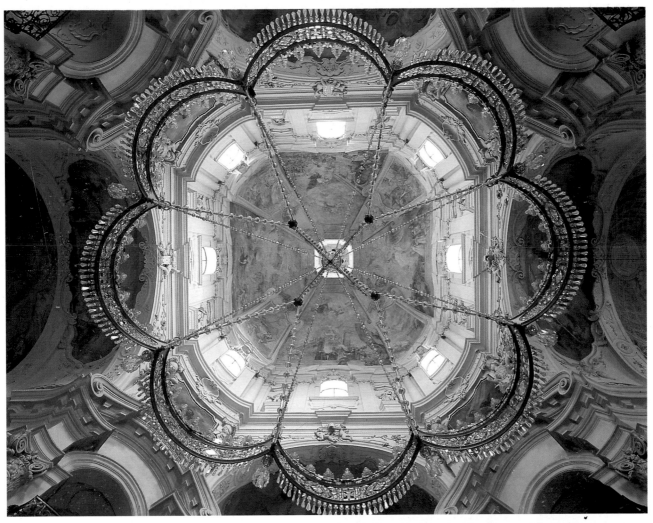

The beautiful Church of St Nicholas in Staré Město, a fine example of Dientzenhofer Baroque architecture in Prague.

Elaborate shot of the dome from the interior of the Church of St Nicholas in Staré Město.

Effects of perspective in Staroměstské náměstí.

CHURCH OF ST NICHOLAS IN STARÉ MĚSTO
(*Kostel svatého Mikuláše*)

This masterpiece of Baroque architecture was built in the first half of the 18th century by K. I. Dientzenhofer. The monumental south-facing **façade** is a triumph of exquisite Baroque architectural and ornamental patterns. The twin bell towers, the dome and the central part of the façade are of a singular elegance. The **interior** consists of a central nave with side chapels. The ceiling paintings, showing the *Lives of St Nicholas and St Benedict,* and the frescoes in the side chapels and presbytery are the work of P. Asam the Elder. The *Statue of St Nicholas* on the side façade was added at the beginning of the 20th century and is by B. Simonovský.

FRANZ KAFKA'S BIRTHPLACE (*U věže*)

Not far from the church, at N° 5 *U radnice*, stands the house where Franz Kafka was born. A *Bust* of the famous Prague writer (1883-1924) can be seen here.

CHURCH OF ST JAMES (*Kostel svatého Jakuba*)

The Baroque appearance of this church is the result of a series of work carried out between the 17th and 18th centuries on an earlier Gothic building. This in its turn had replaced the original 13th century temple, itself destroyed by fire. The **façade** is embellished with fine stuccowork figures by O. Mosto; these represent *St James*, *St Francis*, and *St Anthony of Padua*. The temple's remarkable **interior**, divided by pillars, is extraordinarily long (in fact, it is second only to the Cathedral in this respect). It also contains some rich pictorial decoration. The ceiling paintings are by F. Q. Voget (*Scenes from the Life of the Virgin, Glorification of the Holy Trinity*), while the high altar bears the painting of the *Martyrdom of St James* by V. V. Reiner. The Baroque *Tomb of Count Vratislav of Mitrovice* was designed by J. B. Fischer von Erlach and executed by F. M. Brokoff in the 18th century. Adjoining the building is the **Cloister** of an old Minorite monastery.

POWDER TOWER (*Prašná brána*)

From the top of its 65m, this majestic tower dominates the important Staré Mesto crossroads where *Celetná ulice*, *Na příkopě*, and *Náměstí Republiky* meet. The late Gothic structure was built in the second half of the 15th century on the site of an earlier fortified gateway dating from the 13th century. It was built by M. Rejsek for Vladislav Jagiello, and was modelled on the Staré Město Bridge Tower, forming one of the strongholds of the defence system. The name of the tower derives from a gunpowder store located here in the 18th century. Note the coats of arms which decorate it, together with the statues of *Bohemian Saints and Sovereigns*. Fine views can be had from the top, which is reached by a spiral staircase.

CELETNÁ ULICE

In the second half of the 1980s this important thoroughfare of Staré Město regained some of its past grandeur. It became and remained an important route in ancient times, and was also on the route followed by the coronation processions of Bohemian sovereigns. Today the *Celetná ulice* is noted for the majestic, Baroque constructions which line the street, the result of remodellings of earlier buildings from the Romanesque and Gothic periods. The balustrade at **Sixt House**, situated at n° 2, bears some remarkable sculptures attributed to A. Braun. At n° 12 stands the former **Hrzán Palace** with its attractive façade decorated with sculptures from the F. M. Brokoff workshop; G. B. Aliprandi was probably responsible for the reconstruction of the façade. Note the coat of arms which adorns the door of the building at n° 16. A characteristic *Vinárna* has been opened in **Menhart House** at n° 17. Some of the buildings are now used by the University of Prague (n°s 20-22). The Baroque façade of the house at n° 23 is adorned with an 18th century *Statue of the Virgin* by M. B. Braun. Note also the buildings at n° 31 (the Baroque **Pachtovský Palace**) and n° 34,

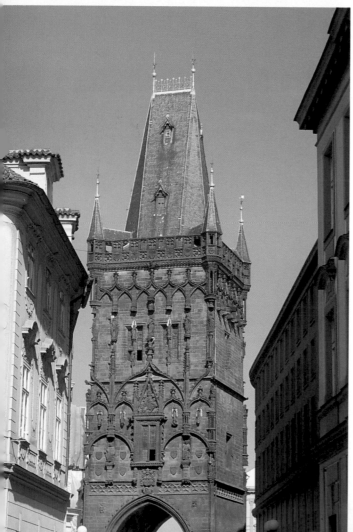

Detail of the splendid stucco-work which adorns the façade of the Church of St James.

The Powder Tower, one of Prague's most representative monuments.

the **House at the Black Madonna,** whose façade bears the sign of the *Virgin Behind Bars*. The **House at the Mint** (n° 36) is a reminder of the Mint which has stood here since the 16th century.

ESTATES THEATRE (*Stavovoské divadlo*)

This was the first theatre to be built in the Bohemian capital. It was founded in fact by Count A. von Nostitz-Rieneck who entrusted its design to A. Haffenecker in the latter half of the 18th century. The theatre has changed both name and owner several times: it has now re-adopted the name which was popular from the end of the 18th century onwards, and is a part of the National Theatre. On 29th October 1787 the debut performance of W. A. Mozart's *Don Giovanni* was given here. Between 1813 and 1816 the theatre's orchestra was conducted by Carl Maria von Weber.

View of the elegant Estates Theatre.

One of the many elegant portals along the Celetná ulice.

Celetná ulice: the 'Virgin behind bars' at the House at the Black Madonna.

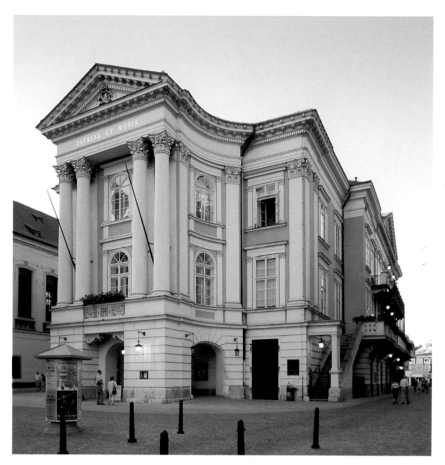

JEWISH QUARTER

Prague's old Jewish Ghetto (*Židovské ghetto*) occupies a part of the Staré Město quarter and is important both in terms of its size, and the cultural and tourist interest it provokes. The *Josefov* quarter takes its name from the Emperor Joseph II. The first Jewish settlements in Prague appeared around the 10th century, and by the 17th century more than 7000 Jews had made the city their home. Persecutions, fires and plundering were regular occurrences throughout the centuries, making life difficult for the Jewish community. Towards the middle of the 18th century Maria Theresa of Habsburg decreed that the Jews should be driven out. Later that century, however, the Emperor Joseph II had the walls of the Ghetto demolished, restoring both the Jewish quarter itself, and its administrative status. The area was named Josefov in his honour. Jews were not granted Civil rights until 1848. The period of Nazi occupation in Prague (1939-1945) was the darkest time for the Jewish community whose members became the object of persecutions and deportations. It is estimated that 90% of Bohemian and Moravian Jews were killed during the Second World War. The group of buildings, used for religious and non-religious purposes, which, together with the cemetery, make up the Ghetto, has now been transformed into a kind of large open-air museum. One of the most beautiful architectural features of the Ghetto is the **Jewish Town Hall** (*Židovská radnice*), a Renaissance building which dates from the second half of the 16th century. It was remodelled in Baroque style in the latter half of the 18th century, and extended at the beginning of the 20th century. Note the unusual clock situated in the tympanum, under the small clock tower: it has Hebrew figures and the hands move in an anticlockwise direction.

Josefov: view of the Jewish Town Hall.

Josefov: the statue of Moses.

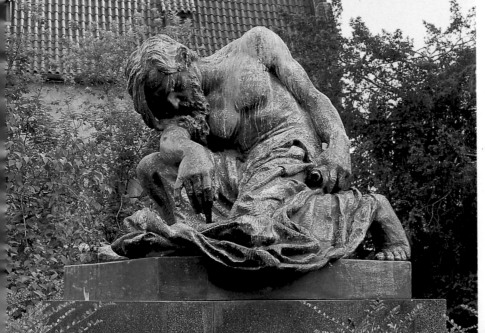

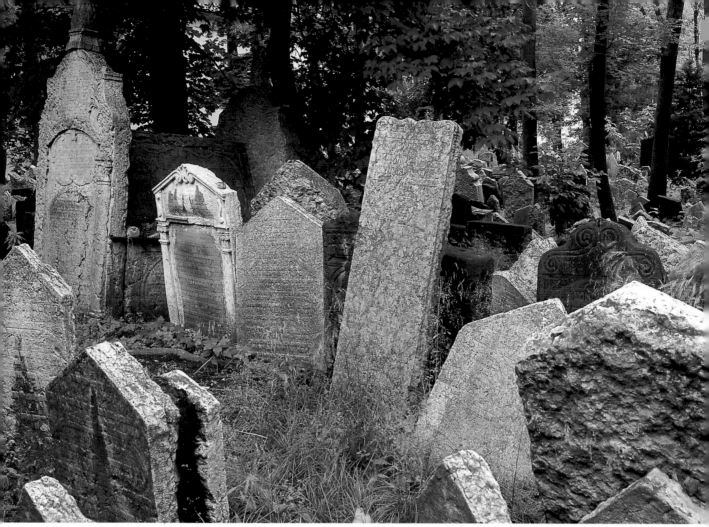

Josefov: the incredible layering of tomb stones characterises the Old Jewish Cemetery.

Josefov: the tomb of Rabbi Löw, one of the most famous and looked for tombs in the Old Jewish Cemetery.

OLD JEWISH CEMETERY
Starý židovský hřbitov

The fact that makes this site so interesting, and one of the most visited places on the tourist trail, is the incredible number of gravestones it holds, about 20,000 of them. Because of the lack of available space, they are all packed tightly together, stone upon stone in a picturesque fashion, giving the place a fascinating atmosphere. It is said that in some parts of the cemetery there are at least nine layers of burials. The Hebrew epigraphs and the reliefs which decorate the tombstones give an interesting insight into the Jewish community of the time, since, apart from the sex and marital status of the deceased, they also record connections with a particular art, trade or social class of any importance, such as that of a priest. The cemetery, which was founded in the first half of the 15th century, continued to be used as such at least until the second half of the 18th century.

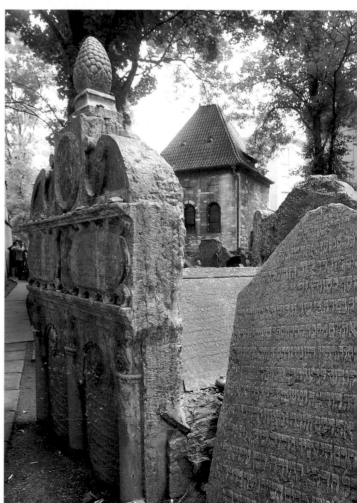

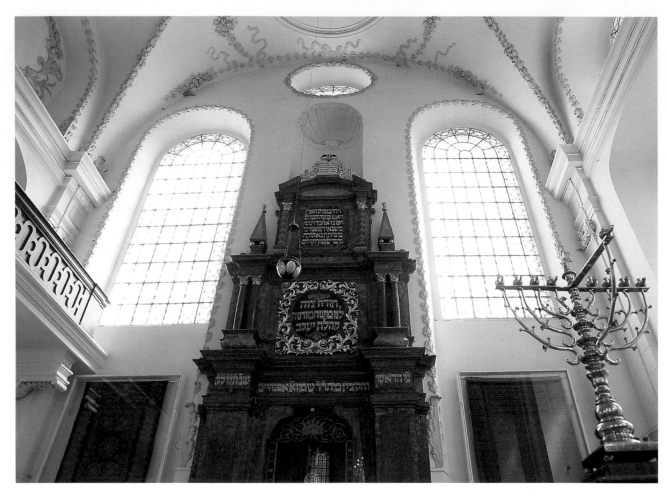

Josefov: detail of the interior of the Klausen Synagogue.

SYNAGOGUES

There are many synagogues in the Jewish quarter. The **High Synagogue** (*Vysoká synagóga*) was built in the second half of the 16th century, to a design by P. Roder. In the 19th century restoration work was carried out to separate it from the Town Hall. The central, square hall, originally Renaissance in style, was transformed in the 17th-19th centuries and remodelled in neo-Renaissance style. Note the magnificent stellar vaulting. The rooms of the synagogue are used for exhibitions by the State Jewish Museum (they contain vestments, manuscripts and precious ornaments).

The 17th century **Klausen Synagogue** (*Klausova synagóga)* is built on the site once occupied by the Jewish School of Löw ben Bezalel, a 16th century Rabbi and philosopher. The Baroque building houses a collection of prints and manuscripts.

The earliest religious building on the site of today's **Pinkas Synagogue** (*Pinkasova synagóga)*, probably a ritual bath, is said to date from the 11th-12th centuries. In the first half of the 16th century a late-Gothic synagogue was constructed in the building which had been the home of Rabbi Pinkas (hence the modern name). This was rebuilt and enlarged in the first half of the 17th century, in late Renaissance style. In the 1950s the synagogue became the seat of the *Memorial of the 77, 297*, a monument erected in memory of the victims of the Holocaust.

The building which today houses the **Spanish Synagogue** (*Španělská synagóga*) bears some striking Moorish features, added in the second half of the 19th century. The temple interior is strongly reminiscent of the Alhambra in Granada. The synagogue owes its name to a community of Iberian Jews who came to Prague to escape persecution. It has been destroyed by fire and rebuilt several times, and occupies the site of the Old School, the oldest synagogue in the city (12th century).

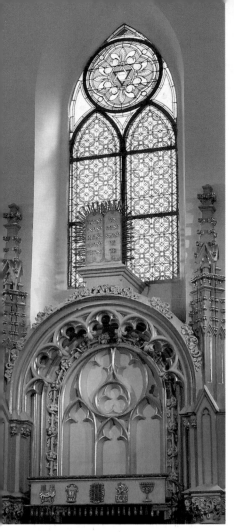

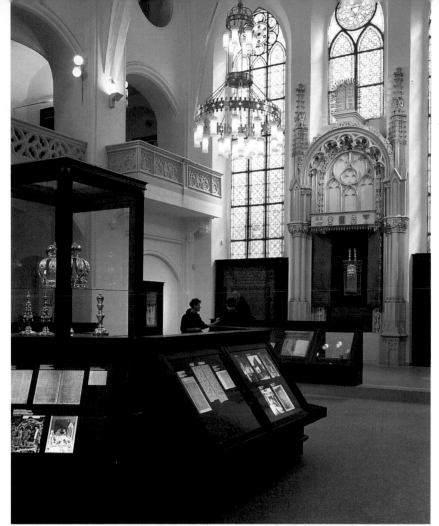

Josefov: various images of the interior of the Maisel Synagogue.

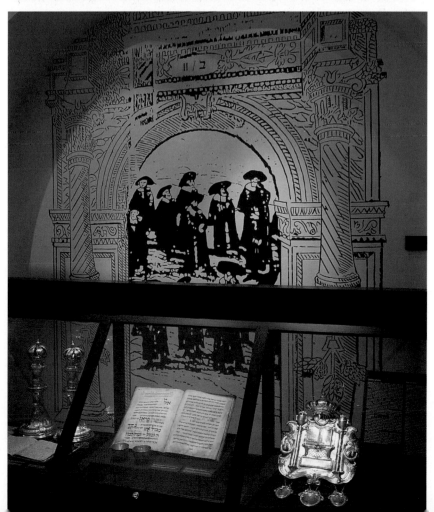

The **Maisel Synagogue** (*Maiselova synagóga*) takes its name from the mayor of the Jewish quarter at the time of Rudolph II. It was built in Renaissance style at the end of the 16th century, and reconstructed in Baroque style about a century later, after a fire. The building as it appears today was restored in neo-Gothic style between the 19th and 20th centuries. The interior houses the splendid exhibition of *Silver from Bohemian Synagogues*, including interesting examples of Baroque and Rococo art by Augsburg, Nuremberg and Viennese craftsmen, as well as decorations and treasures from various eras, collected from synagogues and private homes.

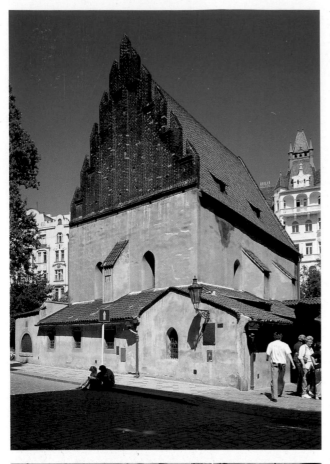

The **Old-New Synagogue** (*Staronová synagóga*), originally Gothic in design, was extended in Cistercian Gothic style in the 13th century. Further modifications and additions were completed between the 15th and 18th centuries. Renovation and restoration work was also carried out in the 19th-20th centuries. The synagogue is still used for religious functions. A *Statue of Moses* by F. Bílek can be seen in the adjoining park.

ST AGNES'S CONVENT
(*Anežský klášter*)

This building, which now houses collections of the National Gallery and the Museum of Applied Art, ranks among the most important historical constructions in the capital. Its building was requested in the first half of the 13th century by Princess Agnes, sister of King Wenceslas I, whose intention it was to provide a seat for the Poor Clares. She subsequently took her vows in the Order of St Clare and became the first Abbess of the new convent. A crescendo of building activity followed, giving rise to the **Minorite Monastery** (1240); the **Church of St Barbara** (14th century, and renewed in Baroque style in the 17th century. The tombs of *King Wenceslas I, St Agnes*, and several Přemyslid sovereigns have been found here); the **Church of St Francis** (mid 13th century) with its Franciscan Monastery; and the **Church of the Holy Saviour** (latter half of the 13th century), an outstanding example of Early Bohemian Gothic. It is said to have been the burial place of the Přemyslids.
Some of the most interesting collections housed in the rebuilt and restored convent complex are the paintings of Bohemian history (19th century) and the works of artistic craftsmanship.

MUSEUM OF APPLIED ART
(*Umělecko-průmyslové muzeum*)

This neo-Renaissance construction, designed by J. Schulz and built between the end of the 19th and the beginning of the 20th century, is situated close to the Old Jewish Cemetery. Some of the most notable exhibits in the museum include furnishings and furniture, goldsmith's work, porcelain, crystal and pottery, textiles, bronzes, measuring instruments and a minter. The Library contains some 14th century parchments.

STATE JEWISH MUSEUM
(*Státní Židovské muzeum*)

The collections which make up the framework of the museum, and which allow us to understand the development of the city's Jewish community and its culture, originate from various synagogues in Bohemia, Moravia, and Europe in general. Despite the fact that the Nazis wanted to make it into the "Exotic museum of an extinct race", the number of exhibits increased considerably precisely during the period of the occupation of Prague.

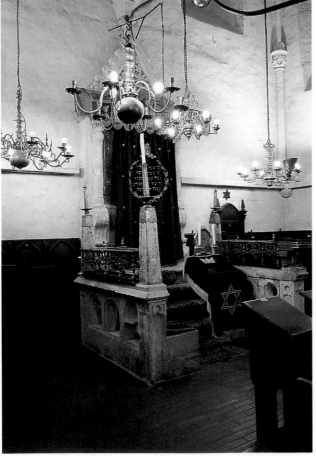

Josefov: view of the Old-New Synagogue and a detail of the interior.

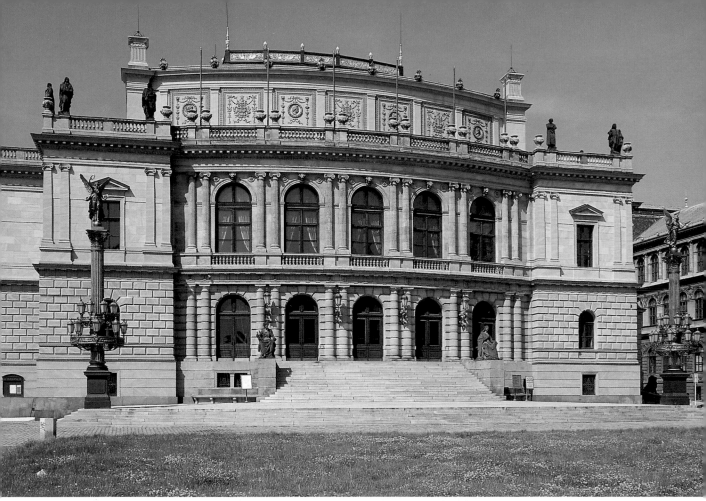

Náměstí Jana Palacha: the huge square is overlooked by the elegant Rudolfinum building, now known as the 'House of Artists'.

This graceful winged figure stands in Náměstí Jana Palacha, elegantly complementing the Rudolfinum.

RUDOLFINUM - HOUSE OF ARTISTS
(Dům umělců)

This grandiose construction, with its elegant architectural forms, stands majestically on the banks of the Vltava and overlooks the square named after *Jan Palach*, the martyr of the "Prague Spring" in 1968. It is also known as the *Rudolfinum*, as it was named in honour of Rudolph of Habsburg. It was built in the second half of the 19th century by J. Zítek and J. Schulz. Once the seat of the Czechoslovak Parliament (1919-1939), it is considered to be one of the most outstanding examples of neo-Renaissance architecture in Prague. An allegory dedicated to Wagner adorns the main entrance, while the balustrade is decorated with statues of illustrious artists and musicians. Of particular interest inside the building is the sumptuously decorated *Dvořák Hall*. Close to the river is the *Statue of Josef Mánes*, by B. Kafka (1951). The nearby *Mánesův most* is also named after this Czech artist.

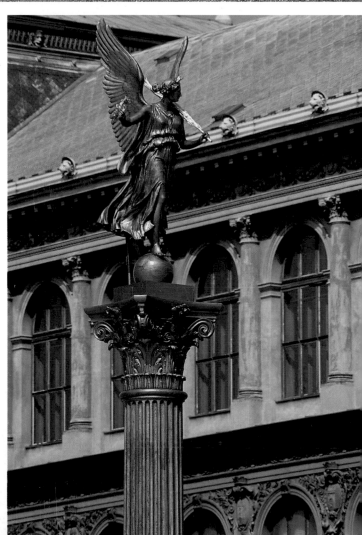

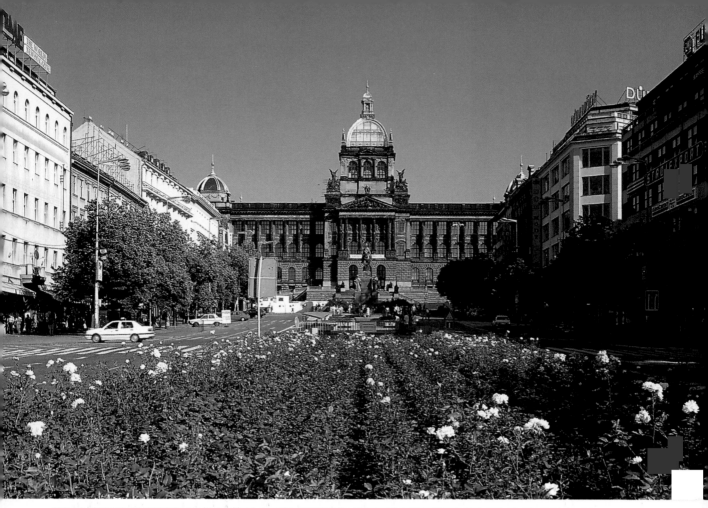

NEW TOWN - NOVÉ MĚSTO

NA PŘÍKOPĚ

Situated at the heart of the *Golden Cross*, this street is Prague's lively commercial centre, full of shops, banks, restaurants and office blocks. Its Czech name means "by the moat" (in fact, *Na příkopě* lies along the path of a moat which divided Staré Město - the "Old Town" - from Nové Město - the "New Town"); a stream once flowed in its bed. At n° 4 is the 19th century building which houses **Dům elegance**, the oldest department store in the Capital. At n° 10 is the **Sylva-Taroucca Palace**, a splendid example of Bohemian Baroque architecture. Also worthy of note are the **Casa Slava**, originally Baroque in design (17th-18th centuries) and renovated in neo-classical style at the end of the 19th century, and the **State Bank Building** at n° 24, erected in the late 1930s. Previously on this site stood some famous hotels where illustrious figures of the 19th century used to stay.

WENCESLAS SQUARE (*Václavské náměstí*)

The impressive *Wenceslas Square* is situated in the heart of the city. Its dimensions (750 x 60m) make it look more like a Parisian *Boulevard* than a square. It is a lively conglomeration of well-known hotels (like the "Evropa" at n° 25, a treasure of Art Nouveau architecture), restaurants and cafés, galleries, shops, cinemas and clubs, which together with *Na příkopě*, *Na Můstku* and *28.října* forms the group of main thoroughfares known as the *Golden Cross*. This is the commercial heart of the Czech metropolis, redeveloped in the 1980s to include wide green spaces, following the building of the underground system. In the square, opposite the National Museum, stands the *St Wenceslas Monument,* the work of J. V. Myslbek (1912-1913). The patron saint of Bohemia is represented on horseback, surrounded by the statues of *St Ludmila, St Procopius, St Adalbert* and *St Agnes of Prague*. The square was originally founded as a horse market by Charles IV, at the same time as Nové Město; it was given its present name towards the middle of the 19th century. Wenceslas Square also represents the moral and historical conscience of the newly-formed Czech Republic. In the early months of 1969 it was the scene of dramatic events following the military occupation by troops of the Warsaw Pact (August 1968). On 16th January the Philosophy student Jan Palach burnt himself to death at the foot of the St Wenceslas Monument, and a few weeks later the student Jan Zajíc committed suicide in the same square. Nineteen years later, on the 28th October 1988, the Communist police forcefully dispersed a demonstration commemorating the proclamation of the First Republic. Again in 1989 there were further incidents of brutality against demonstrators commemorating the sacrifice of Palach. These events led inevitably to the "Velvet Revolution" which, within a few months, gave back to Czechoslovakia the dignity of a free country.

This simple bare monument commemorates the victims of communism.

Wenceslas Square: view towards the National Museum.

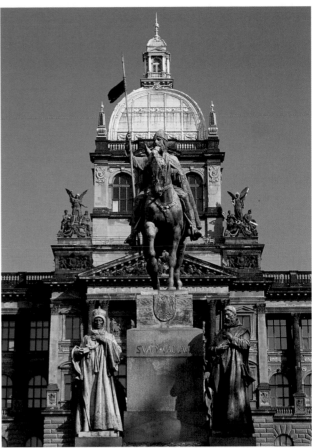

The Equestrian Monument to the patron saint of Bohemia stands in front of the National Museum, surrounded by the statues of St Ludmila, St Procopius, St Adalbert and St Agnes of Prague.

The elegant crowning part of the Grand Hotel Evropa, one of the most representative Art Nouveau buildings in the capital.

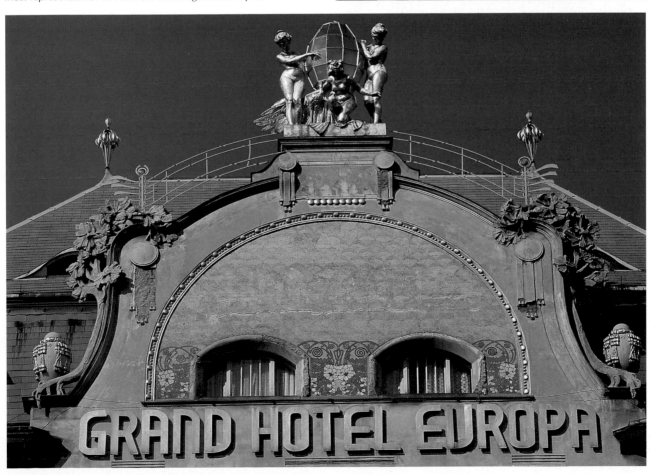

97

NATIONAL MUSEUM (*Národní muzeum*)

This imposing neo-Renaissance building, which stands the full width of the southern end of *Václavské náměstí*, was built in the second half of the 19th century to a design by J. Schulz. It houses the main seat of the National Museum, with the **Museum of History and Natural History**, and the rooms used to house the **Library** (which numbers more than 1.3 million volumes and 8000 manuscripts). The domed **Pantheon** contains various busts and statues representing important figures from Czech culture. The Mineralogy, Botany, and Zoology collections are displayed in the side wings. The Historical and Archaeological sections contain some interesting coins, medals and theatrical exhibits. The National Museum also incorporates sections of the museums dedicated to *Ethnography*, *Musical Instruments*, *Náprstek* and *Physical Culture and Sport*. These are all housed in separate buildings.

National Museum: Celtic sculpture of the 2nd-1st century BC, from Mseke Zemrovice (Bohemia).

National Museum: votive bronzes from the Hallstatt culture (6th century BC), from Hradec Králové (Bohemia).

National Museum: small Celtic votive bronze (1st century BC), from Stradonice.

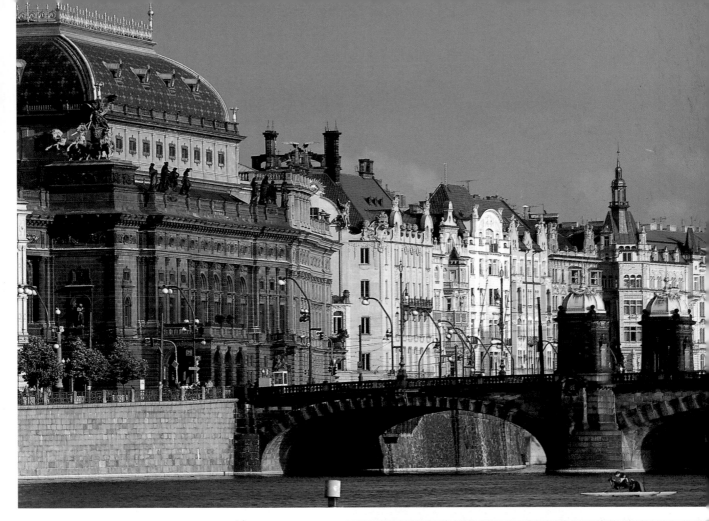

The National Theatre from the Vltava.

National Theatre: detail of the attic storey with the
'Gods of Victory'.

National Theatre from the Most Legií.

NATIONAL THEATRE (*Národní divadlo*)

This beautiful building, with its neo-Renaissance ar-
chitectural features, stands on the right bank of the
Vltava. It was erected in the second half of the 19th
century to a design by J. Zítek. A short time after the
staging of the very first performance the theatre was
destroyed by fire and rebuilt in record time by J.
Schulz, a follower of Zítek's. Careful restoration work
was carried out between 1976 and 1983. The mod-
ern complex called the **New Stage** was added in
1983; this also includes the **Laterna Magica Theatre**.
The northern **façade** is adorned with *Statues of Záboj
and Lumír*, the work of artists from the workshop of
A. Wagner. Two groups of statues adorn the attic
storey, *Apollo and the Muses*, and *Goddesses of
Victory*, both by B. Schnirch. *Allegories of Opera and
Drama* attributed to J. V. Myslbek stand above the
side entrance, and the same artist also created the
busts of illustrious figures. The **interior** of the
National Theatre is richly decorated with paintings.
The ceiling of the auditorium bears eight *Allegories
representing the Arts* by F. Ženíšek who also painted
the *Golden Age, Decline and Revival of Art*, which
decorates the lobby on the first balcony.

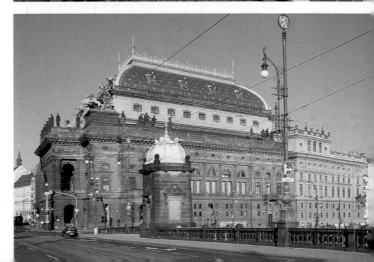

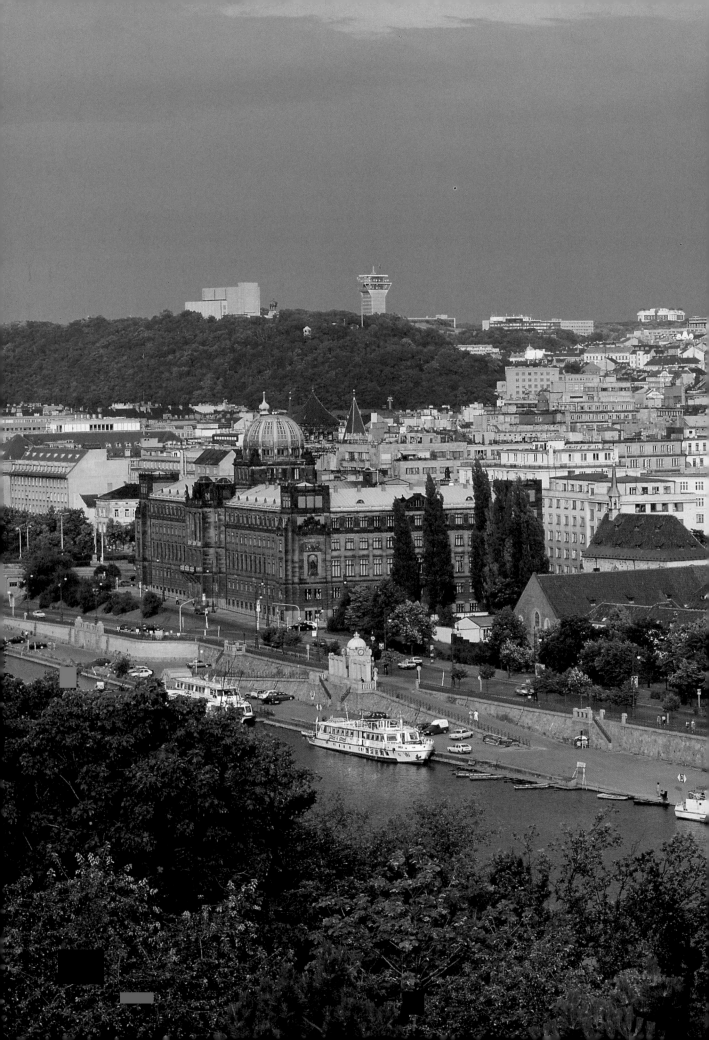

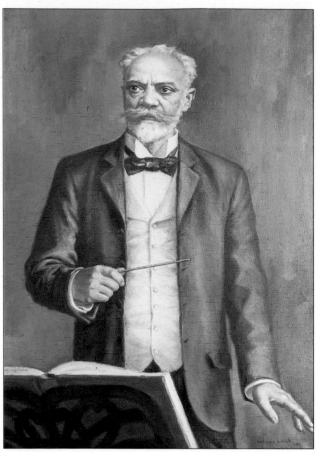

DVOŘÁK MUSEUM - VILLA AMERICA
(Letohrádek Amerika)

Housed in the splendid setting of the Villa America, the Dvořák Museum contains music scores, documents and correspondence belonging to the Czech composer Antonín Dvořák (1814-1904). It is easy to see why the building is considered a treasure of Prague Baroque architecture. It was designed by K. I. Dientzenhofer for Count Michna who made it his magnificent summer residence. The villa, which dates from the first half of the 18th century, is also known as *Villa Michna* and is distinguished by its fine Baroque entrance-gate (a copy), its 18th century frescoes by J. F. Schor, and its statues of the same era situated in the garden, from the A. Braun workshop.

On the previous pages: panorama over Prague, taking in Vítkov hill, with the National Monument of Žižkov (on the left), and the unmistakable outline of the Television Tower (on the right).

Dvořák Museum: portrait of the composer conducting an orchestra.

Dvořák Museum: the birthplace of the Czech composer (water-colour).

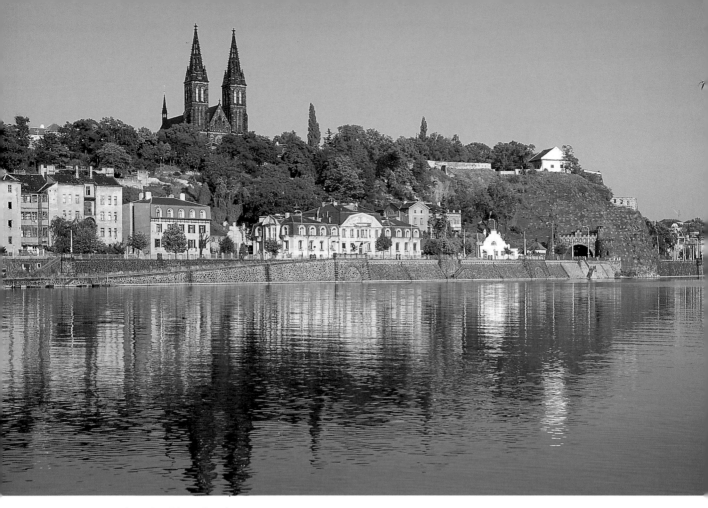

An enchanting view of Vyšehrad from the Vltava.

VYŠEHRAD

The meaning of Vyšehrad is "castle on the heights", and the hill where it is situated is said to have been the seat of the first Přemyslid princes. It was almost certainly founded in the 10th century as a rival to Hradčany Castle. From the 11th century onwards it became more and more important as sovereigns established themselves here, and the building was expanded. It went into a period of decline around the mid-12th century, and was fortified two centuries later. The settlement suffered greatly during The Hussite Wars (15th century). By the beginning of the 17th century the area had taken on the appearance of a Baroque fortress. After its destruction in 1911, Vyšehrad is today undergoing careful restoration work.

CHURCH OF ST PETER AND ST PAUL
(*Kostel svatého Petra a Pavla*)

This church, situated on the heights of Vyšehrad, is a striking feature on Prague's skyline. Its twin spires dominate the houses which overlook the right bank of the Vltava, making it one of the symbols of this quarter of the capital. The first place of worship on this site was built in the latter half of the 11th century. During the reign of Charles IV the church was rebuilt to become a three-naved basilica in distinctly Gothic style. It was subsequently remodelled in Renaissance style in the 16th century, and again in Baroque style in the 18th century. However, the church today offers the neo-Gothic appearance it assumed in the latter

103

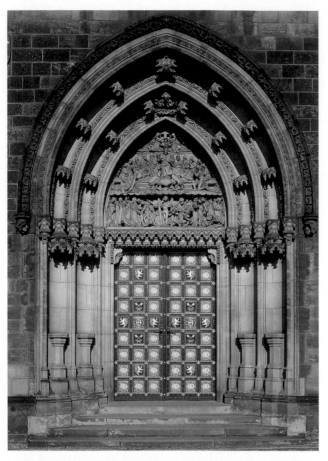

half of the 19th century. Further restoration work was carried out between 1981 and 1987, at the same time as some archaeological excavations. The **façade** of the church is wedged between two soaring spires, erected in the early 20th century and jointly designed by J. Mocker and F. Mikš. The neo-Gothic appearance of the façade is reinforced by its triangular tympanum decorated with sculptures. The lunettes of the magnificent, deeply splayed portals are decorated with mosaics (side portals), and with high relief work (central portal). Note the doors themselves enriched with coats of arms and precious gold-leaf work. The **interior** contains some notable frescoes with stylised motives, dating from the early 1900s. The church's charm is enhanced by the beauty of the decorations and paintings which completely cover the naves and the ceiling (which is formed of ribbed cross-vaulting). Pillars supporting ogival arches separate the three naves. Above the side altars, themselves enriched

Vyšehrad: Church of St Peter and St Paul, the splendid neo-Gothic portal and two details of the artistic doors, adorned with Bohemian decorations and coats of arms.

Vyšehrad: view of the Cemetery.

Vyšehrad: the beautiful St Martin's Rotunda, considered to be the oldest example of Romanic architecture in the city (11th century, rebuilt in the 19th century).

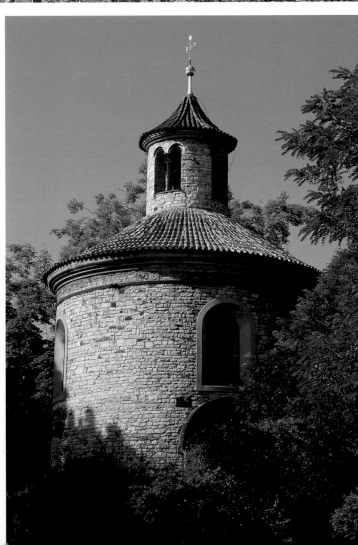

with various works in wood (altar frontals, sculptures, triptychs), there are some finely illustrated windows. The high altar, by J. Mocker, is decorated with four statues by F. Hrubes (late 19th century); these represent *St Peter and St Paul, St Cyril and St Methodius.* Note also, in the first chapel on the right, the *Tomb of St Longinus,* an 11th century Romanesque stone sarcophagus, and in the third chapel on the right the 14th century panel painting of *Our Lady of the Rains.* Observe the fine wooden pulpit and the beautiful choir made of the same material.

CEMETERY
(*Vyšehradský hřbitov*)

Originally a medieval cemetery adjoining the Church of St Peter and St Paul, it was transformed into a memorial of Czech art and culture in the latter half of the 19th century. The famous figures buried here include the painter M. Aleš, the writers K. Čapek, B. Němcová and J. Neruda, and the composers A. Dvořák and B. Smetana. The *Slavín Chapel* contains the sculptors B. Kafka, J. V. Myslbek and L. Šaloun.

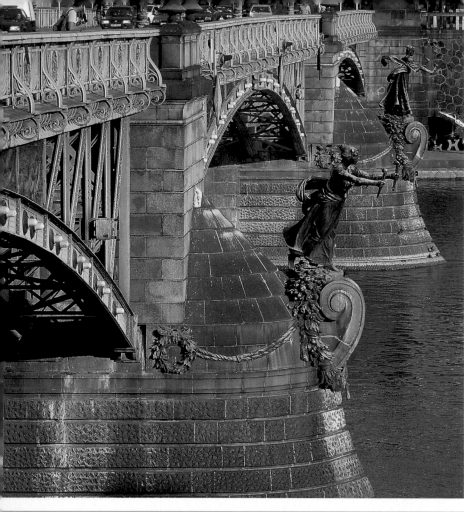

A perspective of the River Vltava with its various bridges: the second is the famous Charles Bridge.

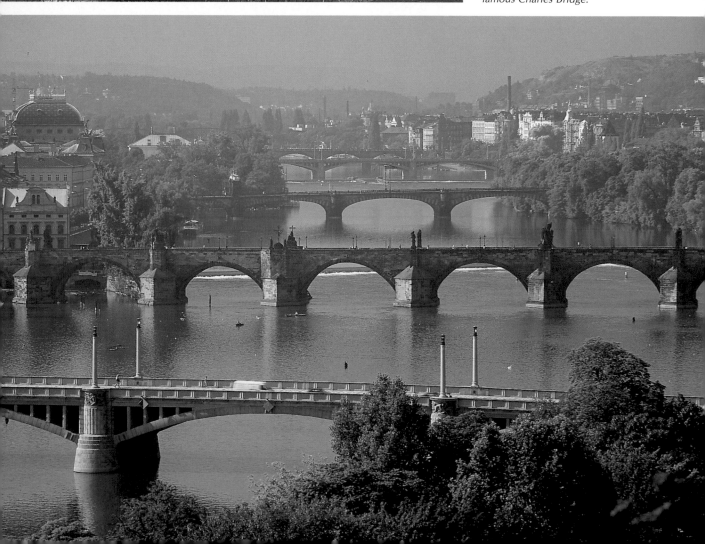

The Vltava from 'Legií' bridge.

The 17th century Villa Bertramka, the prestigious setting for the Mozart Museum.

VILLA BERTRAMKA (*Bertramka*)

The villa dates from the 17th century and has had various owners. In the second half of the 18th century it belonged to the Dušeks, with whom W. A. Mozart often stayed, composing and attending some of the debut performances of his works. This Prague residence of Mozart's is situated at the foot of a wooded hill with a magnificent park behind it.

MOZART MUSEUM

Named after the great Salzburg composer, the museum was founded around the middle of the 19th century by the Popelkas, father and son. It is arranged on the first floor of the Villa Bertramka and was opened in 1956. Along with the Smetana and Dvořák museums, it forms the *National Museum's Independent Section of Musicology.*
Note the *Bust of Mozart* by T. Seidan set in the villa's gardens. Of particular interest, besides the composer's study and bedroom, are some of the music scores, letters and historic concert posters. Concerts are held in the villa.

PETŘÍN

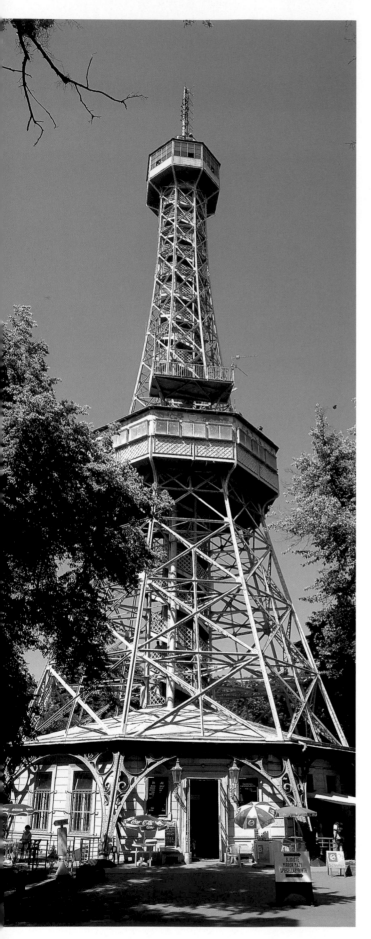

PETRIN OBSERVATION TOWER
(Petřínská rozhledna)

The fact that Prague is often defined as the "Paris of the East" by travel publications is only partly due to the pleasant nature of its monuments and localities; the term also derives from this iron tower which was built for the Prague Industrial Exhibition in 1891 as an imitation of the Parisian Eiffel Tower. It is 60m tall and now used as a television tower. Unlike its French counterpart, the climb to the top has to be made on foot (299 steps), but the view is well worth the effort: on a clear day the "Golden City", its hills and the surrounding areas are all visible.

MIRROR MAZE (Bludiště)

The maze is housed in an attractive pavilion which also contains a wooden model of the Charles Gate, and a diorama of *The Defence of Prague against the Swedes in 1648*. The painting is by A. Liebscher and V. Bartoněk (end of 19th century). The Mirror Maze was built at the same time as the Observation Tower and is one of Petřín hill's attractions.

OBSERVATORY
(Hvězdárna)

The observatory houses the Czech Academy of Science's Astronomical Institute. Part of the building was opened to the public for the first time in 1928. Guided tours and astronomical events are organised for those interested in this subject. The collection of telescopes used for observations ranges from the modern instrument to models now obsolete.

CHURCH OF ST LAWRENCE
(Kostel svatého Vavřince)

The present Baroque appearance of this place of worship dates back to the 18th century when an earlier Romanesque building, first recorded in the mid-12th century, was reconstructed by I. Palliardi. The **façade** is enriched with a 19th century *Statue of St Adalbert*, the work of F. Dvořáček. Inside the church note the late 17th century painting above the high altar showing *The Torment of St Adalbert*, by J. C. Monnos. The Sacristy ceiling is decorated with an 18th century fresco illustrating *The Legend of the Foundation of the Church of St Adalbert*.

On Petřín Hill stands this panoramic tower, a smaller version of the famous Eiffel Tower.

The Church of St Lawrence from Petřín Observation Tower.

On the following pages: the extraordinary panorama of the 'Golden City' from Petřín Observation Tower.

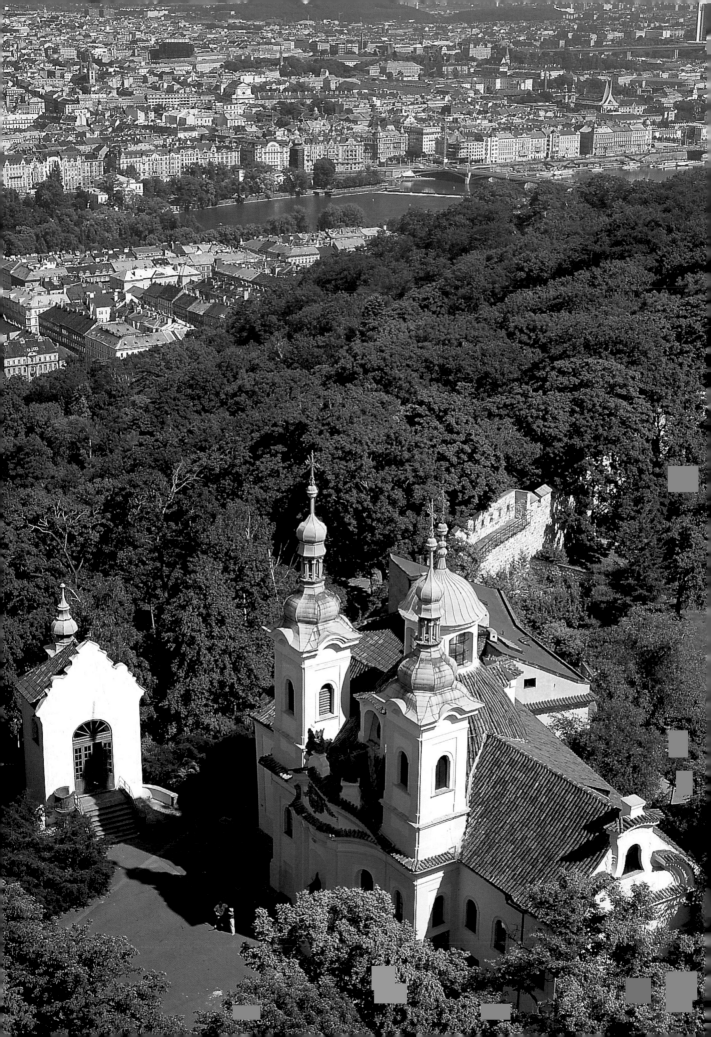

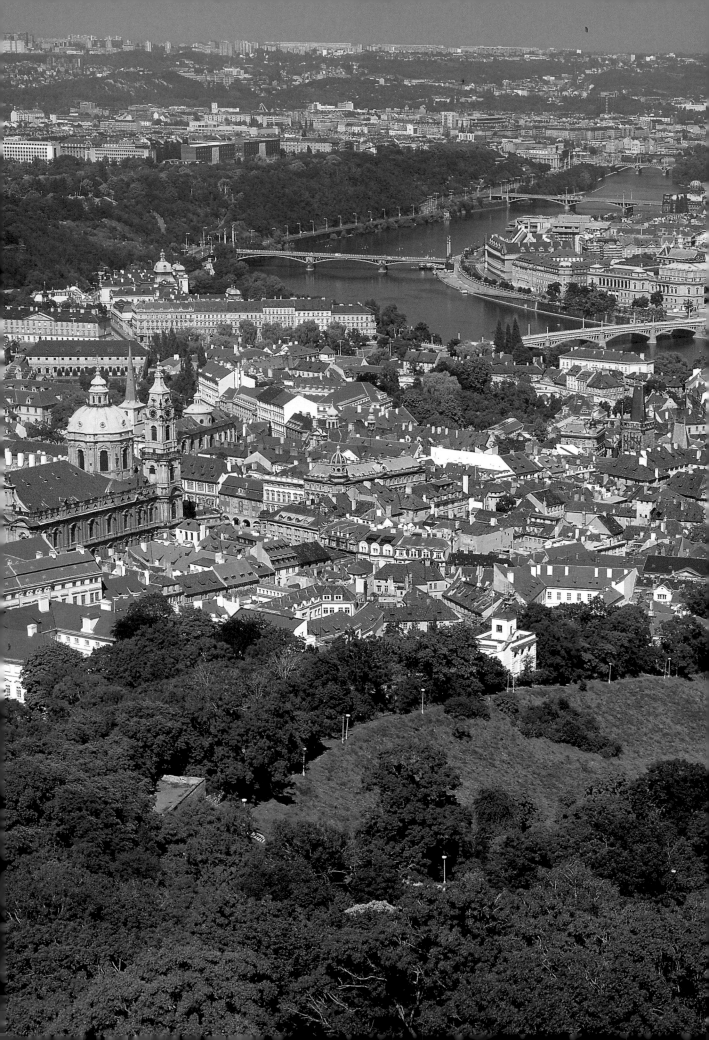

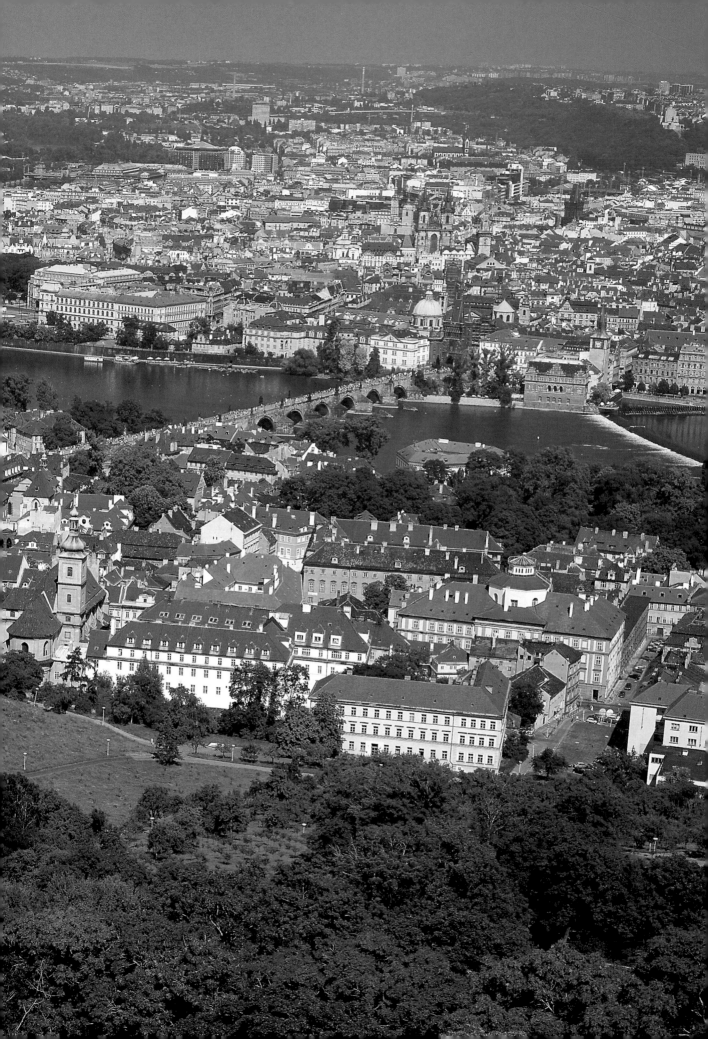

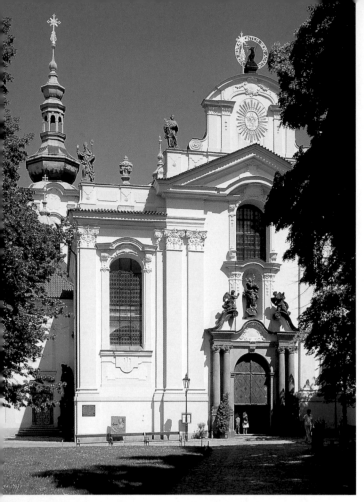

STRAHOV MONASTERY
Strahovský klášter

This building, founded by the Premonstratensians, dates from the 12th century when it was built under the patronage of Duke Vladislav II and the Bishop of Olomouc. In 1258 it was destroyed by fire and rebuilt in Gothic style. In the second half of the 14th century, Charles IV had the building included within the walls of Prague. It was considerably extended and embellished during the Renaissance period, but destroyed by the Swedes at the end of the Thirty Years' War. The architect J. B. Mathey remodelled the monastery complex in Baroque style in the second half of the 17th century. Damaged once again by the events of war (1741), it rose to its former splendour in the neo-classical period. In the early 1950s restoration work brought to light the remains of the Romanesque foundations. In the courtyard there is a Baroque gateway, above which stands the *Statue of St Norbert,* the founder of the Premonstratensians. Rudolph II had the former Chapel of St Roch built in the first half of the 17th century; today it is used for exhibitions. Behind the 17th century *Column of St Norbert* lies the **Church of Our Lady**, also dating

Strahov Monastery: façade of the Church of Our Lady and a view of its interior.

Strahov Monastery: two images of the Theological Hall with its precious stucco-work and frescoes.

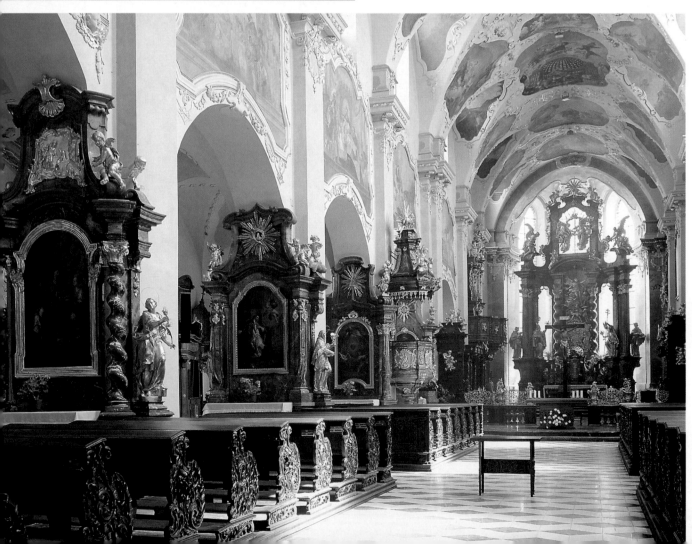

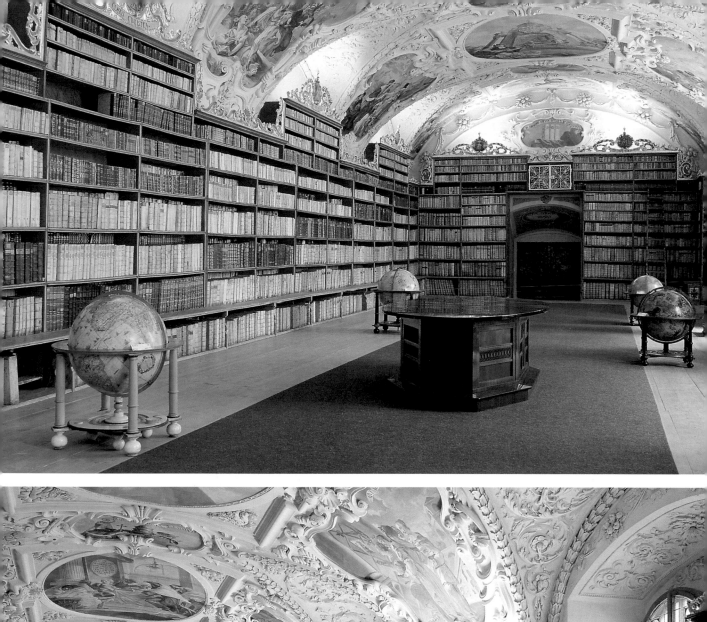

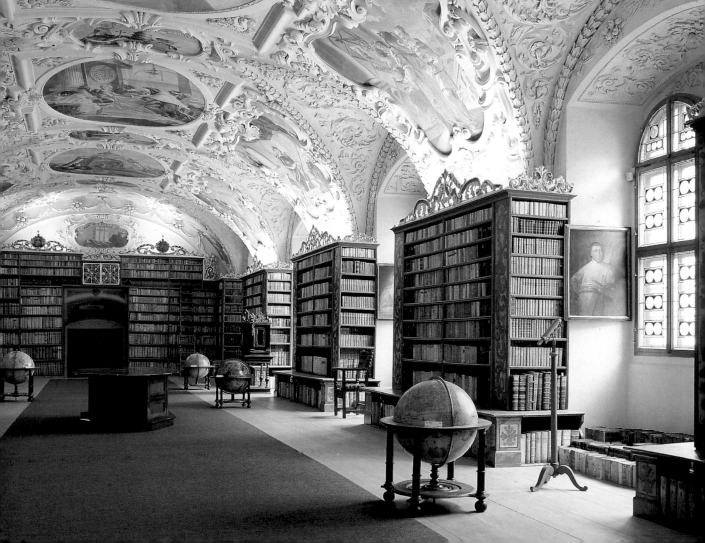

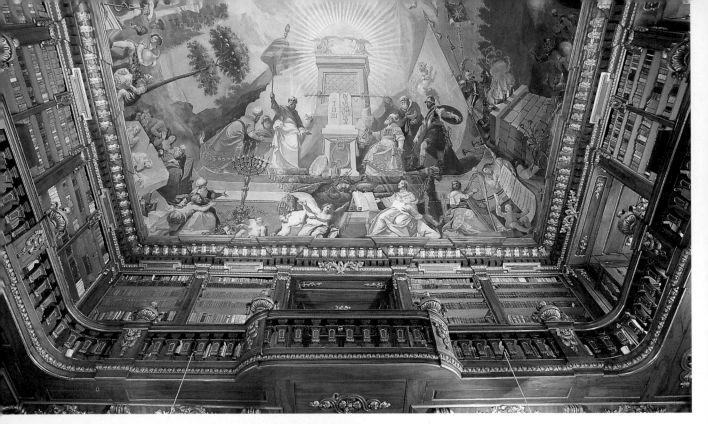

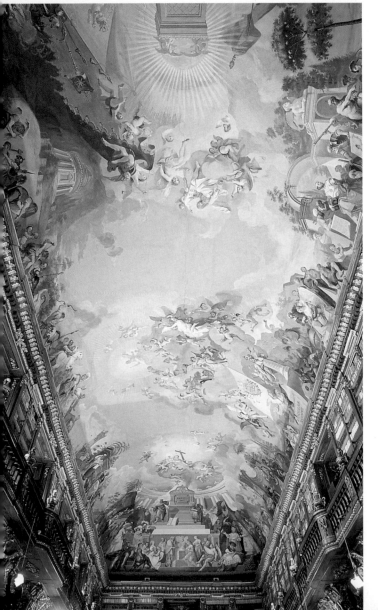

Strahov Monastery: detail of the ceiling painting in the Philosophical Hall.

Strahov Monastery: global image of the Philosophical Hall ceiling.

Strahov Monastery: the grandeur of the Philosophical Hall.

from the 17th century. Above the harmonious Baroque **façade** stands a *Lamb*, surrounded by the golden epigraph *Vidi supra Montem Sion Agnum*. The **interior** is divided into three naves and is richly decorated in Baroque style; it contains some fine furnishings (scrolls in stuccowork with images of the Virgin Mary). Next to the church is the part of the monastery which houses the **Museum of National Literature** (*Památník národního písemnictví*). The monastery's Historical Library, now once again in the possession of the monks (1992), contains 130,000 volumes, 5000 manuscripts, 2500 incunabula and a large quantity of old maps. It also houses examples of Czech literature from the 9th to the 18th centuries. The Library's *Theological Hall* is of particular interest for its fine stuccowork and its 18th century paintings. The barrel vaulting, clearly Baroque in style, is the work of G. D. Orsi of Orsini. The cycle of 25 frescoes by S. Nosecký, the Strahov monk, is a masterpiece in itself. The *Philosophical Hall* is of remarkable dimensions, corresponding to the size of the bookcases which it holds. The large ceiling fresco was painted in the 18th century by F. A. Maulpertsch. Also on display in the hall is a *Bust of Francis I,* made in marble by F. X. Lederer in the 19th century. The most notable items in the library, those which constitute its wealth, are the valuable *Strahov Gospel Book* (9th-10th century), the *Historia Anglorum*, the *Schelmenberg Bible,* and the *Strahov Herbarium*.

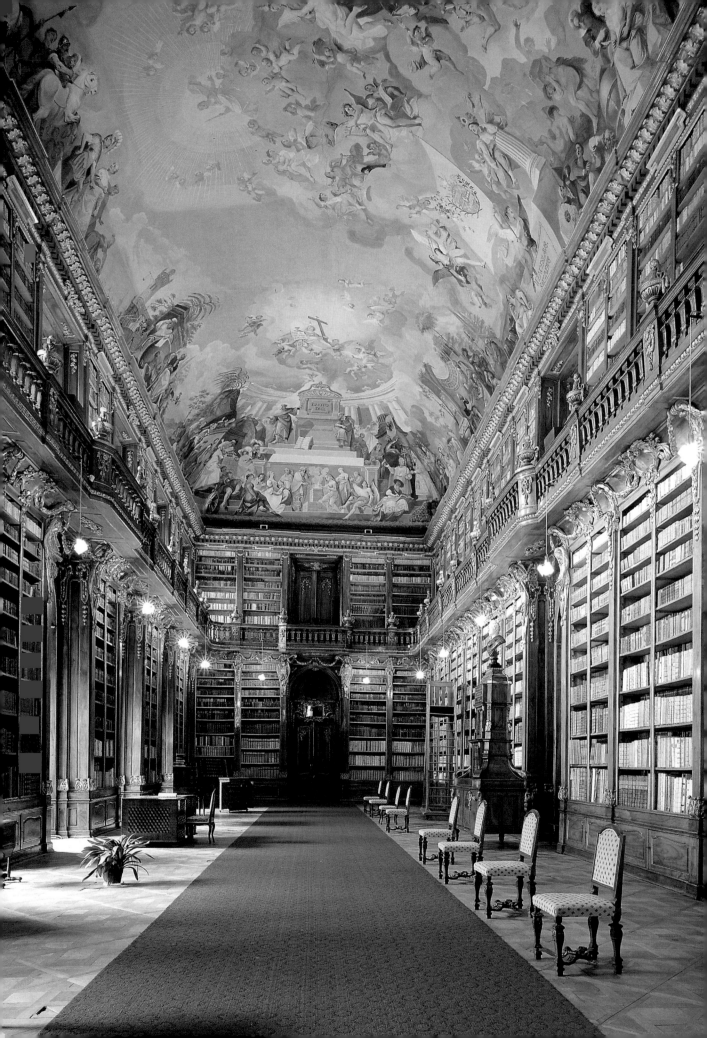

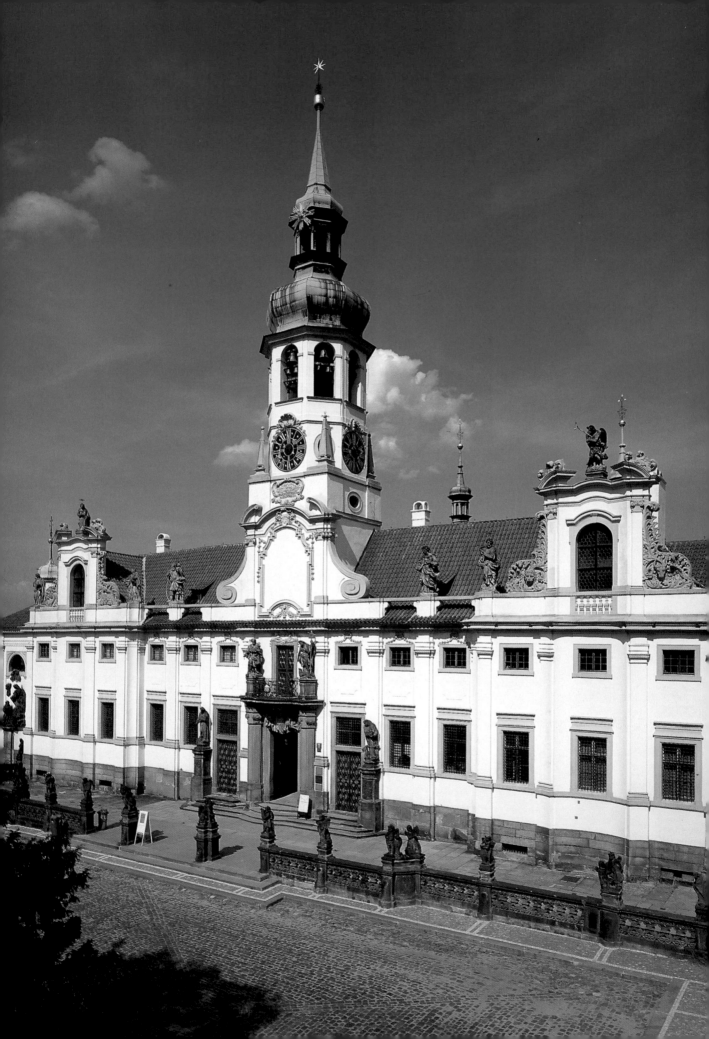

HRADČANY

THE LORETO
Loreta

The origins of this sanctuary, which ranks as one of the most visited religious destinations and places of pilgrimage in the whole of Bohemia, date back to the 18th century, although the legend which tells of the transportation of the Santa Casa from Nazareth to Loreto is much older (13th century). Following the Counter-Reformation, a great number of sanctuaries modelled on the one in Loreto were built, in order to promote Catholicism in the previously Protestant areas. The **façade** of the sanctuary was begun after 1721 by the Dientzenhofers, who had been commissioned by the Prince of Lobkowitz and his wife Eleanor Caroline. The main entrance is distinguished by the statues of *Saints* and the marble coats of arms which stand above it, all by F. Kohl. The Baroque bell tower houses a set of 27 bells (1694) which ring out

Complete view of the Loreto.

The Loreto: detail of the bell tower.

The Loreto: two details of the façade, enriched with numerous sculptures.

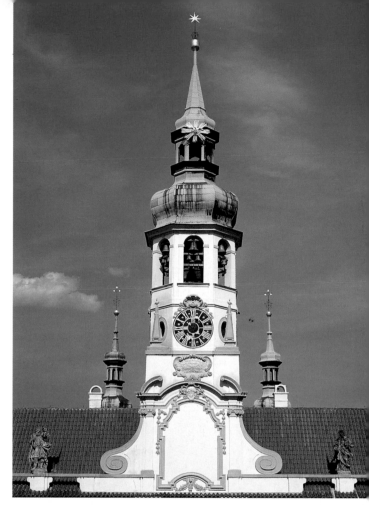

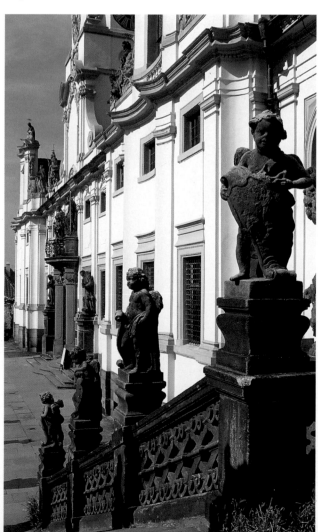

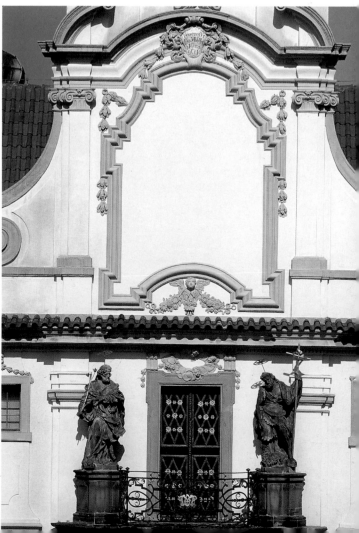

in honour of the Virgin every hour. The **Santa Casa Chapel** was completed in the first half of the 17th century by G. B. Orsi from Como. It is found in the Cloisters, surrounded by porticoes and decorated with two fountains. The external decorations are either inspired by *Episodes from the Life of the Virgin Mary,* the *Legend of the Santa Casa,* or represent *Prophets from the Old Testament* and *Pagan Sibyls.* The **interior** of the chapel, which is beautifully painted by the 17th century Malá Strana artist, F. Kunz, contains an ornate silver altar, a wooden *Madonna,* and various silver decorations weighing a total of over 50kg. The atmosphere inside is tranquil and enchanting; a splendid iconostasis stands before the image of the Virgin Mary. On either side of the Santa Casa are two 18th century fountains representing the *Assumption* and the *Resurrection.* The **Cloister** dates from the first half of the 17th century and is adorned with 18th century frescoes by F. A. Scheffler. The chapels which surround the cloister are rich with frescoes, paintings and sculptures, and they are distinguished by wooden confessionals and altar frontals of excellent craftsmanship. The construction of the **Church of the Nativity,** situated on the eastern side of the Loreto, halfway along the cloister, was begun by the Dientzenhofer father and son team in 1717, and

Hradčanské náměstí: a charming scene of the spacious square from the side overlooked by Prague Castle.

Hradčanské náměstí: buildings of notable architectural value overlooking the square.

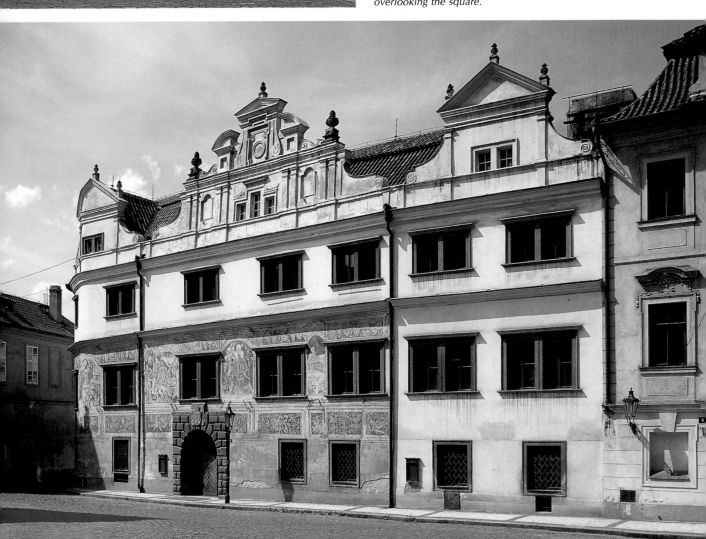

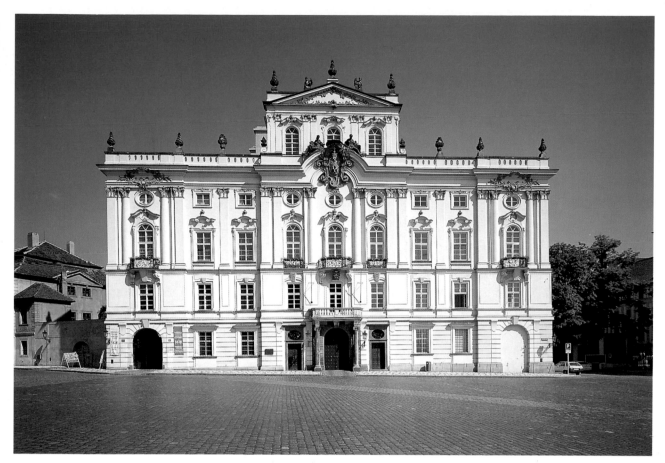

Hradčanské náměstí: the elegant architectural lines of the Archbishop's Palace further enrich the Castle square.

completed by G. Aichbauer in 1735. The **interior** is a genuine triumph of Baroque, with its incredible wealth of decorations including sculptures, wooden inlay work, gold-leafed stuccowork, painted vaulting, angels and *putti,* and multi-coloured marble.

The high altar is adorned with an altar-piece by J. G. Heintsch (*Nativity*), and there are numerous frescoes including *Christ in the Temple,* on the ceiling, (V. V. Reiner, 18th century) and *Adoration of the shepherds, Adoration of the Magi* (J. A. Schöpf, 18th century). It is also worth visiting the interesting *Treasury*, situated in the upper passage of the cloister. It contains liturgical items, chasubles and some valuable 16th-18th century monstrances, including several exquisite examples, decorated with pearls, diamonds and other precious stones. Some of these priceless jewels were made in Vienna by J. Künischbauer and M. Stegner, jewellers to the Habsburg Court.

CAPUCHIN MONASTERY (*Kapucínský klášter*)

This building with its plain features extends along the northern side of the *Loretánské náměstí.* It was built at the beginning of the 17th century and was the first Capuchin monastery in Bohemia. An overhead covered passage connects it to the Loreto Sanctuary. Nearby is the simple **Church of the Madonna** which contains a cycle of Gothic panel-paintings.

HRADČANSKÉ NÁMĚSTÍ

This charming square, given a certain dignity by the Baroque buildings which overlook it, has always formed the entrance to the Castle. It is adorned with the 18th century *Plague Column* (F. M. Brokoff). The surrounding buildings are the result of the reconstruction work carried out after the fire of 1541.

ARCHBISHOP'S PALACE
(*Arcibiskupský palác*)

The original building was a Renaissance residence which was then transformed in the second half of the 16th century, extended around 1600 and converted to Baroque style in the second half of the 17th century. In the same period the architect J. B. Mathey, who had designed the Baroque transformations, completed the splendid main portal. In the second half of the 18th century J. J. Wirch gave the palace's **façade** its present day Rococo appearance. Above the coat of arms of the Prince-Archbishop A. P. Příchovský there is a group of sculpted figures by I. F. Platzer. The exquisite interior furnishings in late-Baroque style are also the work of Wirch. Note in particular the nine gobelins, the wood carvings, the stucco decorations and the collections of porcelain and crystal. Ferdinand I bought the palace in 1562 for the Archbishop who had just returned to Prague at the end of the Hussite wars. It is still the Bishop's See today.

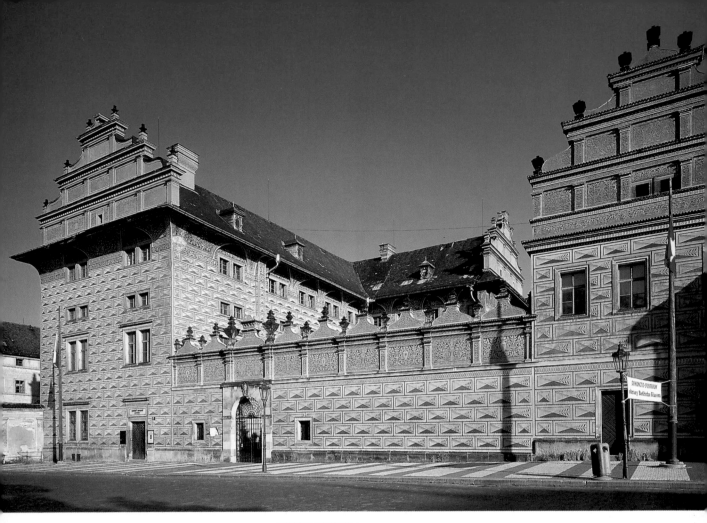

Hradčanské náměstí: the sgraffiti-decorated façade of Schwarzenberg Palace, giving the illusion of diamond-pointed rustication work.

The courtyard of Schwarzenberg Palace.

SCHWARZENBERG PALACE - MUSEUM OF MILITARY HISTORY
(*Schwarzenberský palác - Vojenské muzeum*)

The building as it is today is in fine Renaissance style, clearly imitating northern Italian prototypes. Its designer, the Italian architect A. Galli, commissioned by the Lobkowitz family, carried out the work between 1545 and 1576. Observe how the external decoration, made with the *sgraffito* technique, looks exactly as if the masonry is clad in projecting pyramid shaped stones. The beautiful exterior decoration dates from the 16th century but was renovated between the 19th and 20th centuries. The Museum of Military History collections have been housed in the 16th century wing of the palace since 1945 and are enclosed in rooms of elaborate decoration. They include prehistoric weapons, arms supplied to the various European armies up until 1918, cannons, uniforms, medals, flags, military maps and plans of famous battles.

THE NATIONAL GALLERY COLLECTION OF EUROPEAN ART
(*Sbírka evropského umění Národní galerie*)

Since 1949 this collection has been on show in the Baroque **Sternberg Palace** (17th-18th centuries) and includes works by Italian, German, Dutch, French and other European artists. The palace takes its name from Franz Josef Sternberg who founded the "Society of Patriotic Friends of the Arts" in 1796. The works of art made available by its members gradually increased in number and, before the Second World War, the collection became the property of the State. Paintings by 14th and 15th century Italian artists are displayed on the first floor, including Sebastiano del Piombo, Antonio Vivarini, Palma the Elder, and Piero della Francesca. We then find 15th and 16th century Dutch artists such as P. Brueghel the Elder (*Haymaking*); P. Brueghel the Younger (*Winter Landscape*); G. tot Sint Jans; J. Gossaert (*St Luke Drawing the Virgin*). On the second floor are paintings by 16th - 18th century Italian artists such as Canaletto (*View of London*); Veronese, Palma the

Portrait of Frederik III (L. Cranach, 1532).

Landscape with peasants (P. Brueghel).

121

Portrait of Ambrogio Spinola (P. P. Rubens, 1627).

Portrait of Lawyer (Rembrandt, 1634).

Younger, Tintoretto (*David with Goliath's Head*); Tiepolo (*Portrait of Venetian Patrician*). Other noteworthy Italian painters of the same period are G. Reni and Agnolo di Cosimo, known as "Il Bronzino". Next come the artists from the German school, most importantly A. Dürer (*The Feast of the Rosary*). Others worthy of note are H. Holbein the Elder, H. Baldung Grien, L. Cranach the Elder (*Adam and Eve*), and Altdorfer. The most outstanding among the Flemish and Dutch 17th century artists are P. P. Rubens (*Cleopatra, St Augustine, Martyrdom of St Thomas*); A. van Dyck (*Abraham and Isaac*); F. Hals (*Portrait of Gaspar Schode*); J. Jordaens (*Apostles*); Rembrandt (*Rabbì*). Spanish 16th century painting is represented by a canvas by El Greco (D. Theotokópulos) depicting the *Head of Christ*. Two floors of the northern and western wings house the works of the 19th and 20th century Masters: G. Klimt, O. Kokoschka (noted for his views of Prague, including the famous *Charles Bridge and Hradčany*), C. D. Friedrich, R. Guttuso, G. Manzù, Delacroix, Courbet, Monet, Cézanne, Gauguin, Renoir, Van Gogh, Toulouse-Lautrec, Matisse, Picasso and Chagall.

The Blue and Red Promethean (F. Kupka, 1908).

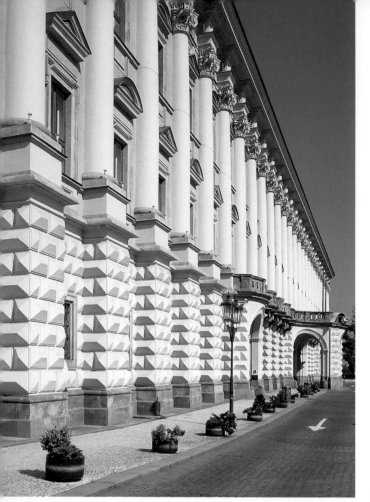

CZERNIN PALACE (Černínský palác)

Now the seat of the Ministry of Foreign Affairs, the distinguishing marks of this majestic building are its imposing size and the massive colonnade which runs the length of the façade. The whole length of the ground floor level is constructed with massive diamond-pointed rustication. Work was begun on the palace in the second half of the 17th century by order of the Ambassador to Vienna, Count Czernin of Chudenice. It was completed towards the end of the century under the supervision of the diplomat's son, Hermann Czernin. The many eminent Italian artists who took part in the construction of the palace made some outstanding contributions, among whom was F. Caratti. In the first half of the 18th century the adjoining garden was added, as was the magnificent stairway with its ceiling fresco by V. V. Reiner (*Fall of the Titans*). During the same period, F. M. Kaňka made some adjustments to the building. Towards the middle of the 18th century renovation work was needed, following the French occupation, and this was carried out by A. Lurago who added three doorways and rebuilt the garden *Orangery* in Rococo style. Around this time I. F. Platzer produced several sculptures which now decorate the palace halls.

View of the imposing colonnade of Czernin Palace, now the seat of the Foreign Ministry.

A characteristic glimpse of the quarter of Hradčany.

TROJA PALACE
Trojský zámek

This splendid Baroque palace ranks among the most beautiful summer residences in the capital. It is situated in the quarter of Troja, which lies to the north of the Vltava, in the northern suburbs of Prague. The architect G. B. Mathey was commissioned to build the palace by Count Sternberg, one of the most well-known members of the city's aristocracy. Mathey completed the building between 1679 and 1685, modelling the exterior on the style of the Classical Italian villa.

The magnificent staircase which leads down to the garden was added between 1685 and 1703. It has a double flight of steps and is decorated with mythological statues by Johann Georg, Paul Hermann, and the Brokoff brothers (*Sons of Mother Earth, Struggle between the Olympian Gods and the Titans*). Inside the building note the great *Imperial Hall,* decorated with beautiful frescoes by A. Godin showing the *Glory of the Habsburgs.* This Dutch artist, who worked on the hall's decoration, also painted the noteworthy *Personification of Justice.* The so-called *Chinese Rooms* contain a collection of ceramics and

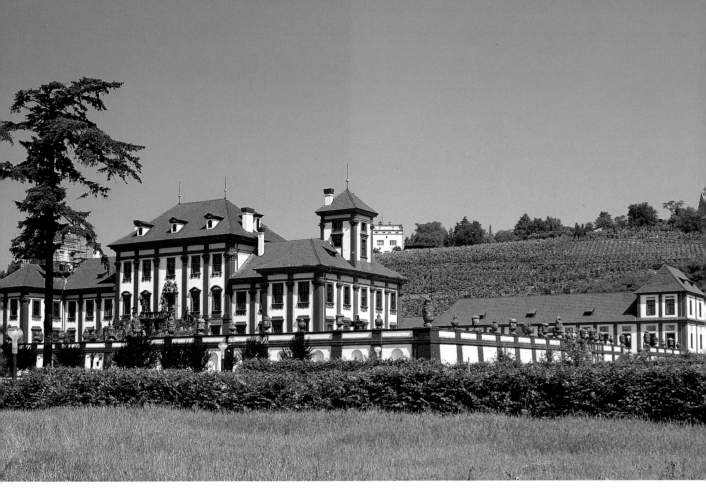

A fine vista of Troja Palace, the miniature Bohemian 'Versailles'.

Troja Palace: detail of the spectacular Baroque double-staircase.

are decorated with 19th century wall paintings of Chinese scenes. The palace, which because of its imposing nature is also known as *Troja Castle,* is complemented by the beautiful and enchanting Troja Gardens (*Letohrádek Troja*). These were designed by the architect Mathey, who in fact planned the entire complex; he made the gardens in a distinctly early-French Baroque style. From the *Orangerie*s at the bottom of the gardens, not far from the Vltava, there is a charming view of the whole of this miniature Bohemian "Versailles".

Careful restoration work has restored The Troja palace and gardens to their former splendour. The palace contains a 19th century art collection.

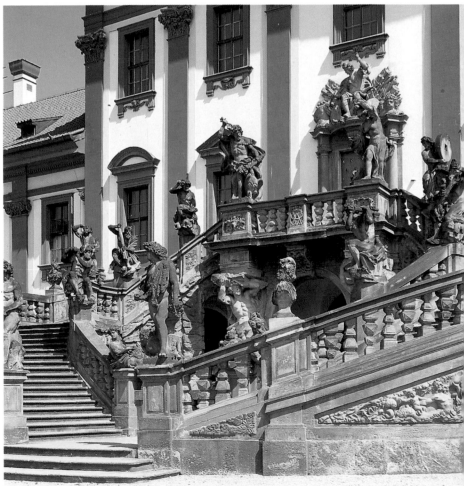

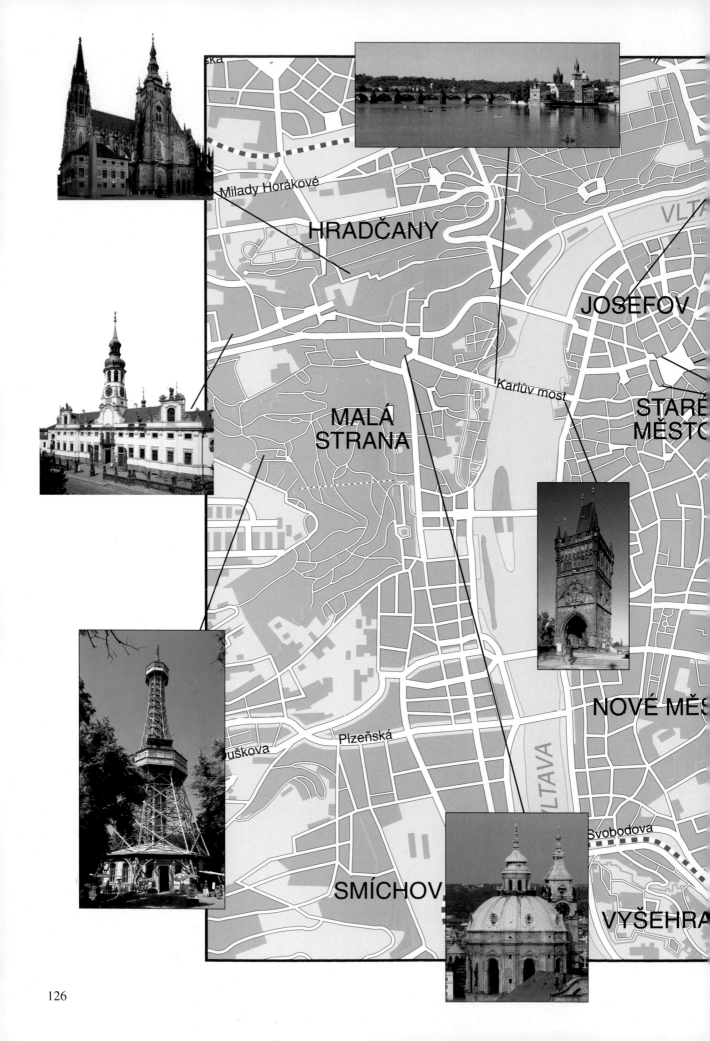

Milady Horákové

HRADČANY

JOSEFOV

MALÁ
STRANA

Karlův most

STARÉ
MĚSTO

NOVÉ MĚS

Plzeňská

uškova

VLTAVA

Svobodova

SMÍCHOV

VYŠEHRA

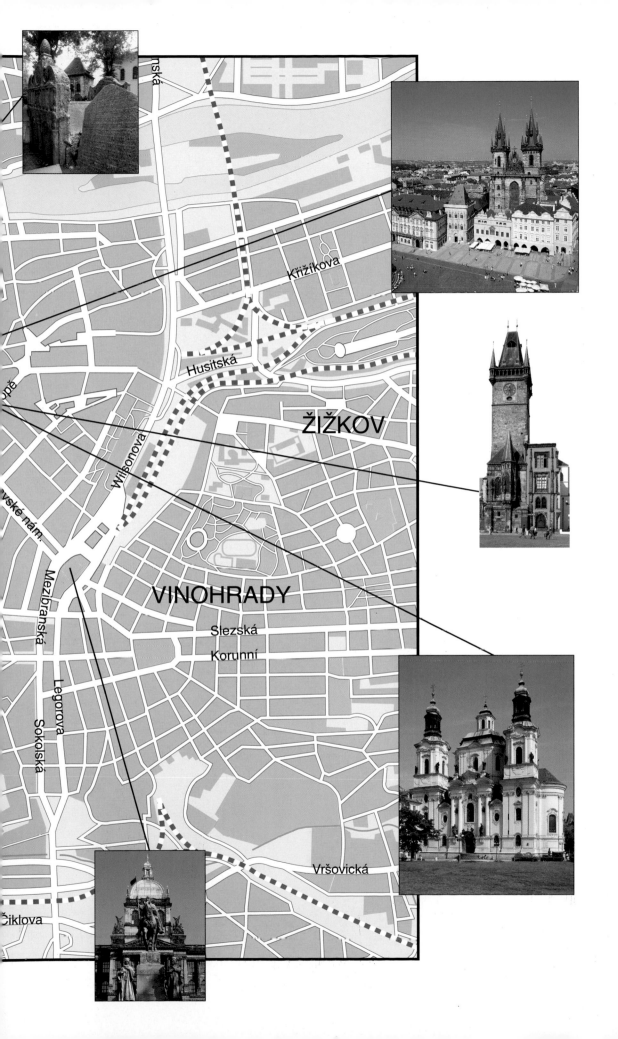

Křižíkova

Husitská

ŽIŽKOV

Wilsonova

vské nám.

pě

nská

VINOHRADY

Slezská

Korunní

Mezibranská

Legorova

Sokolská

Vršovická

Čiklova

INDEX